...milias

sürü köpört főzünk
... öntre kb. 10-15 percig
... forni hagyjuk. ...
...ra is keverjük és ...
...re rakjuk. Mielőtt ...
... kell ...
... öljük be csak ...
... egy kevés ...
...ben.

Meggy jam

A ... tele annyi ...
kell. Kiszemeljük 10 percig ...
... és együtt 20-25 percig ...
... teszünk bele és csak 1-2
nap múlva ...

Barack befőtt

Barackot ... késsel ...
... vékonyan, bekenezzük és ...
hideg vízzel leöblíteni. Üve...
... tele ... mint ...
... a vízet. Minden
üveghez 8 dkg cukrot ...
... rá öntjük és ...
... dunsztoljuk.

Barack jam

A barackot héjával együtt ...
... darabokra 4 féle ...
vágjuk kg. ként 30 dkg ...
cukorral keverjük ...
... is bele ...
... kavargatni. ...
... forralni főzni. ...
... kevés ... akkor ...
... kavargatni ...
...

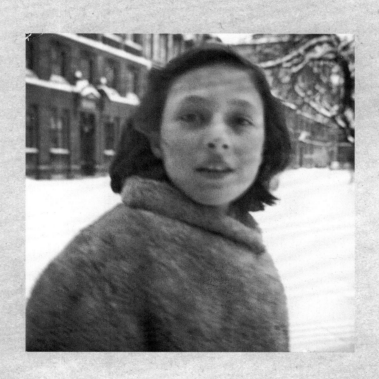

Self portrait with cows going home

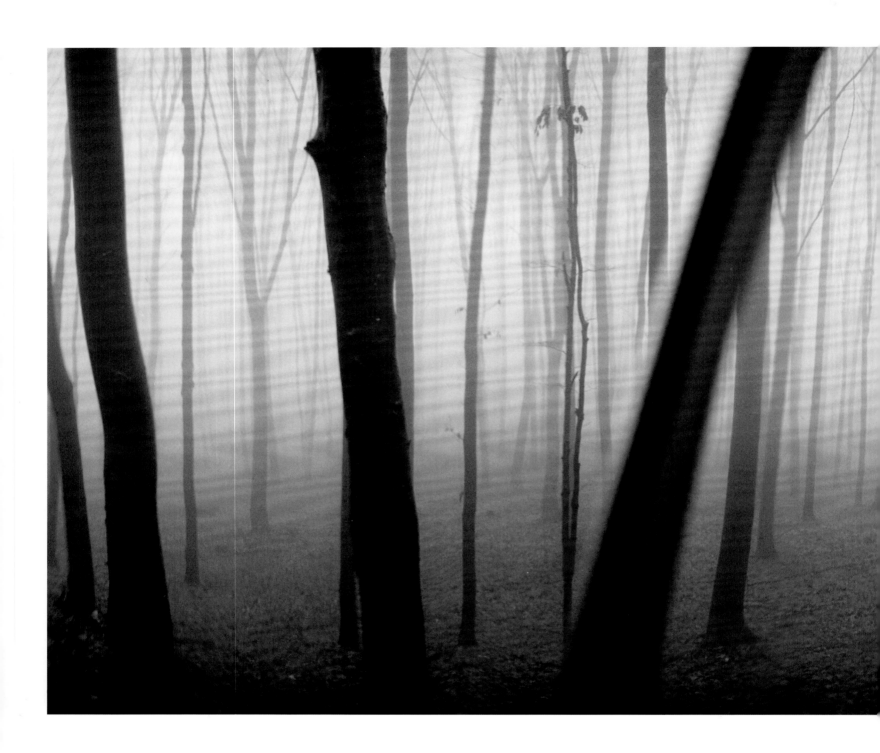

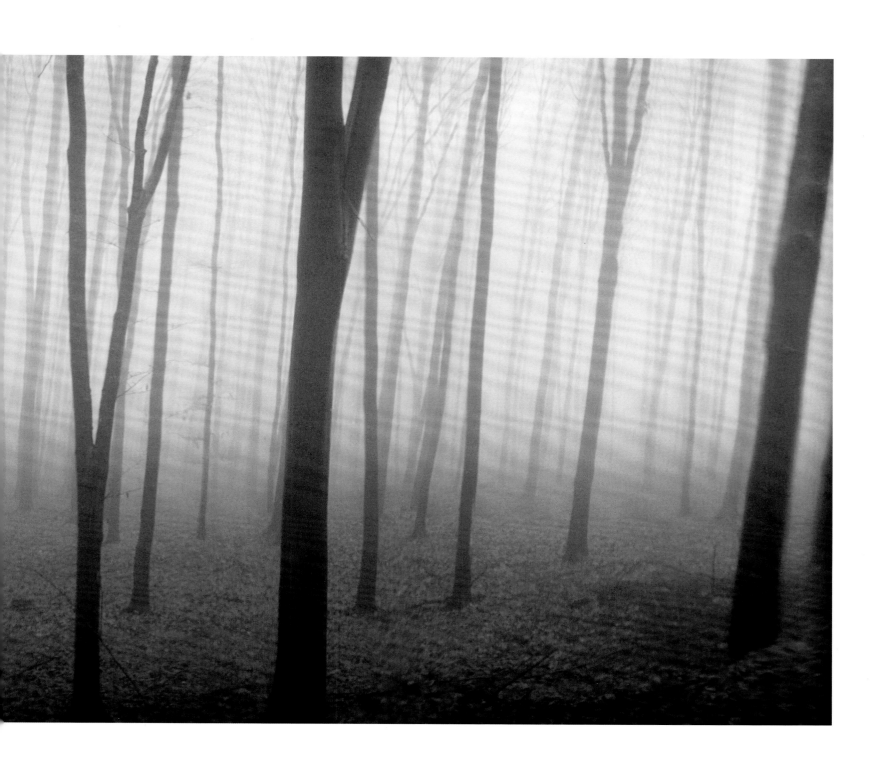

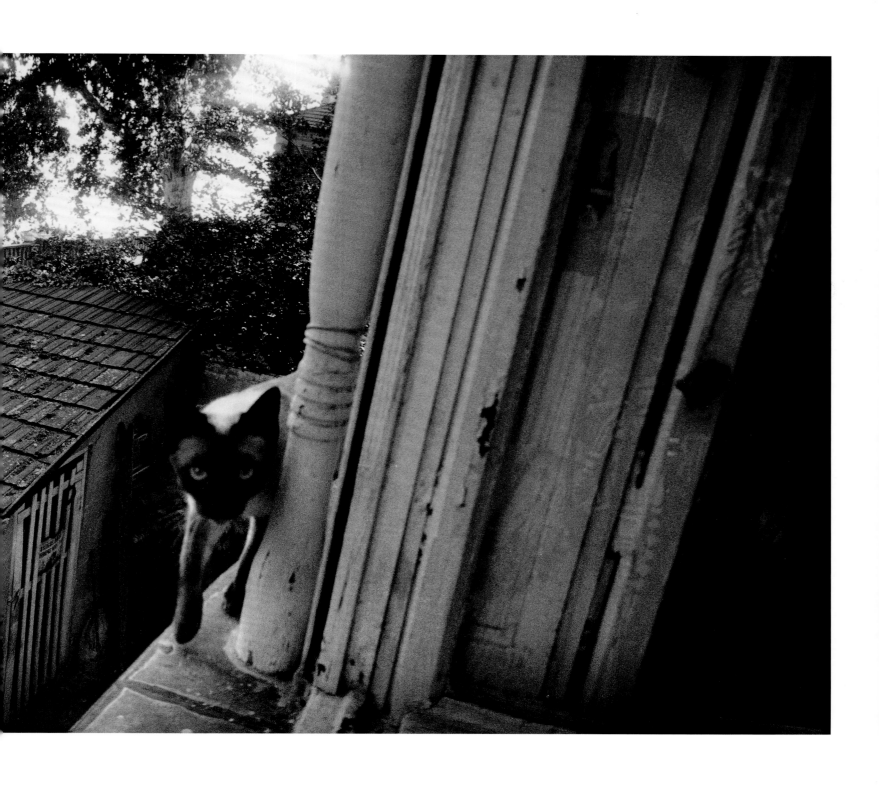

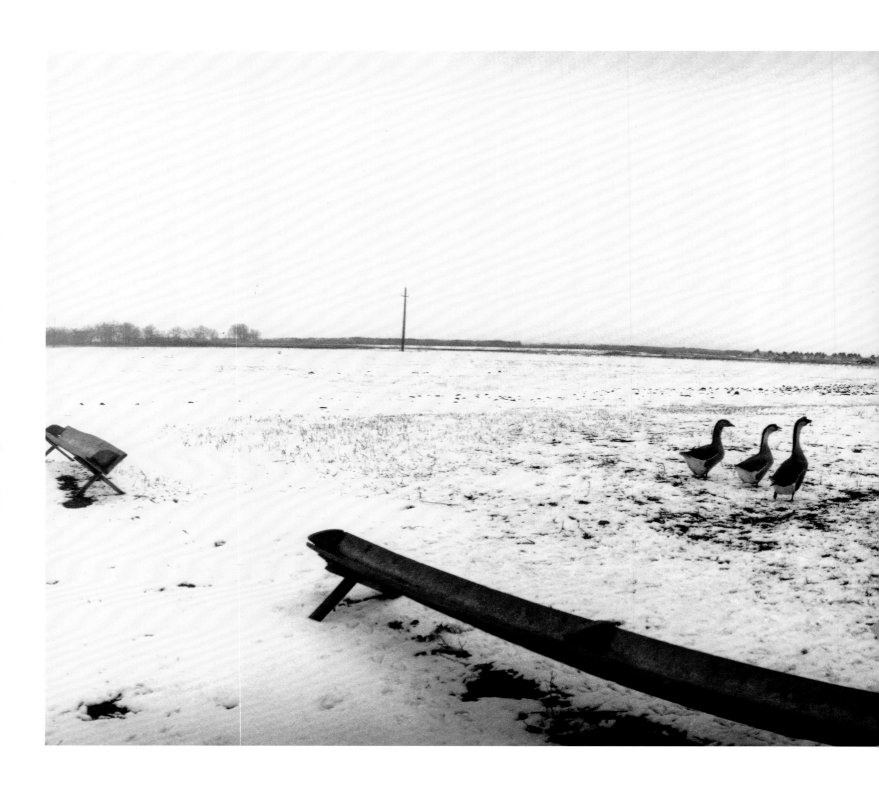

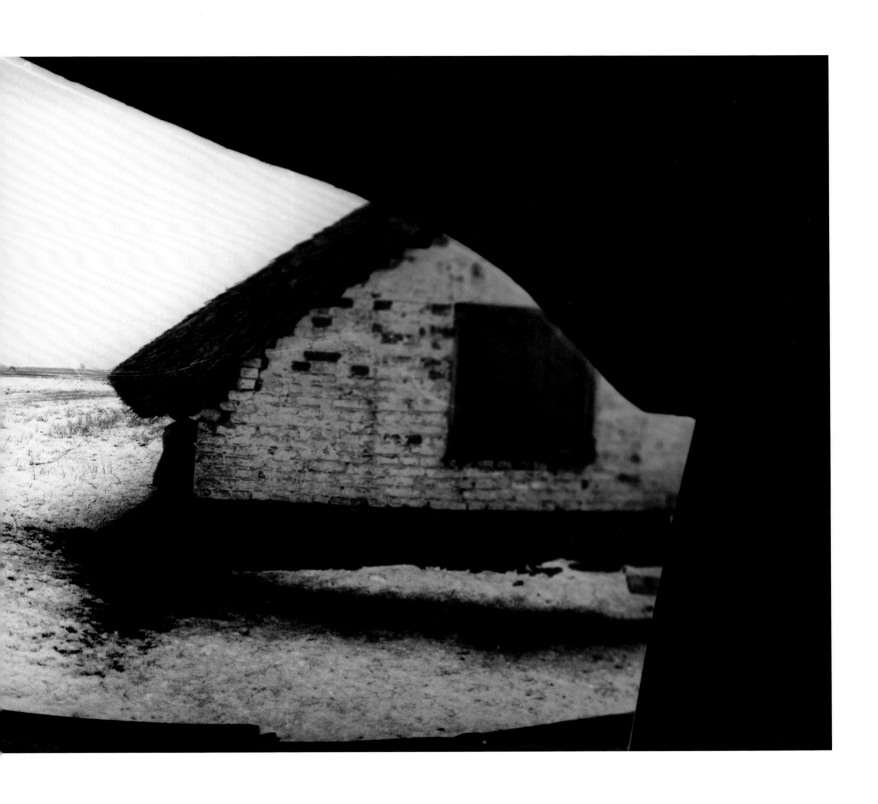

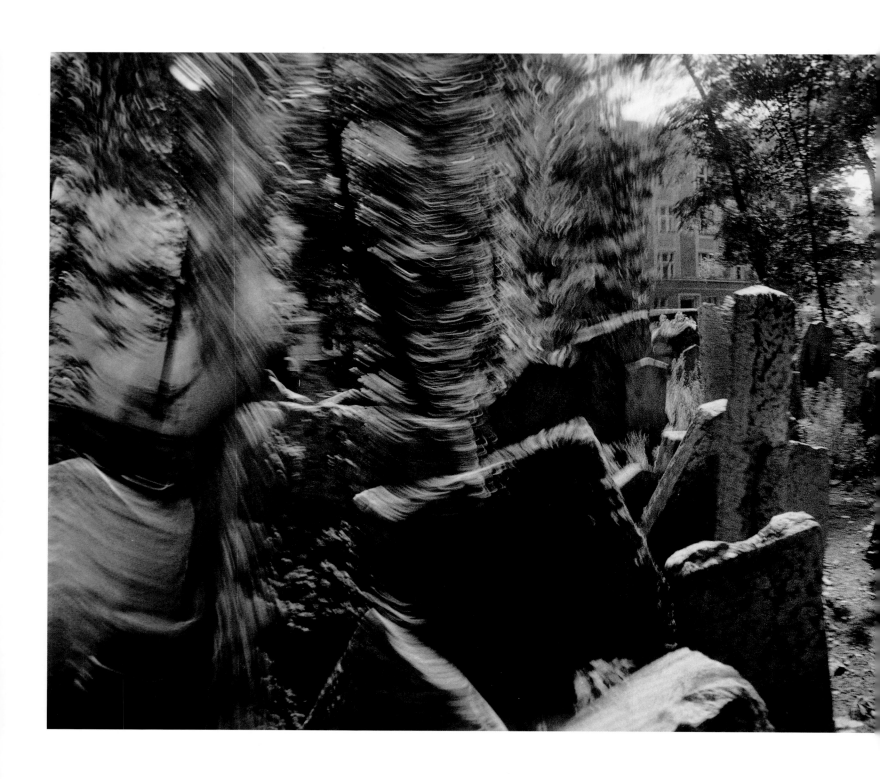

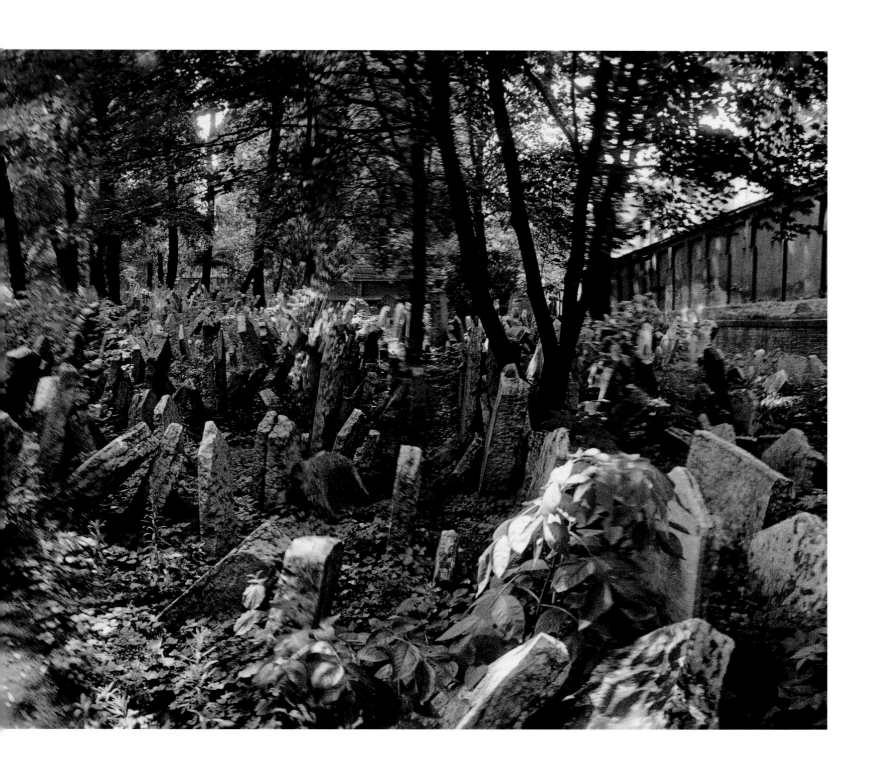

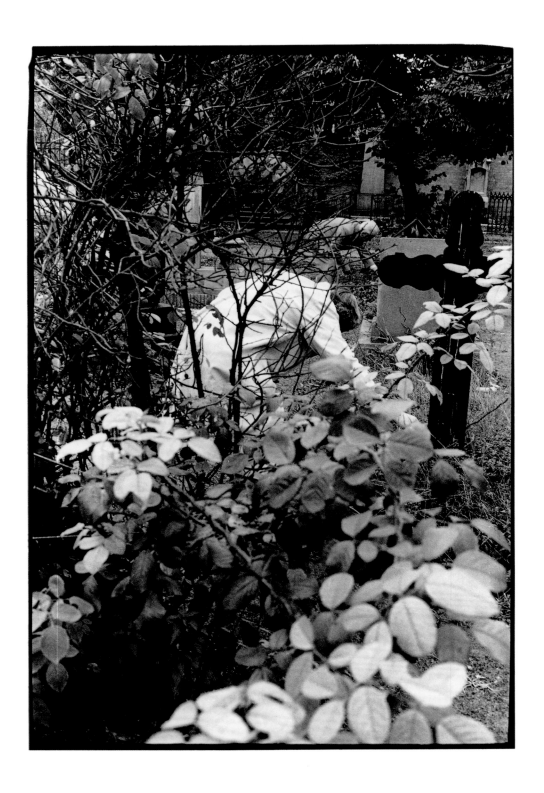

Great-Aunt Klári and Great-Uncle Károly
tending to the graves of their parents, side by side,
in the Kerepesi Cemetery, Budapest, 1964

Sylvia Plachy

Self portrait with cows going home

aperture

"It was long ago and maybe it wasn't even true..."
is how Hungarian fairy tales often begin. (Or was it just a phrase
my mother used to repeat about her idyllic girlhood?)

I walked around dazed, touching walls and fences as I went. The textures on my fingertips calmed me. My mind numb, but my senses awake, I looked hard, fixing everything in memory. The front of a six-story apartment building at the corner had been torn away by Soviet tanks—floors gone, doors open and leading nowhere. Pictures clung to the walls and one chair leaned over the precipice. Dead men, I had seen just days before lying on the sidewalk and covered with lye, had been removed and put into mass graves. Budapest was ominously quiet. The Revolution was over, hope was crushed and repression was certain to follow. My parents made the difficult decision to leave the country and warned me not to talk to anyone. I had one day to say my silent good-byes.

The night before our departure my father opened the one cabinet that was kept under lock and key and took out the Swiss chocolate that he'd been saving since the War. On each holiday as a special treat, he would dole out just one small square of this dark delight to each of us. Now that we were leaving for good and there wouldn't be another New Year in Budapest, we were about to gorge ourselves. We held our breath as my father unwrapped each silver foil, revealing hazelnut, raspberry and nougat—but too late. Little white worms had gotten there first.

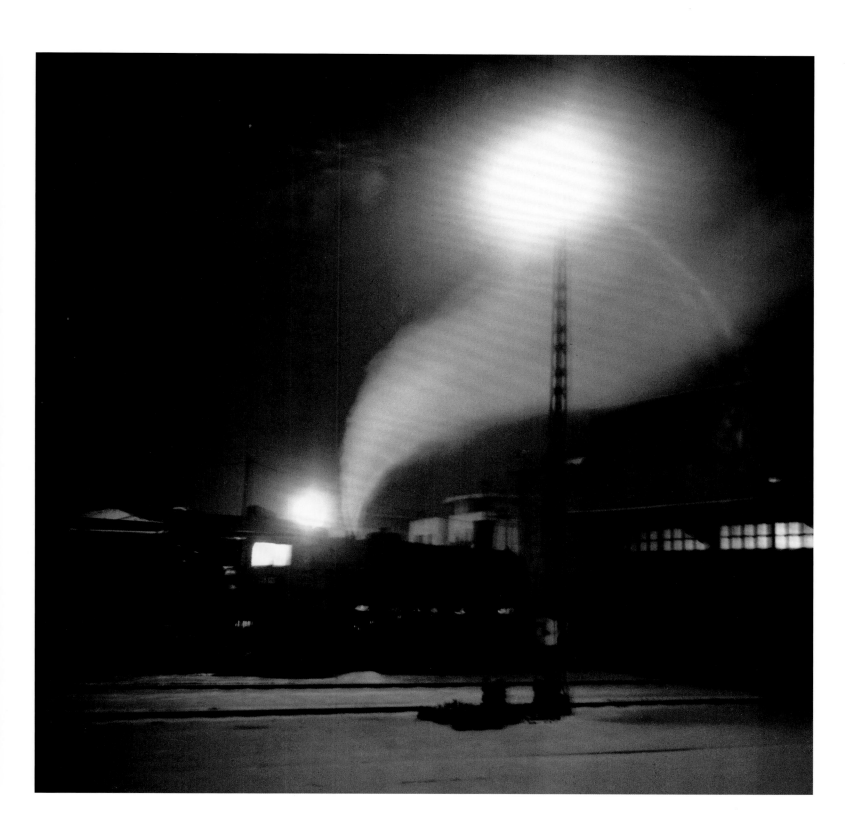

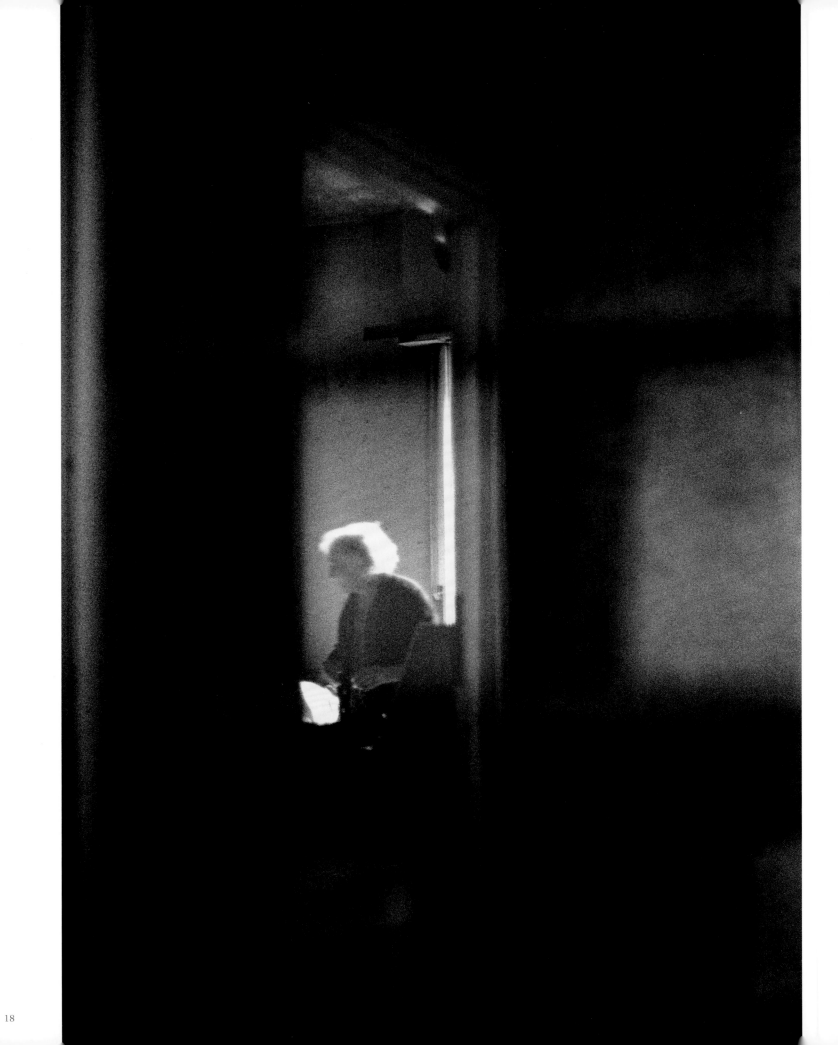

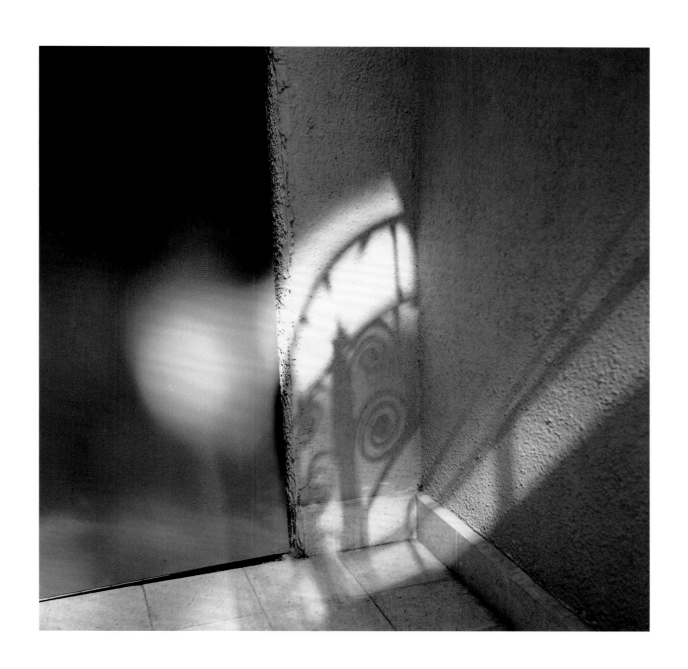

We each carried a small valise and wore several layers of underwear. I, the unknowing smuggler of the family treasure, carried a rag toy monkey with gold coins and a bracelet sewn in its belly. My teddy bear, Maci, hidden from my parents, was tucked under my shirt and in my pocket I put a snail shell. What I didn't take were my braces; before we left, I shoved them far back into the drawer.

A steam engine took us from Budapest to Győr. At dusk our guide piled us into a horse-drawn cart and covered us with corn. We rattled through town on our back, lying on hard wood, until we got to a hut near the border, where we waited for the moon to dim before starting our long trek to the West.

The stars looked on with indifference. The ground was frozen into hard ridges. It was December 10, 1956. My feet were taking me forward, but in my head I was kicking and screaming. Careful not to step on mines we played possum in a morbid game of hide-and-seek with the guards, dropping to the ground as flares lit up the horizon.

Somehow we made it to Austria. In the headlights of a Red Cross van, waiting for those who crossed, my mother kneeled down and kissed the earth. I turned back and looked back. There was darkness behind us and darkness ahead.

I was thirteen at the time, "the child," as my parents called me. My father promised me two things if we made it across the border: one, he would buy me that previously unattainable drink of the West, Coca-Cola, and two, he would treat me, from then on, as an adult. He bought me the Coke and though he really did mean to treat me as a grown up, he couldn't—not then, not ever.

As a prelude to the bitter pill of exile, Coca-Cola tasted medicinal. We were only a few hours away from Budapest, the place I longed to be, yet what I really wanted—my life as it had been before—I knew, I could never have again.

Vienna, they say, is a beautiful city, but I only remember its cold glitter. Naively, we thought that we'd be able to go to the United States right away, but the quota for Hungarians had been filled. Not knowing how long it would take, we waited in a small hotel, in one small room, in a state of unreality. My mother, who aside from Hungarian spoke Czech, Russian, French, German and English, eventually got a job as an interpreter at a refugee agency. My father, who had a wooden ear for languages, stayed home. He wrote letters on a borrowed typewriter and cooked for us. He learned to make dishes on an electric burner with foods that came in C.A.R.E. packages; American cheese, powdered milk and Spam. I didn't go to school that first year, instead I took courses offered to refugees: English and how to color black-and-white photographs. I stood on line for meal tickets and stared into shop windows. I especially liked to look at miniatures and was transported into other worlds on backs of tiny glass horses. Each night I cried myself to sleep and wrote in my diary. In the afternoons, I went to the church nearby and prayed to the Virgin in the grotto. Once, I'm certain of it, I saw tears in her eyes.

As "any day now" had turned into months, the following fall I was enrolled in a girls' public high school. As I did not speak German, I looked up all the words in the dictionary and then memorized them. I could do nothing about my accent and each time I was called on to speak, the girls giggled. One day I hid behind the stove during recess. I was locked in and for a few minutes I breathed free. I managed to do this a couple of times. When they caught me, they whispered that I meant to steal.

But then again, it was not all bad. Gyuri, a young Hungarian I met in English class, took me riding on his motorcycle. The free meal at the restaurant did not include dessert, but a man at the next table always sent over a slice of cake for me, and the waitress refused our tip. In March of 1958, I spent a glorious week skiing with my classmates in the Alps, where I took my first photograph: a black goat in white snow. The camera, an Agfa Box bought at a pawnshop, was a gift from my father.

Finally, on August 8, 1958, we crossed the ocean in an Army plane. A bus plunked us down outside of Grand Central Station in New York City where the air sparkled with heat and noise, and crowds rushed about us. Another bus took us to New Jersey, to my mother's Aunt Ilu, who did her best to settle and assimilate us "greenhorns." Unlike in Vienna, at Saint Michael's High School in Union City, I was not made fun of—after all I was someone who had survived a Revolution and had lived in European capitals. I had two friends: Doris and Mary Jane and the encouragement of Sister Margaret, my Latin teacher, whose prayers and letters followed me long after High School. I bided my time and saved my money for the trip back to Budapest from a part time job at the cosmetics counter at Woolworth.

In 1964, when I was twenty-one and already at college, studying Art at Pratt Institute, I could finally return—I had my U.S. citizenship and the Hungarians gave me a visa. This time I carried not Maci the teddy bear, but a Robin, a hybrid camera, made of American and Japanese parts. I stayed with Nagyi, my grandmother, my father's mother, who had remained in Hungary and had moved into the room that once was mine (her name was Matilda; people called her Matyi néni and I called her Nagyi). The rest of our former apartment was rented to a policeman and his family. Everyone shared the bathroom and the kitchen, but the refrigerator, bought by the tenants, was padlocked. Each time I came for a visit, my grandmother gave me her bed in my old room and slept on the couch in the hallway. The stars from my pillow looked the same as when I was a child in my crib. Pigeons still roosted on the ledges, while in the courtyard below, hopeful cats with upturned faces waited for a meal. From the earth, black with soot, pale and spindly trees reached for the light and swirls of black smoke rose to the sky to the beat of someone hitting a rug. In the morning, rays of sun entered to wake the dust specks and enticed them to dance.

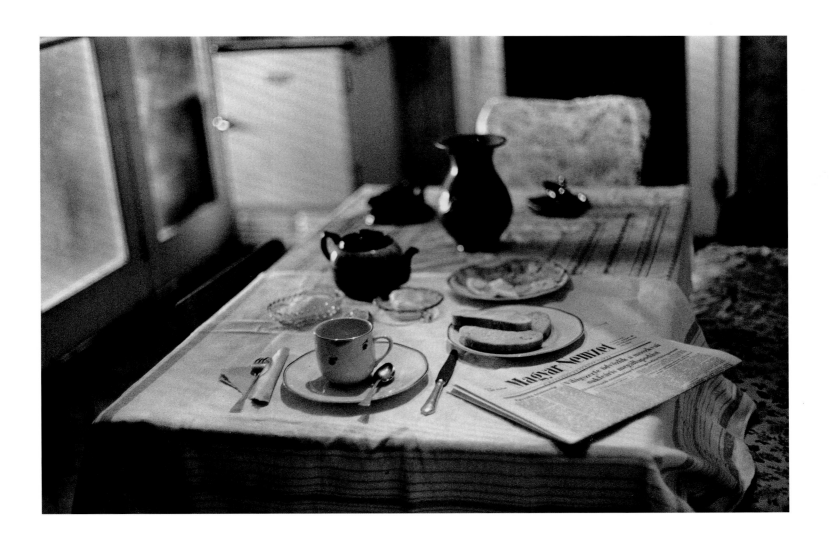

Above: This is the breakfast my grandmother prepared for me
in the old dining room, on the old tablecloth, with the old teapot, cup and silver.

Page 24: A view from my bedroom window.

Page 25: My grandmother tacked up this photo of my father and our dog,
Jackie, taken in Queens, onto the wallpaper, just to the right of Little Red Riding Hood
facing the Wolf in our bedroom in Budapest. I took this in the summer of 1972,
the last time I saw my grandmother.

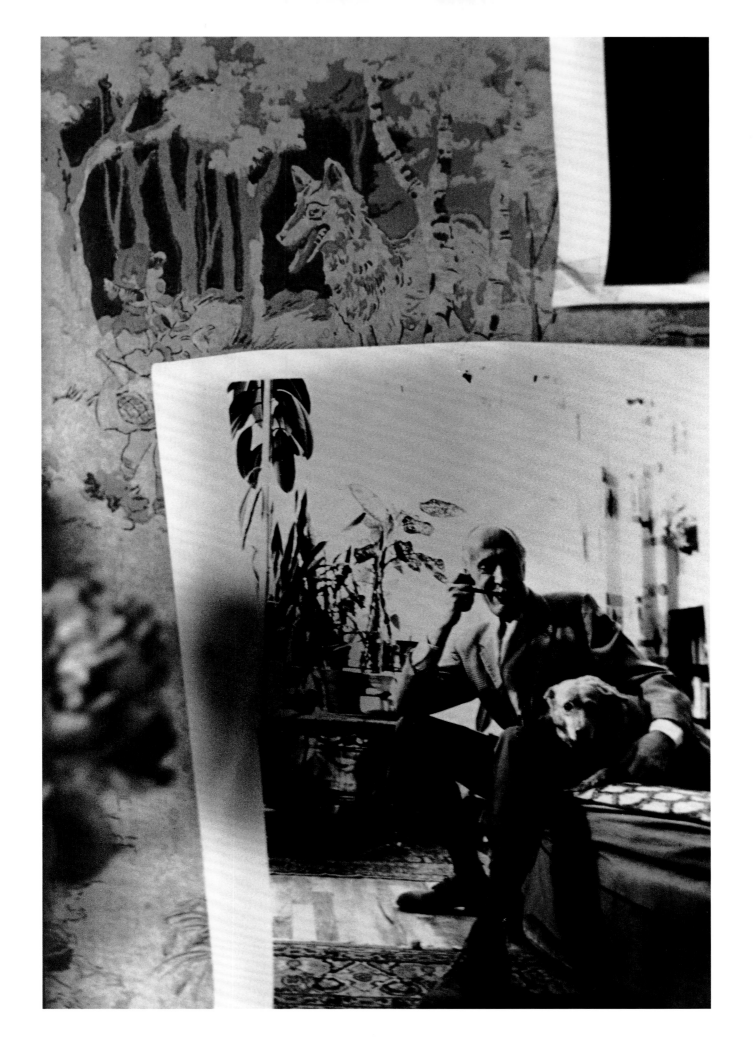

Daylight is fading. Memories start like this, like in a dream or mist or a vignetted photograph. I see her sitting in a chair. She is ninety-two and her hair is wispy white. Her voice is thin and frail, like her body. She asks about me, and my parents. She talks about politics, the weather and the neighbor's daughter—who came in late again last night. Her straight back and the black she wears shields her past. She never talks about her youth and I don't insist. She doesn't have to—she is with me. Until she died, I knew only that she was a widow and that she came from an impoverished, aristocratic family, the Ábrányis, many of them listed in the Hungarian "Who's Who," as artists and writers and theater people.

Her father, Ábrányi Lajos, was a painter and made his living from portrait commissions. Paintings by him of their country house, portraits of himself and his wife, and a portrait of my great-great-great-grandmother adorn my living room. Sadly, there is no one left to ask and I can only imagine the story behind their enigmatic faces.

There is one story I recall, a wrenching event concerning Nagyi's grandmother, who saw a specter of one of her sons lying drenched in blood on her couch an hour before his good-bye letter came by courier from another town. It said: he was sorry, he gambled away his money and shot himself.

My grandmother, who was thought to have been a beauty, had no photographs of herself from her youth: she burned them all. Only after her death did my father tell me more about her. The love of her life—a guard in the Hapsburg Court—was not permitted to marry her, as she didn't have a dowry. These were Victorian times and when she had a daughter out of wedlock, her parents pressured her to give her away. Her first child was raised by peasants, ended up in France and had three children. Once, many years later, when my twelve year-old French cousin, Roger, came to visit and stayed with us, he would have nothing to do with my grandmother.

When my grandmother's second child, my father, was born in 1906, she refused to give him away—instead, she moved to a village in the country, hidden away from the eyes of society. Perhaps, eventually, she and her dashing officer would have wed, but he fell in battle in World War II. She wore black from then on and although she had many suitors, she wouldn't have any of them. The eventual marriage to Plachy Zsigmond was arranged to legitimize my father. He is only a name, but a name that suits me: *plachy* means shy in Czech.

Opposite: My grandmother lived among our things. "Treasure"
is what I call this photograph. It shows her putting away with care the Q-Tips,
Band-Aids, and soap I brought her. The title refers to everything in the room, but mostly to her.

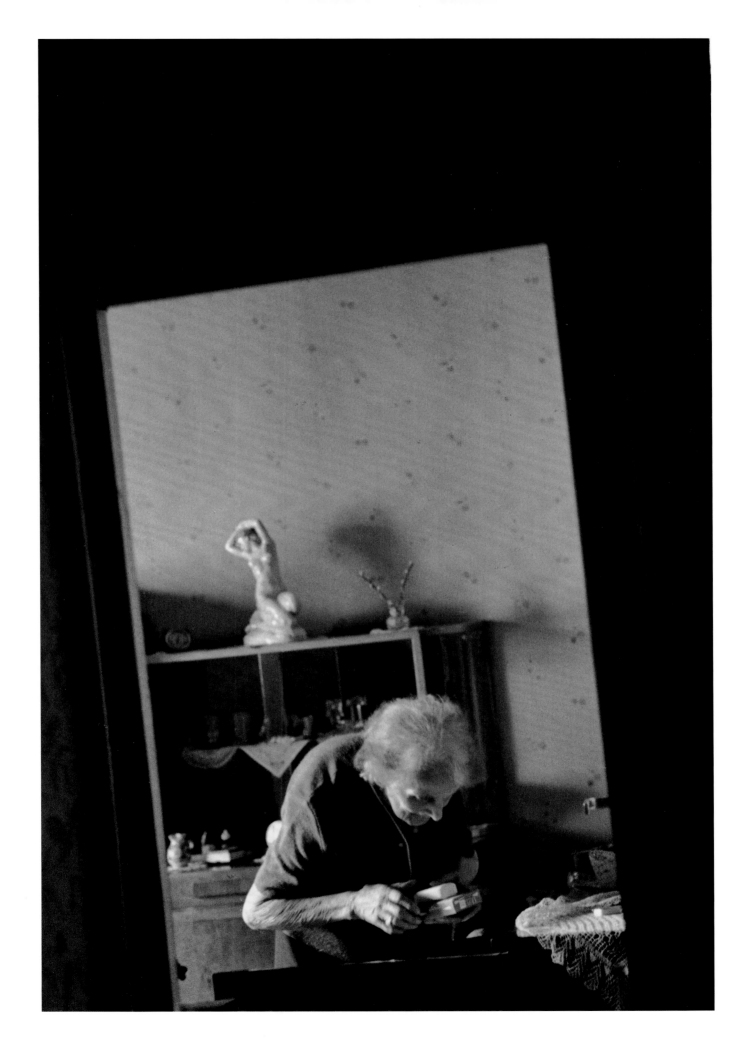

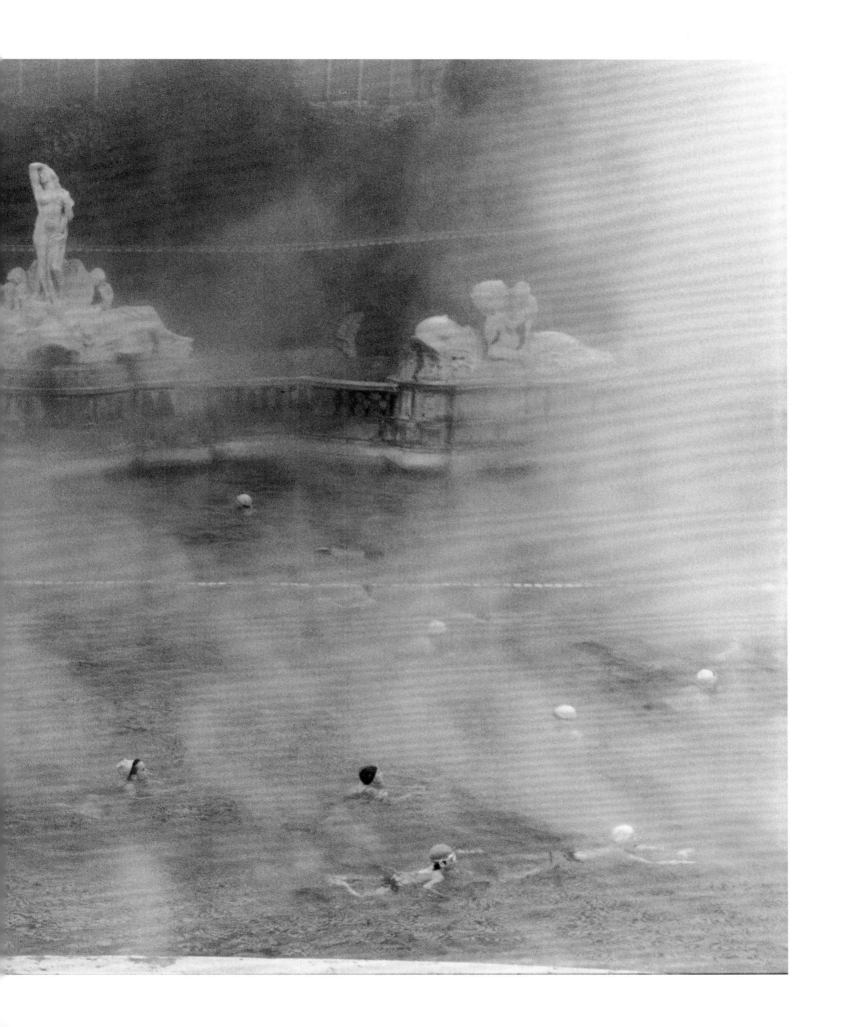

When I was about four or five, to delight my parents' friends, I would recite the ballads of the Hungarian epic poet Arany János. My Father taught me to express these tales of suffering based on Transylvanian and Welsh folklore with the dramatic verve of a Shakespearean actor. Sin is what these tales were about, murder mostly, and the guilt that followed. "…Edward király, angol király, léptet fakó lován, Körötte csend a merre ment és néma tartomány…" (…King Edward, the English King, rides his pale horse, surrounding him is his silent territory…"), was about King Edward of England, who brutally annexed Wales and when the bards refused to sing his praises, he had them burnt at the stake—all 500 of them. By the end he had trouble sleeping.

King Edward stood for our despots, to whom none of us could afford not to say, "long live, comrade." It was my father's way to survive those oppressive years in Budapest after World War II. He retreated from the contemporary tales of camps, gas chambers, tortures, rapes, and gulags to refrains of horrors from another age. I believe that these legends transformed into verse and performed by a child were reminders to everyone present that life was tragic and always will be, but art could and had to sustain you.

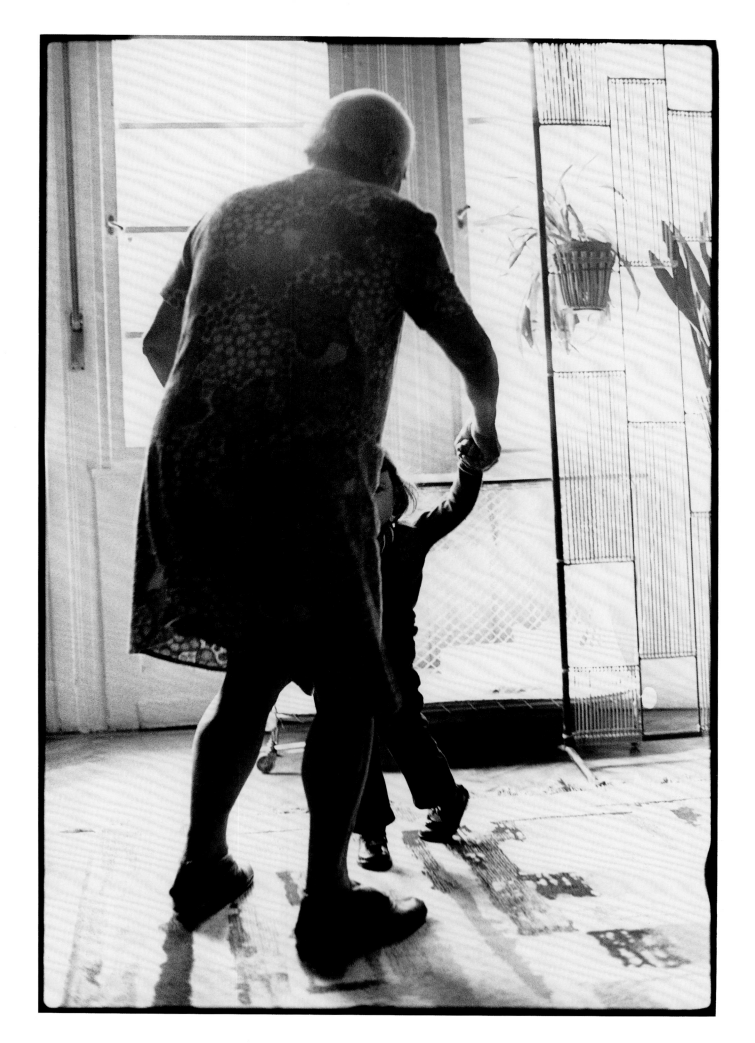

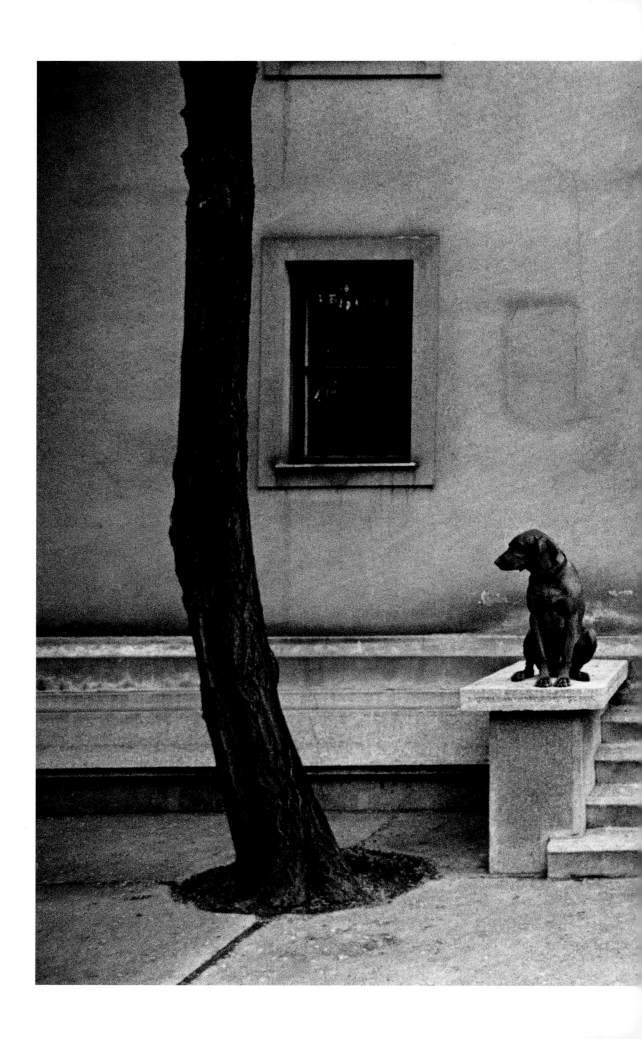

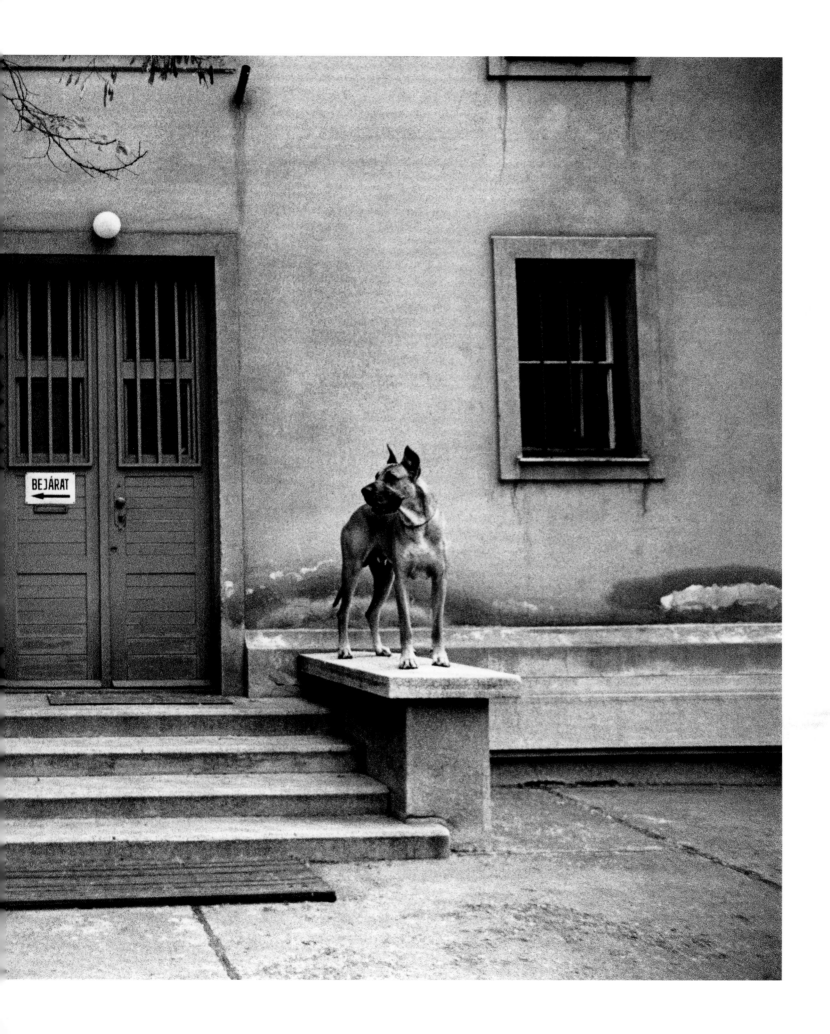

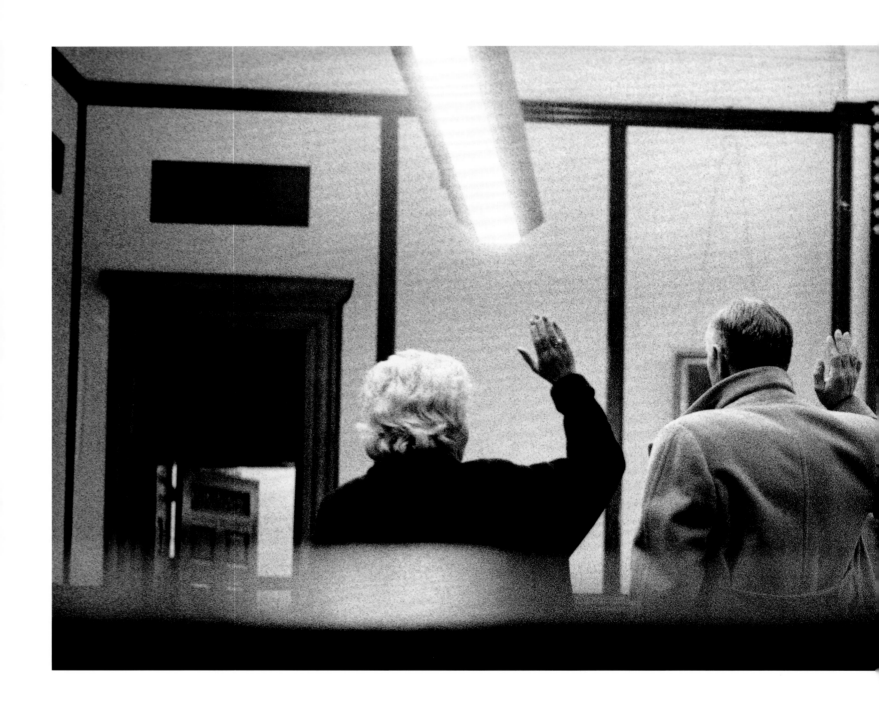

In 1963, my parents and I became United States citizens. Here they are, raising their right hands, in a Manhattan courthouse.

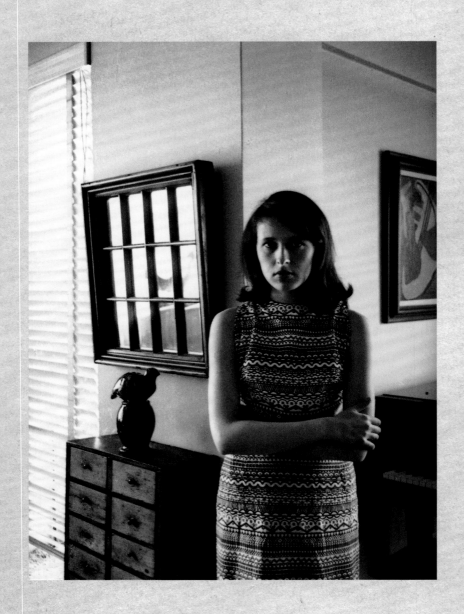

André Kertész was my friend, my mentor and my honorary grandfather.
During my visits, we had tea and jam and spoke Hungarian with each other.
He took this portrait of me when I was twenty-one in his apartment
on Fifth Avenue, around the time when I made my first trip back to Europe.
He called me taknyos, *which means snot nose, affectionately.*

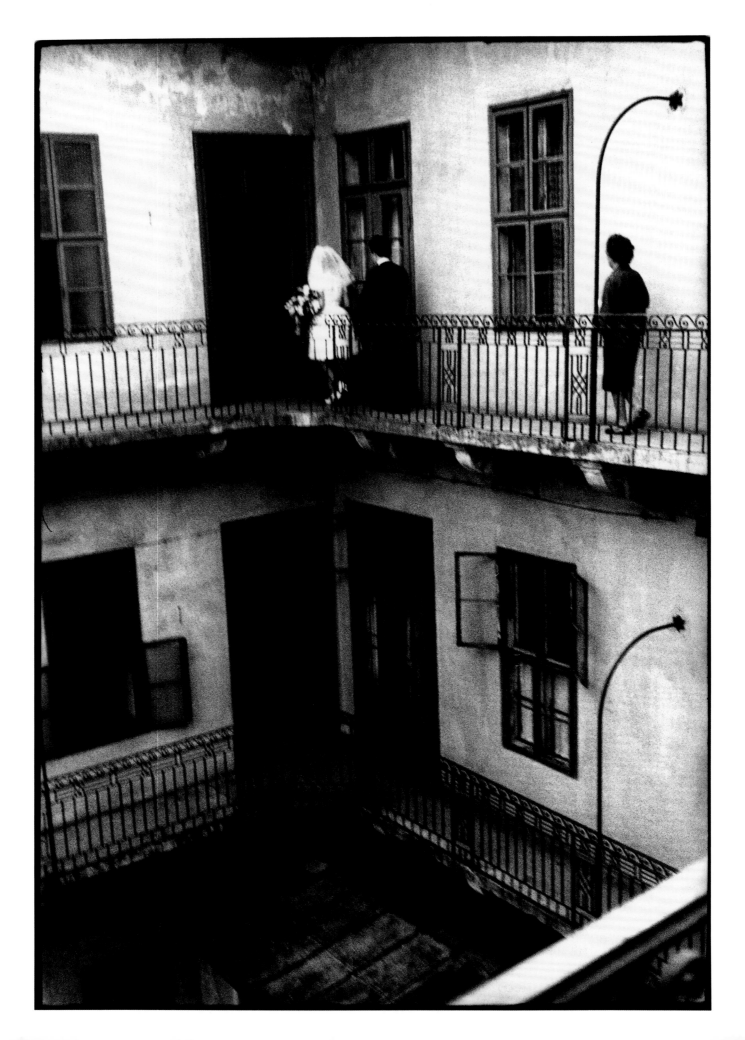

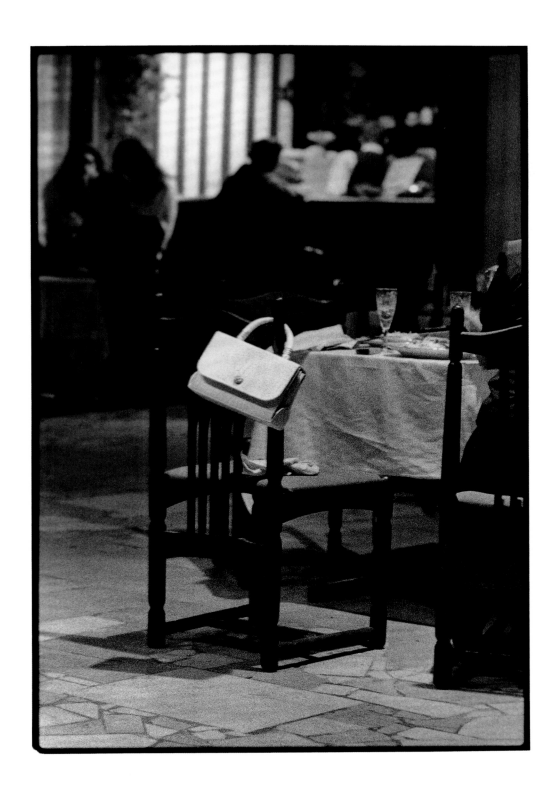

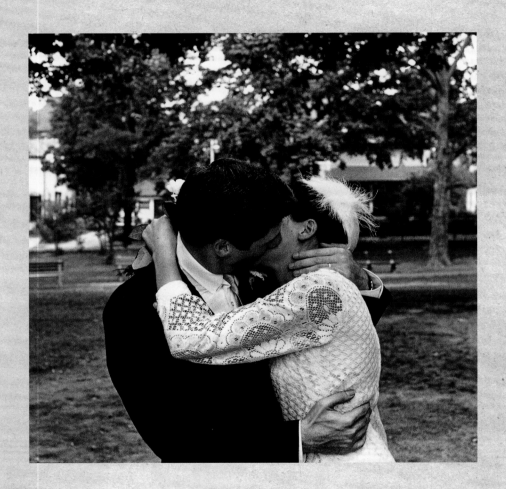

Above: *Elliot and I,*
on our wedding day, photographed by a policeman
in a park in Mount Vernon, 1966.

P38: *Marika on the balcony, on her way to be married.*

It was love at first sight as I stepped on the bus, Elliot gave me his "killer look." We were on our way to Camp Meadowbrook, Upstate, to our summer jobs; he, as a fencing counselor and me, Arts and Crafts. I was 19 and he was 21. We argued about the existence of God, took long walks, and in the evenings, danced in the rec. hall to the velvety voice of Johnny Mathis. "Chances are…" is still ringing in my ears. It was a summer romance and four years later we eloped. Among my friends in Hungary we were the last to marry. Anikó married Karcsi; Lulu married Ahmed, an exchange student from Algiers; and Gabi married Roberto, a Cuban, studying at a University in Budapest. My first visit back to Hungary in 1964 coincided with the wedding of Marika and Feri.

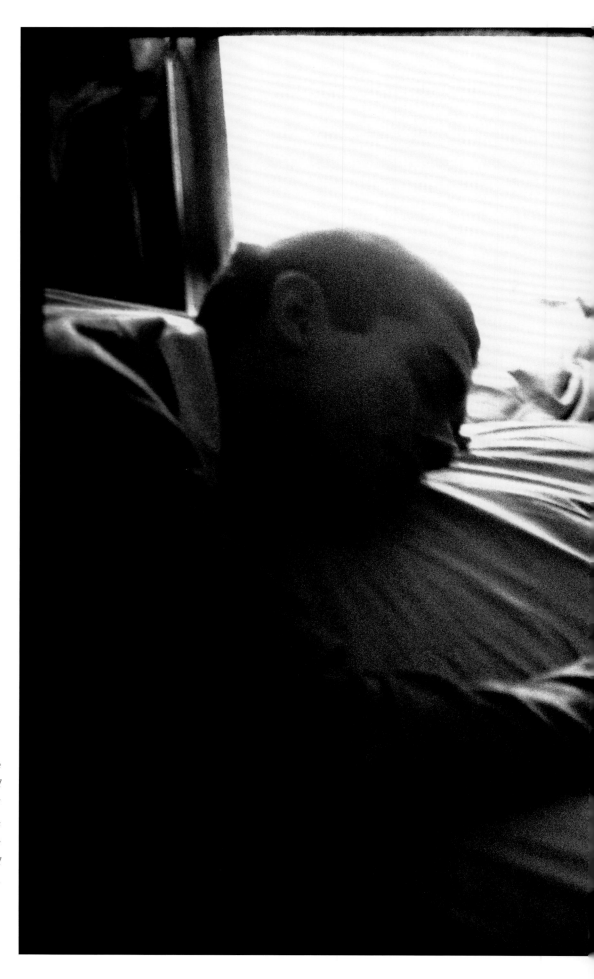

*Roberto and Gabi in Budapest before we
lost touch with one another. They married and
moved to Havana. I was in Cuba in 2001 and I
had trouble finding their address. A woman on a
nearby street remembered them: Roberto had left
Gabi and went to Miami, where he later died
of a heart attack. Gabi, her sister and her daugh-
ter live somewhere, in Canada.*

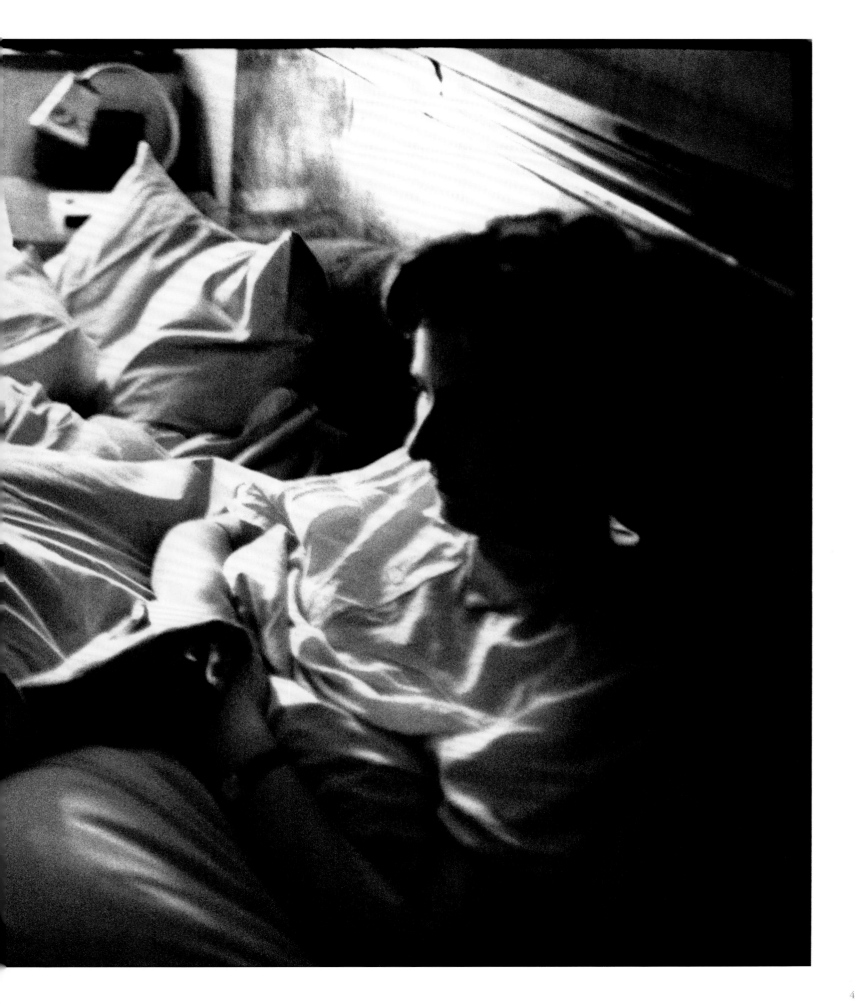

Karel Plachy, a homeless man from Prague, lived on a lot near New Brunswick.
He found me in the Queens phone book and got it into his head that I was one of his two children
that he misplaced during World War II in Eastern Europe.
He called me from a phone booth and even came to the house a few times.
I tried to tell him that he was mistaken and that I knew my real father, but he wouldn't listen.
After about a year he gave up and disappeared from my life.

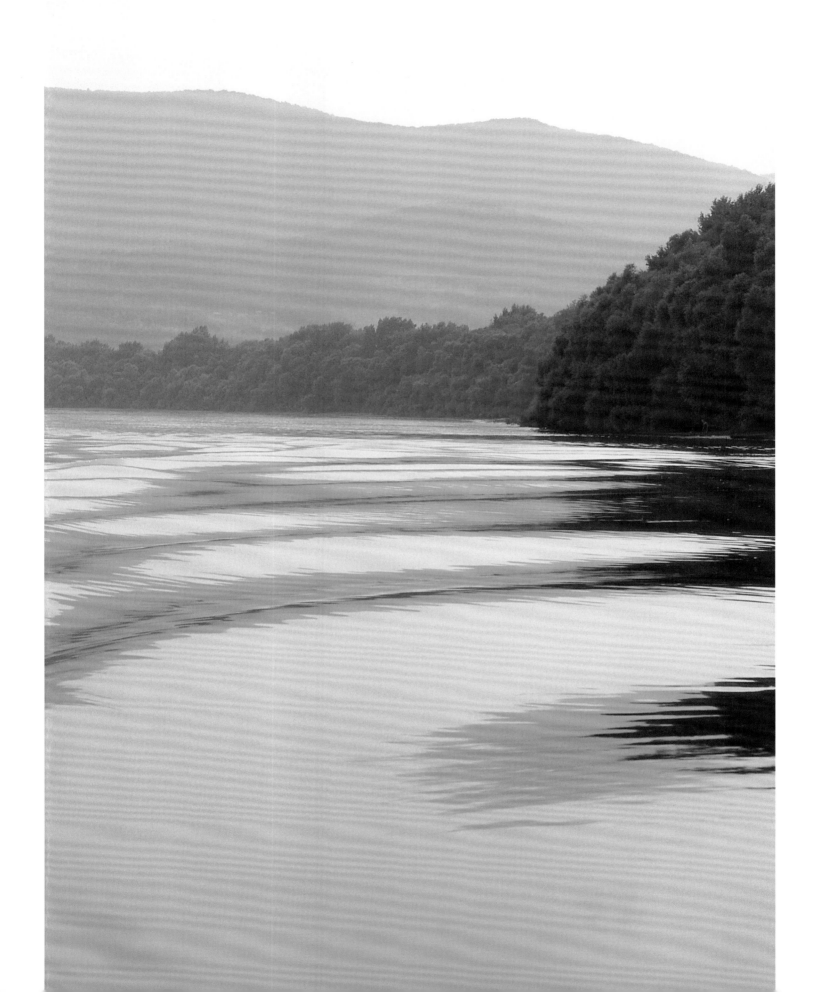

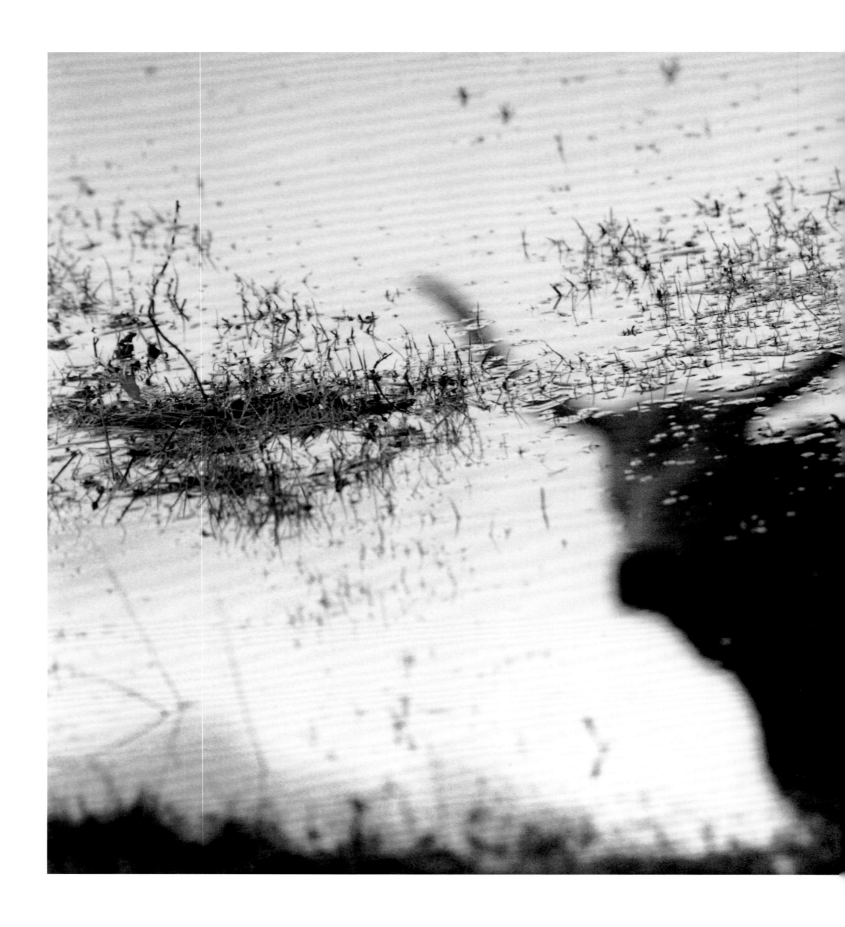

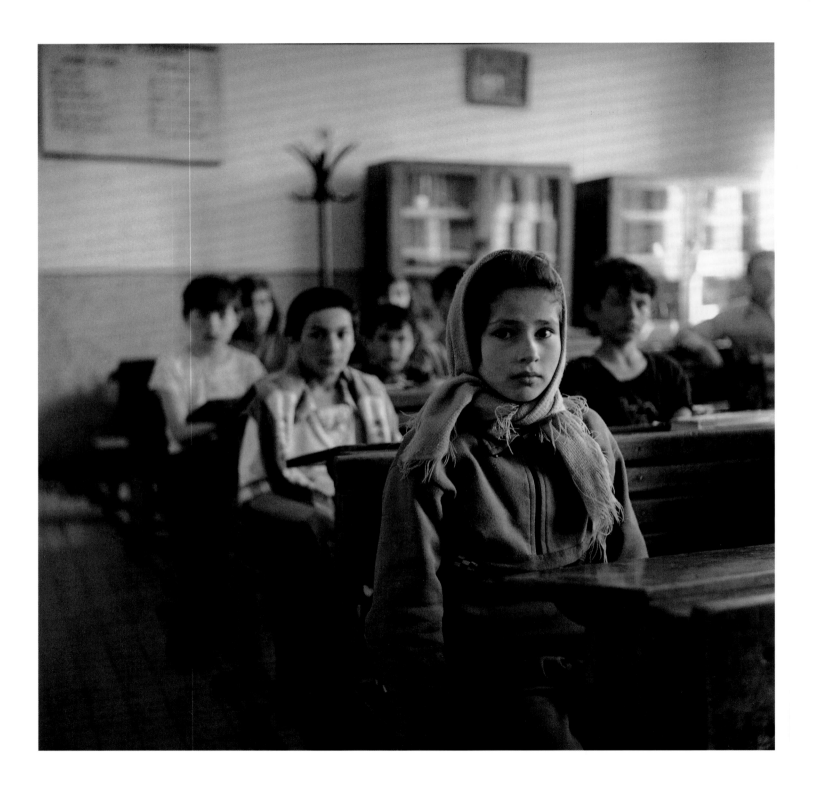

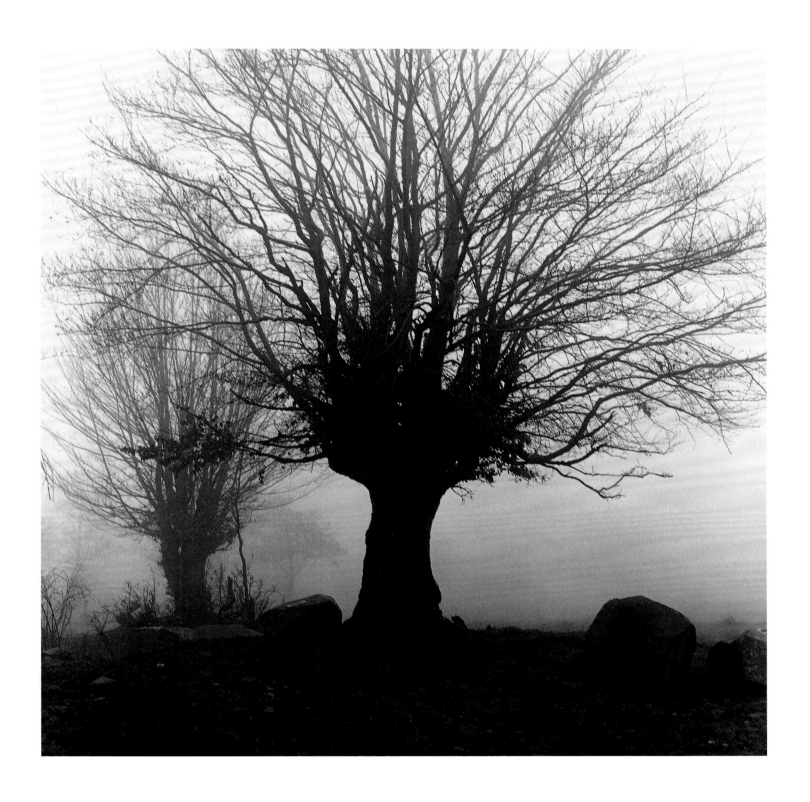

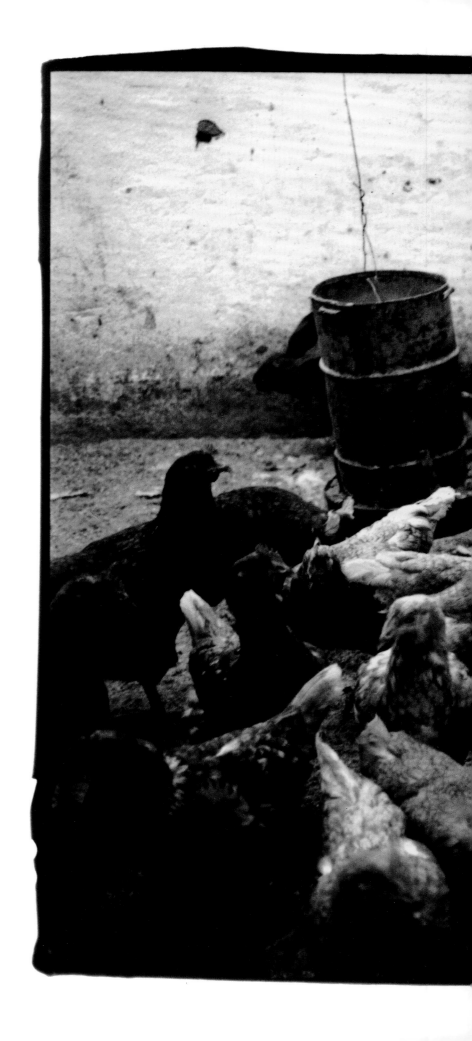

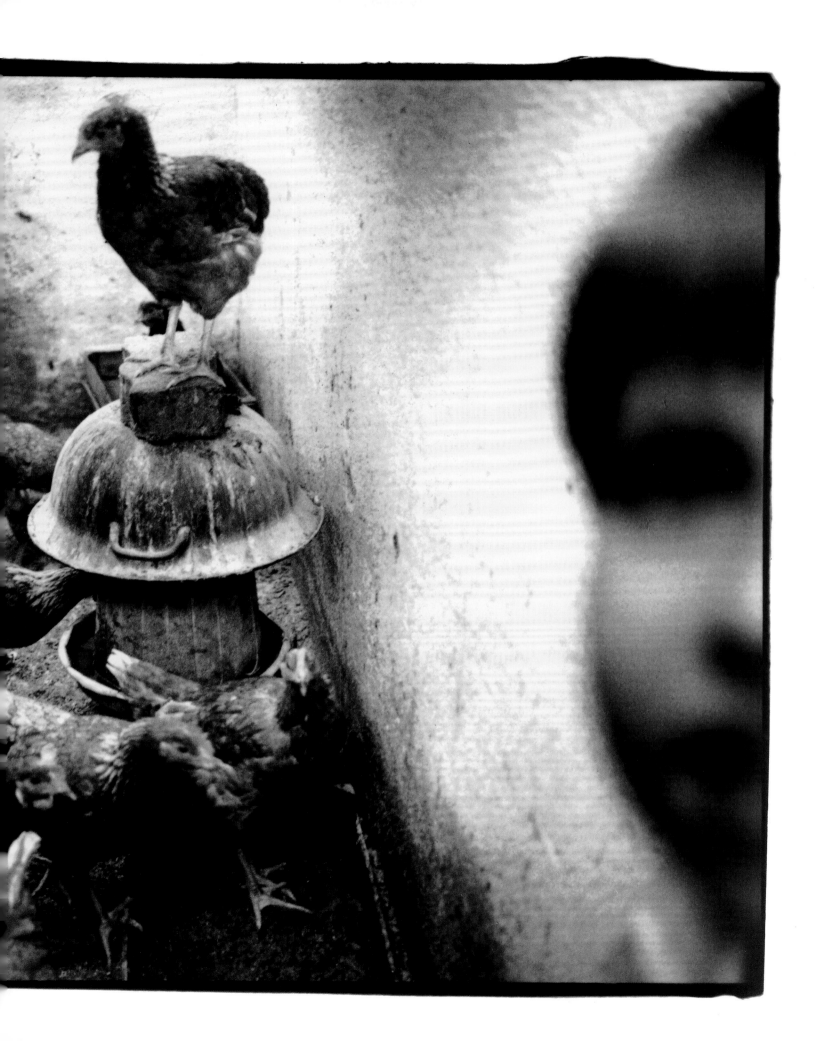

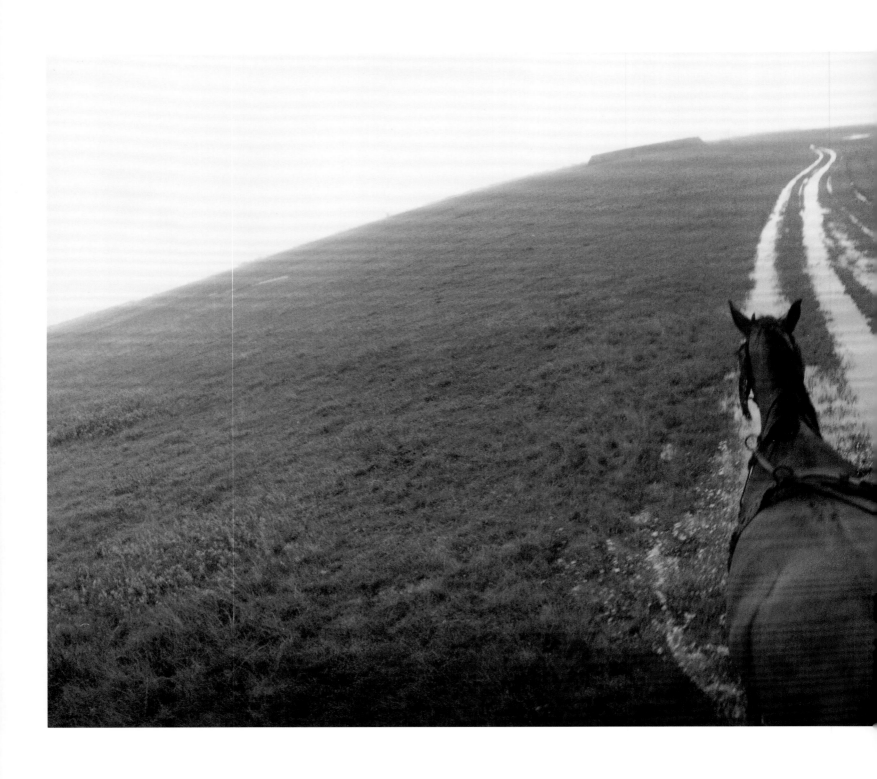

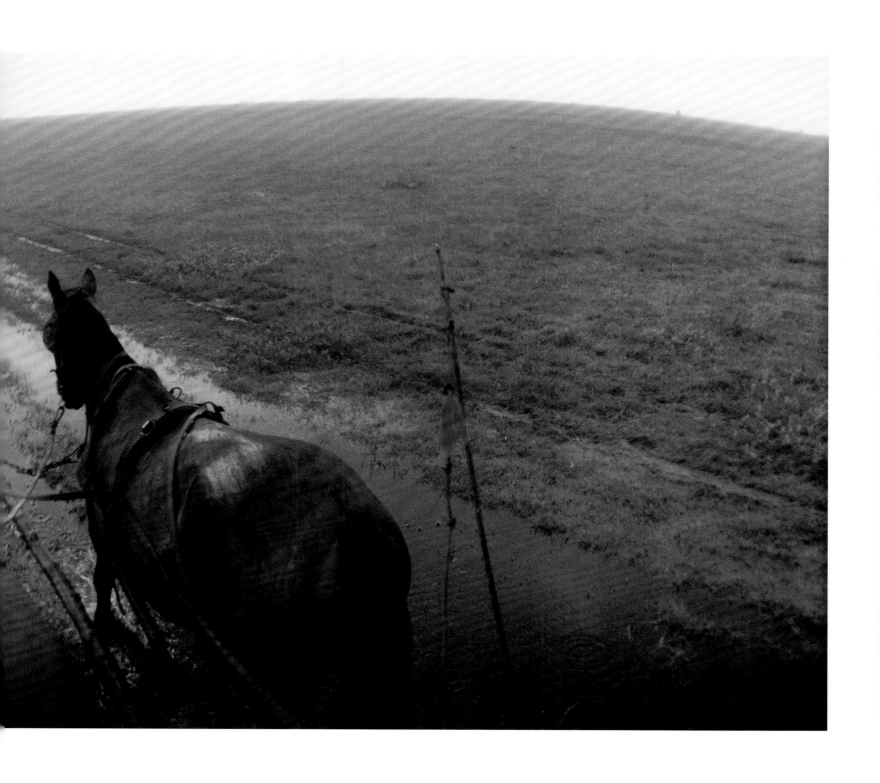

In the Spring of 1939,
my future father, who lived in Budapest,
sent a telegram to my future mother,
Iluci, who lived in the town of Raho,
in the Czech Republic, formerly in Hungary,
which is now in the Ukraine:
I HEAR YOU LOVE ME STOP
WHEN DO WE MARRY STOP VILY

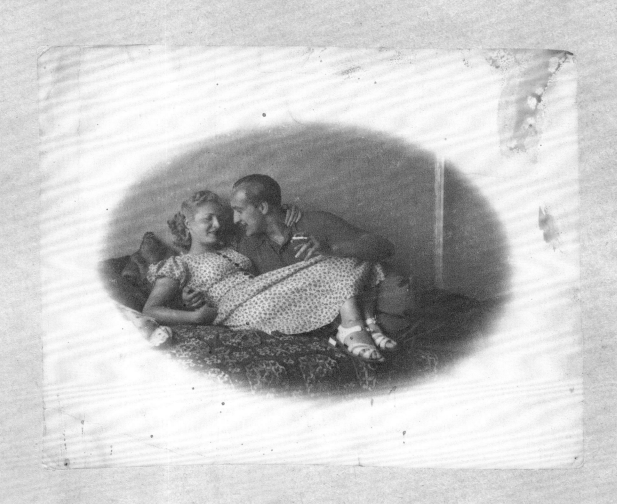

My mother and my father ca. 1939

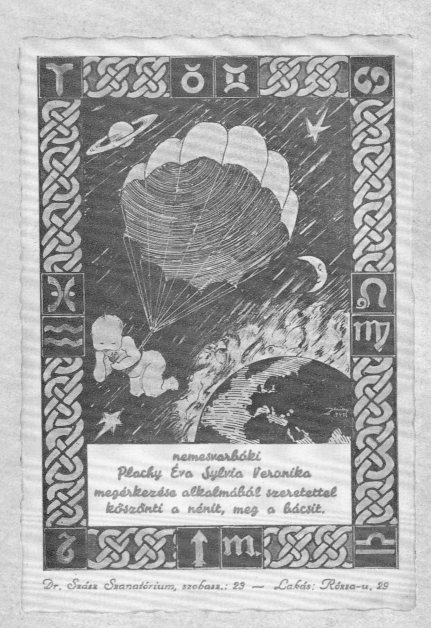

nemesvorbáki
Plachy Éva Sylvia Veronika
megérkezése alkalmából szeretettel
köszönti a nénit, meg a bácsit.

Dr. Szász Szanatórium, szobasz.: 23 — Lakás: Rózsa-u. 29

The earth is on fire.
A little baby is gliding down toward
the flames by parachute. It is Budapest, May 1943.
This is my birth announcement, etched by my father.

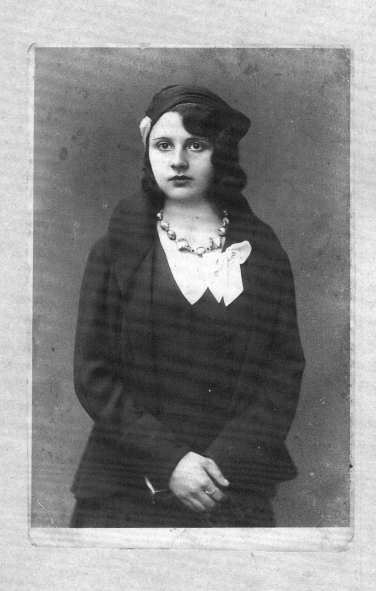

My Aunt Hédy, ca. 1936

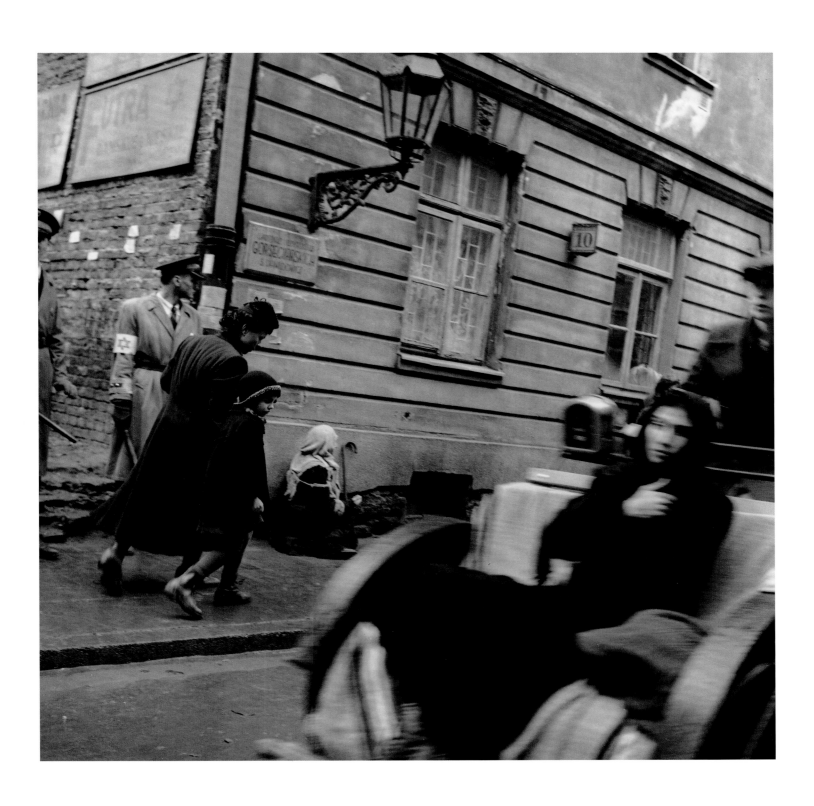

A street scene from The Pianist, *a movie about World War II, filmed in Warsaw in 2001.*

"One cannot pee against the wind," goes the Hungarian proverb, yet with a sense of foreboding, my parents married against their parents' wishes. My mother was Jewish and my father, Catholic, and World War II was about to break out.

My father, a chauffeur for the army was stationed in Budapest and as he drove around the city, he managed to help many of his Jewish friends. He found hiding places and smuggled coats and blankets into the ghetto, but he couldn't save my mother's family. Her parents wouldn't be convinced to leave their home in Raho and to come and hide in Budapest. My grandfather, Dr. Jahr Miklós, a well-respected lawyer in his town, would not believe anyone would harm them. But, late in the war, after my birth in 1943, all the Jews of Rahó were rounded up, including my grandparents and my mother's sister and brother. Before they were taken away to Auschwitz, they were herded into a building, where they were to wait. My uncle Sanyika, who was then 18, snuck out and went back to his house where he smashed every piece of crystal and the chandelier with a hatchet.

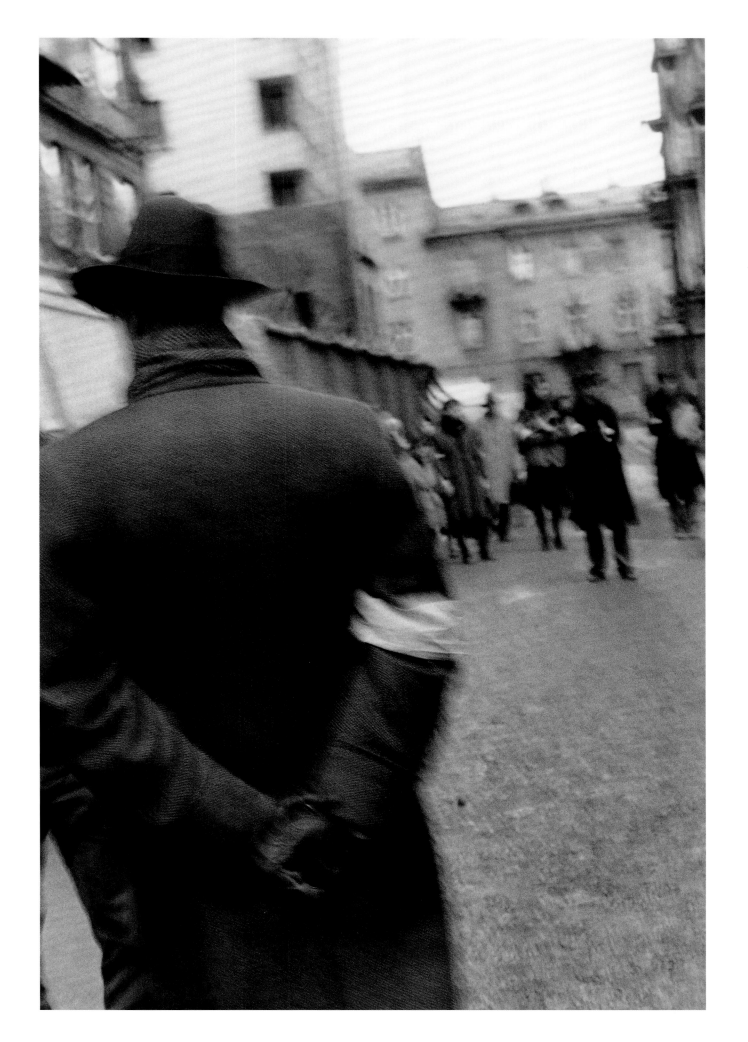

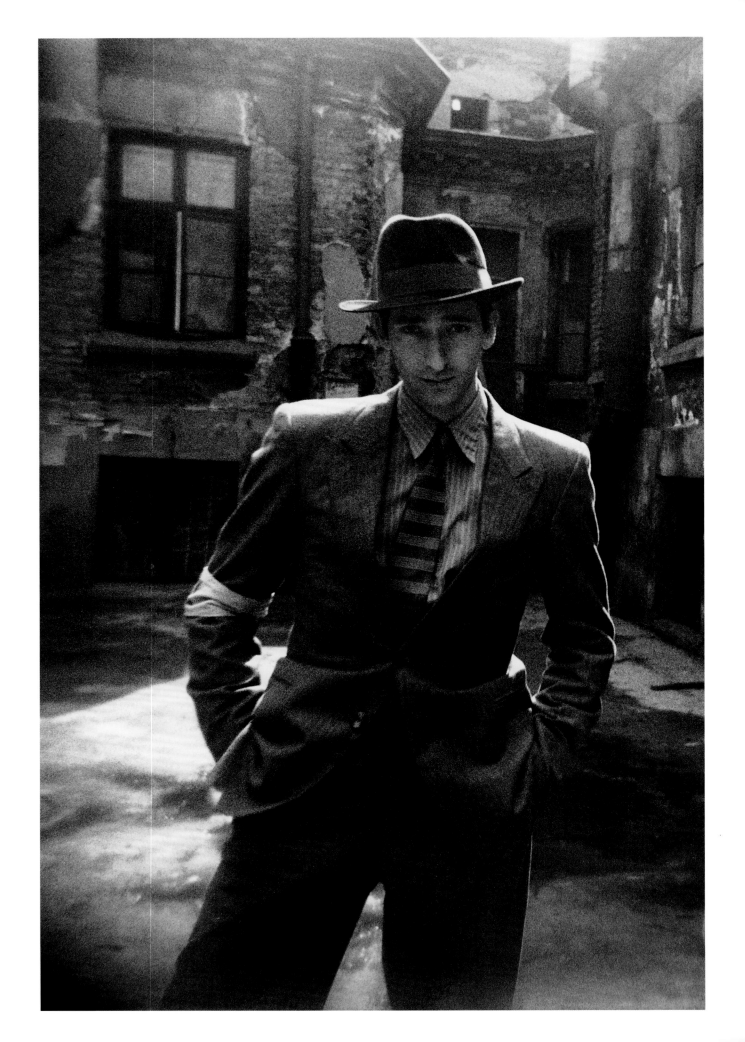

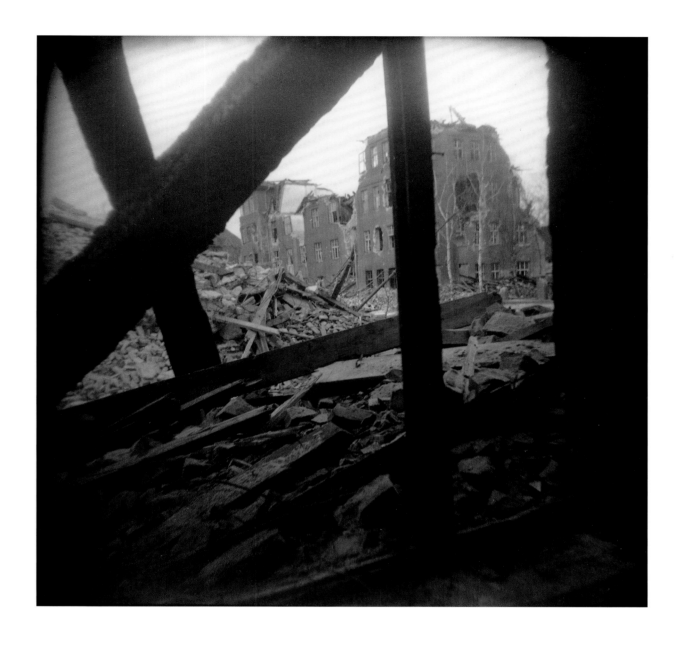

Opposite: *In 2001 I visited my son, Adrien, during the filming of* The Pianist,
which was based on the life of the Jewish classical pianist, Wladyslaw Szpilman.
Adrien was playing the role of Szpilman who miraculously survived the War while hiding in Warsaw.
On the set, he was dressed in a suit and fedora and in this old-world neighborhood setting,
framed by extras in period costumes. He was an apparition of my father as a young man.
Adrien seemed so authentic to that time and place, that some people even thought him to be a Polish actor.
On another set in Berlin, I was shocked to see Adrien emaciated and stooped over and
"…the pain of World War II…in his wonderful sad eyes" (as described by a fan in a letter from Germany).
How thrilling and disturbing when your own son can conjure up ghosts.

Above and pages 64–65: blown up Soviet barracks in East Berlin are used in the film to represent
Warsaw destroyed during World War II. From The Pianist, *2001.*

Boo and Bah were my first words — they were the sounds bombs made:
my parents were proud that I could tell which ones hit the city and which ones fell at the outskirts.

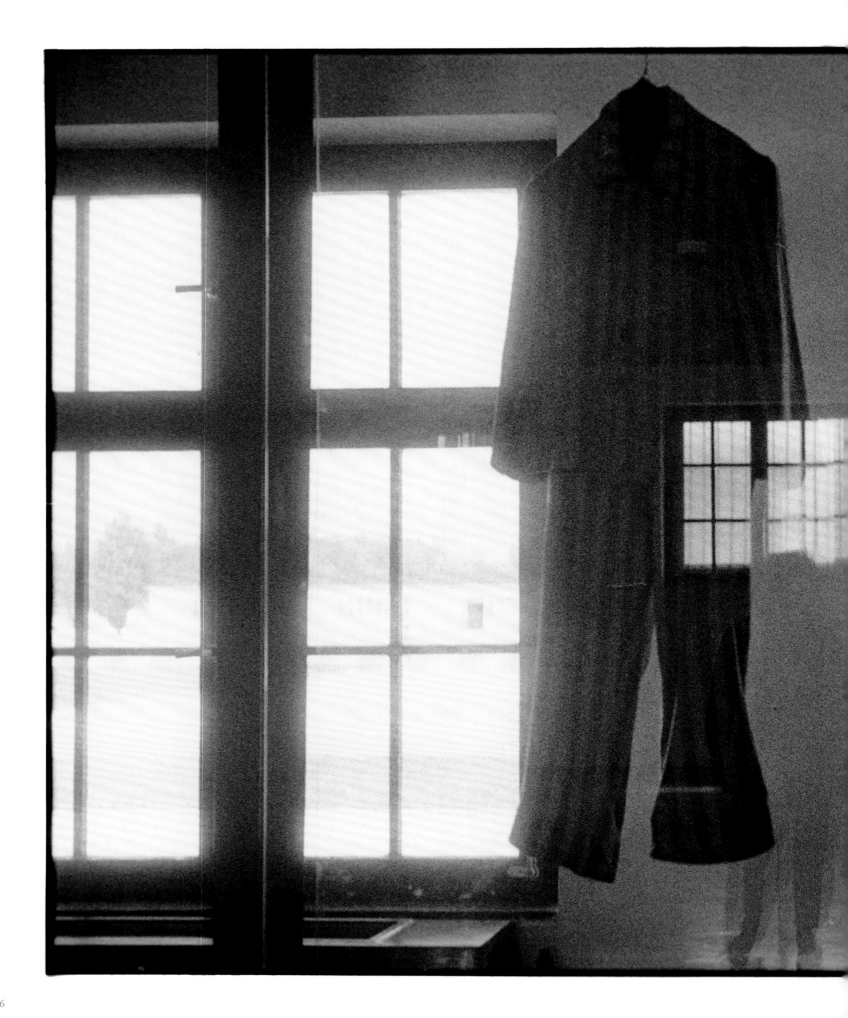

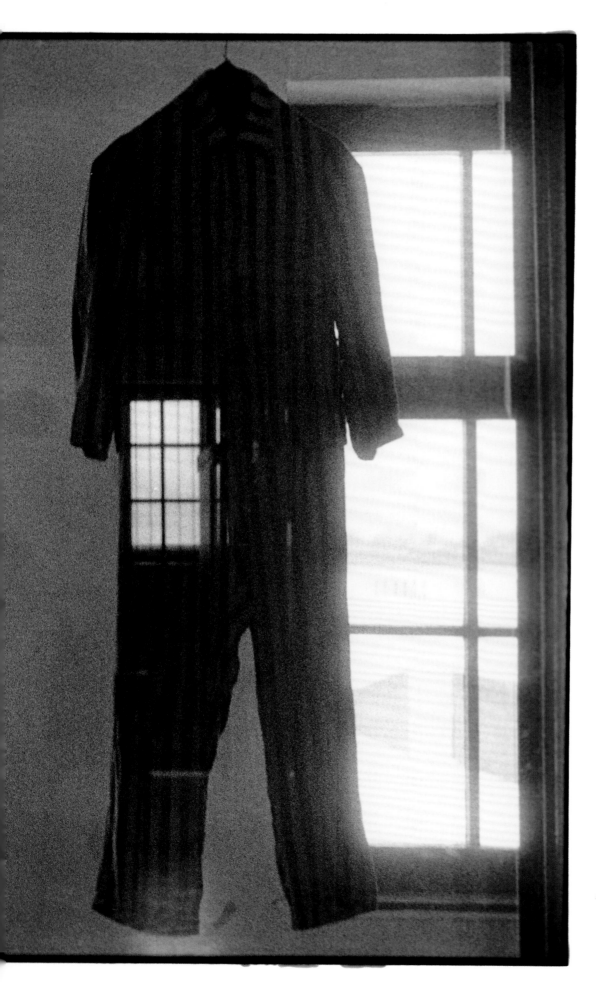

In the end my mother's
parents were gassed
and her sister, my aunt
Hédy, survived. Sanyika,
my mother's brother,
though he was seen
waiting at a train platform
somewhere in Europe,
didn't ever make it back.
My mother never
stopped looking for him.

Dachau, now a museum, 1985.

When the war was over and my mother learned about the deaths of her parents, she was devastated. One day she was sitting alone in a darkened room, looking at her parents' framed portrait on the wall when a golden moth landed on the glass. The visitation consoled her and from then on golden butterflies and moths were sacred.

My aunt Hédy came to live with us. She was two years younger than my mother, but more like a sister to me. She looked a lot like her distant cousin, Hedy Lamarr. We shared the same room and when in bed, she slept under the covers and I heard her cry often. She cradled her left arm, which was partially paralyzed from childhood meningitis. With the money from her menial jobs she would buy herself espressos, an occasional schnapps, and lollipops for me.

As a child, I asked my mother if Hédy was Jewish. She said, no. Why then was she taken to concentration camp, I wanted to know? Because, she said, the Nazis didn't just go after Jews—they took Communists and Gypsies too. Was she a gypsy, I asked? She just said, no. "And why do we eat matzos?" I wanted to know. "I like the taste," my mother said.

That I was half-Jewish, took me years to figure out. We had already left Hungary by then. My parents believed I'd be better off not knowing, as anti-Semitism in my mother's words, "came from mother's milk" and it was bound to recur.

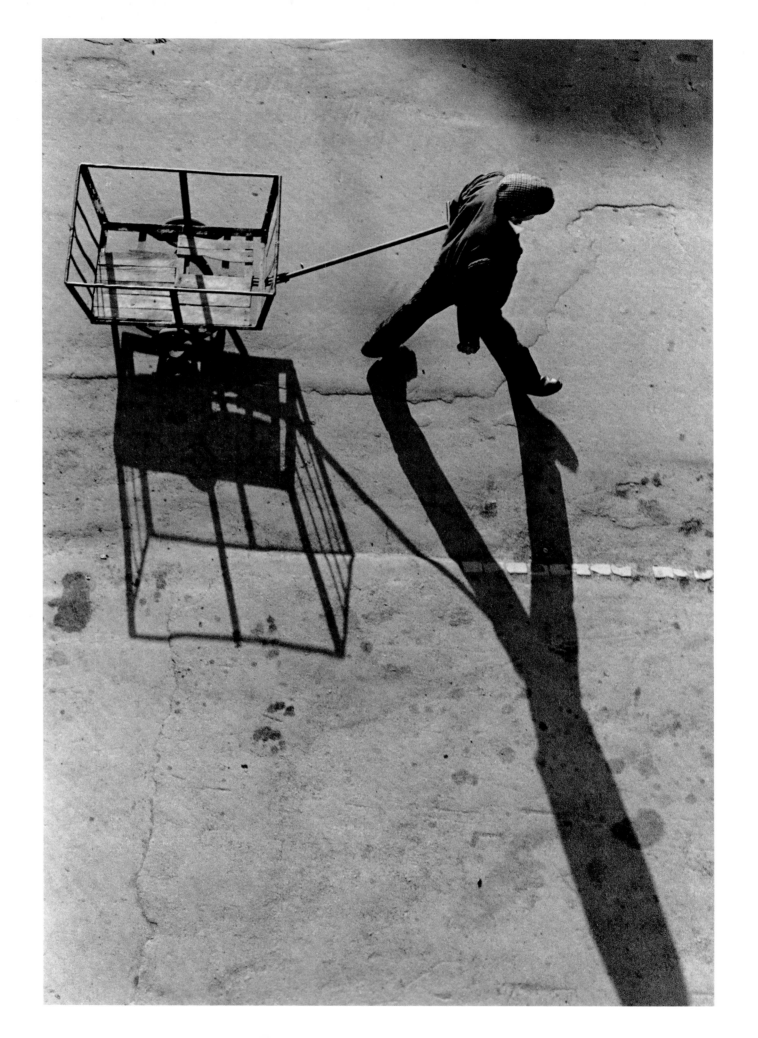

In an early nightmare, at age six or so, my mother and I are underground in a subway car. We are not moving.
Across the platform is another train. It's lit up, and I see children hanging by the neck from the straps. The doors on our car
open and close rhythmically. Every time they open, a commissar-like stout woman on roller skates snatches a child from
our train and hangs him or her in the other train. I'm next. The woman on roller skates, rolls toward me. Tugging at her coat,
I'm desperate to get my mother's attention, but she keeps on talking to a friend. Just as the woman is about to reach in
and grab me, the doors close. Thankfully, I wake up.

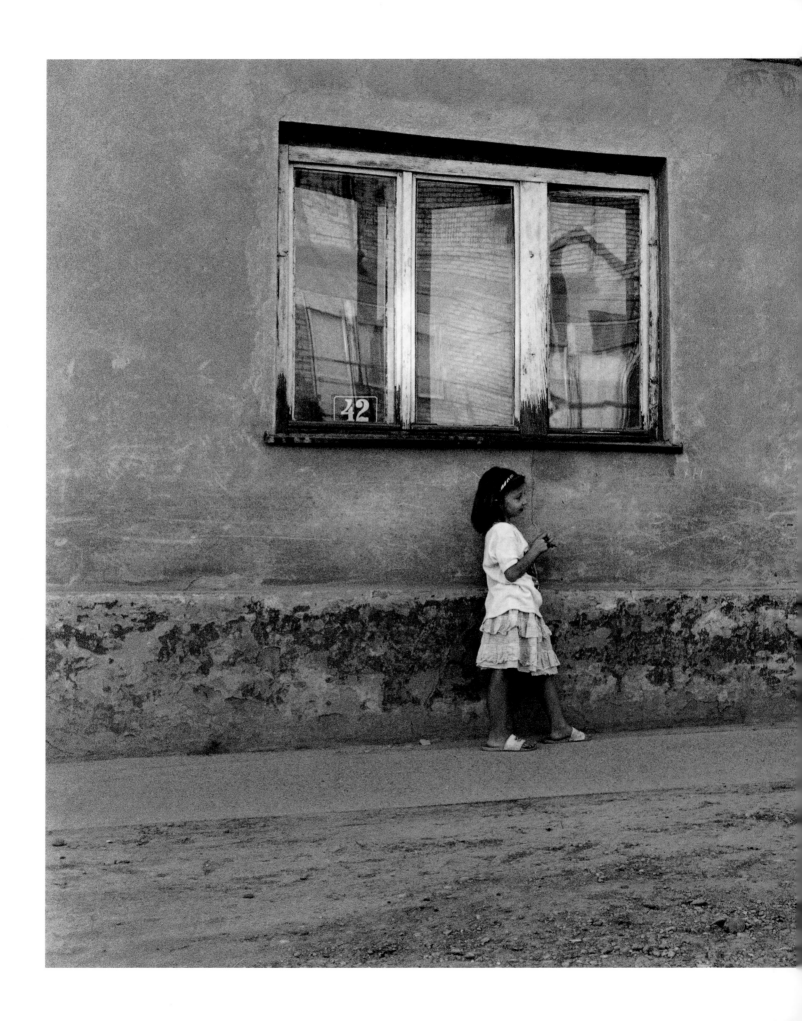

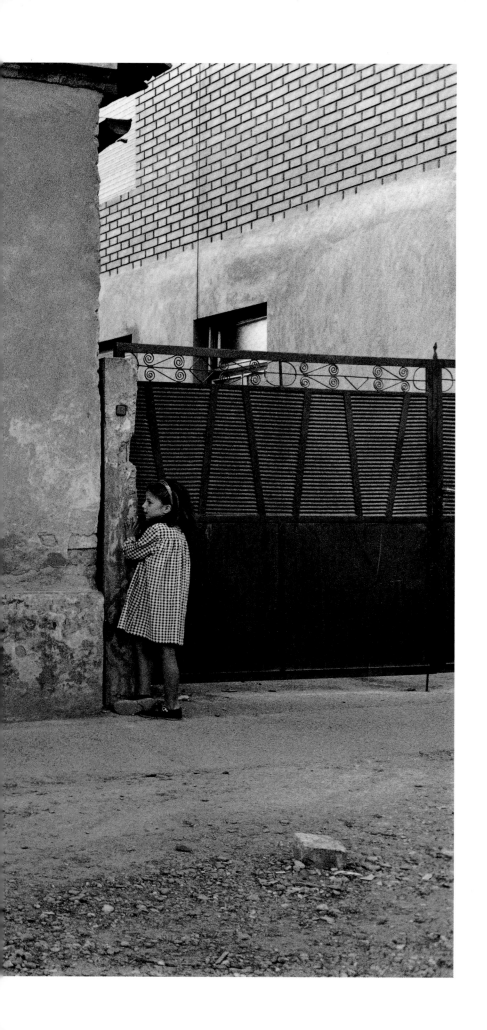

"My father is stronger than your father,"
I don't know who started it, this contest
between my friend Lulu, in the first
grade and me. When I got to the part,
where my father was so strong that he
could lift up the Universe, Lulu, stopped
speaking to me for a month. Well, maybe
he couldn't lift a house, but he could
make a caramel appear in his hand by
rubbing his arm and he could shout
"HOPLA," slap his knees and I would fly
like an acrobat and land on his shoulder.
When the spirit moved him, he could
dance like a skeleton to a record of
"Danse Macabre," and he would have
been an entrepreneur, a writer, an actor
or a painter if he hadn't been born in the
wrong place at the wrong time.

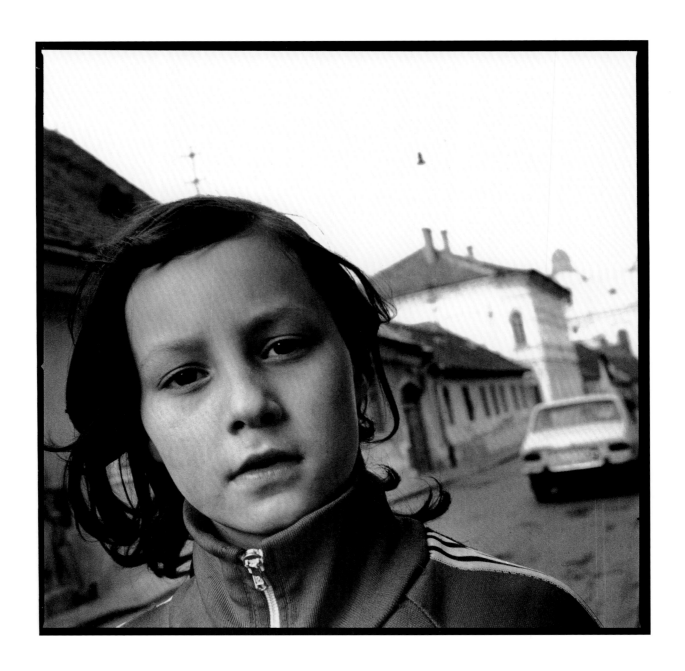

Scars of the war were my early
signposts. Silence, heavy with secrets is
what I remember most, but in the gray of
winter the smell of coal was sweet.

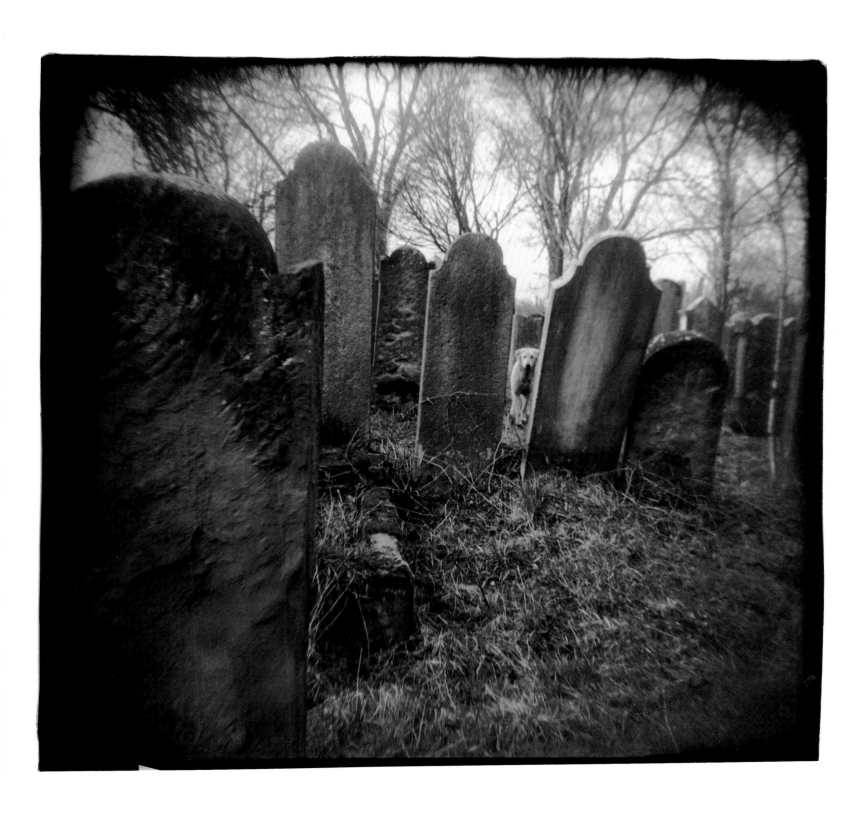

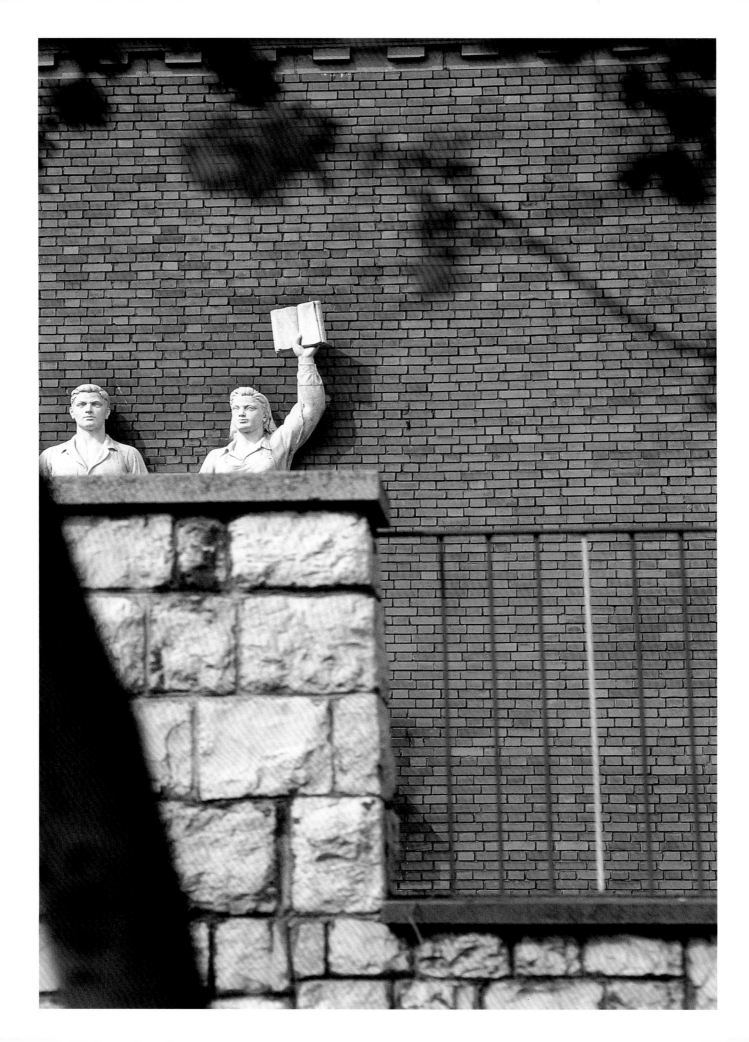

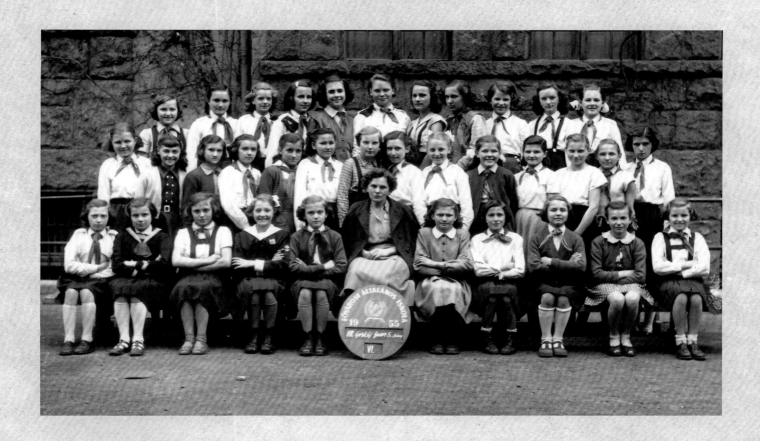

School was for discipline and indoctrination. In first grade, when we were punished, we were made to stand with our arms outstretched at our desks. When not writing, we had to put our hands behind our backs. Over the blackboard, the Hungarian Premier, Rakosi, was flanked on either side, by official portraits of Lenin and Stalin. Uncle Engels and Uncle Marx watched our backs.

Our class portrait in the sixth grade;
I'm the one in the front row with the toes turned in,
Budapest, 1955.

Az a legszebb tudomány,
Ha szeretve gondolsz rám.

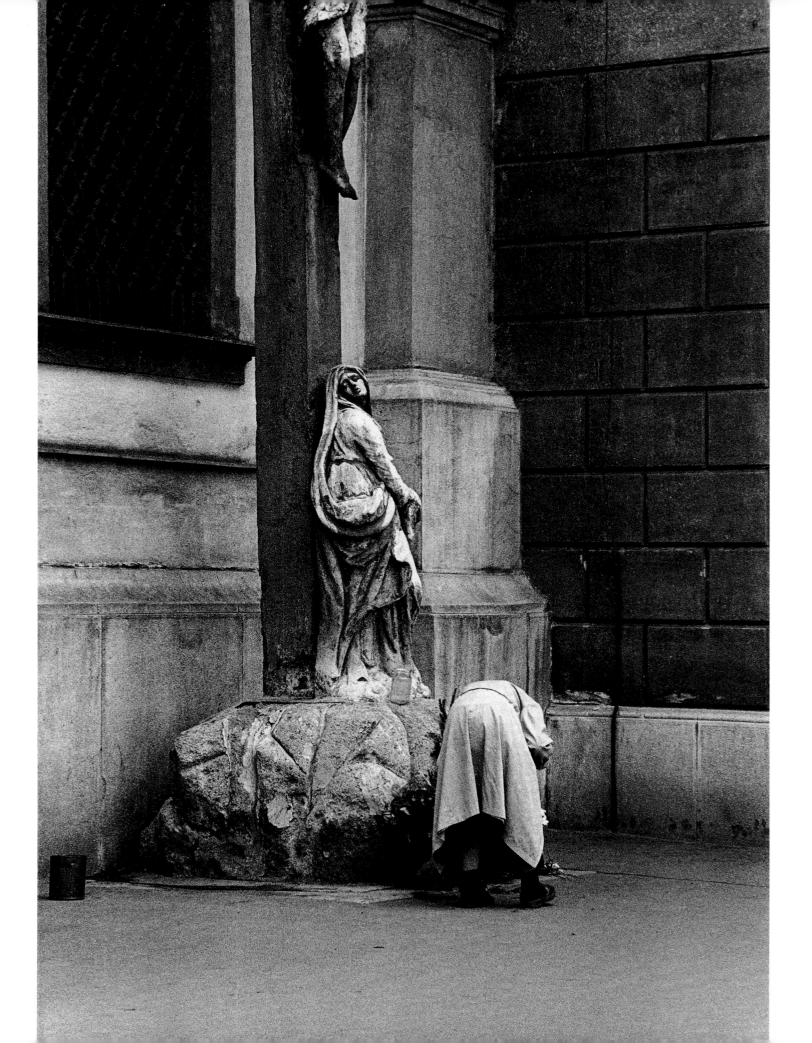

Our teacher in second grade was Ilonka néni, a good looking strong woman like Garbo in *Ninochka*. (*Néni* means aunt and *bácsi* means uncle. Children in Hungary add theses words to names of adults as signs of respect.) She dressed her two daughters in the manner of Soviet schoolgirls: white shirts, black aprons and red neck kerchiefs. Their hair looped into tight braids was tied with fluffy white bows.

One morning as she opened her desk drawer, she found a couple of prayer cards, "holy pictures," as they are called in Hungarian. Ilonka néni was right to assume that she was set up. Implicit in "building Socialism" is the denial of God. She tore up the pastel colored pictures of Mary and Baby Jesus and lectured us on the evils of superstition and reactionaries. She had one of the students throw the cards into the trash. As a rebel and a Catholic I waited until everyone left, I scooped up the saints and rushed home to scotch tape them together with care. I still have the one on page 78.

On Sundays, in case I was followed, I took a circuitous route to church. Once inside the cool, incense-filled interior, I murmured prayers under the approving glances of kindly old ladies. After saying one Hail Mary, one Our Father, I prayed for my parents and everyone else I loved, and because I once read a gruesome story about pirates, I finished with, "please, let there be no more pirates." I still cross myself at all those times, when I think of the pain in the world that I can do nothing about, when in the night I hear a screech or a scream, when someone yells at a child or when I see a stray—and since 9/11, when a plane flies low. What is really odd is that to cheer myself, I sing the march of the proletariat, "The International."

"Not so loud…walls have ears." I was quiet and well behaved. You couldn't trust anyone. Several doctors who lived in our building belonged to the AVO, the KGB of Hungary. They were polite and said hello in the stairway, but I wondered if they tortured people. I also feared for my parents; any knocking on the door at night might mean the police. People were taken away and sometimes didn't return. Danger was lurking everywhere. Our maid, Mária, was afraid of being hit by a car. Even more, she was afraid of not being her best, when she was found. Every time she went out on the street, even to buy a loaf of bread, she changed her underwear. Then there were the ordinary, non-political threats: the drunkards, exhibitionists, pedophiles and murderers. Once, during a school holiday with my friend Lulu, we saw a man half-hidden among the stalks in the cornfield and his fly open. We ran. Come to think of it, happy or scared, I was running most of the time.

I was also afraid that one day the bluebird—our blue parakeet, Pityu—that once flew in through my window, would fly out, and it did. My father and I rushed around the ring of rooftops, calling his name, but the sky had already swallowed him up. All along, the wind howled with unseen fears in its grip, slamming them against windows and doors, making them shriek until they eventually stopped and crouched to hide in the corners.

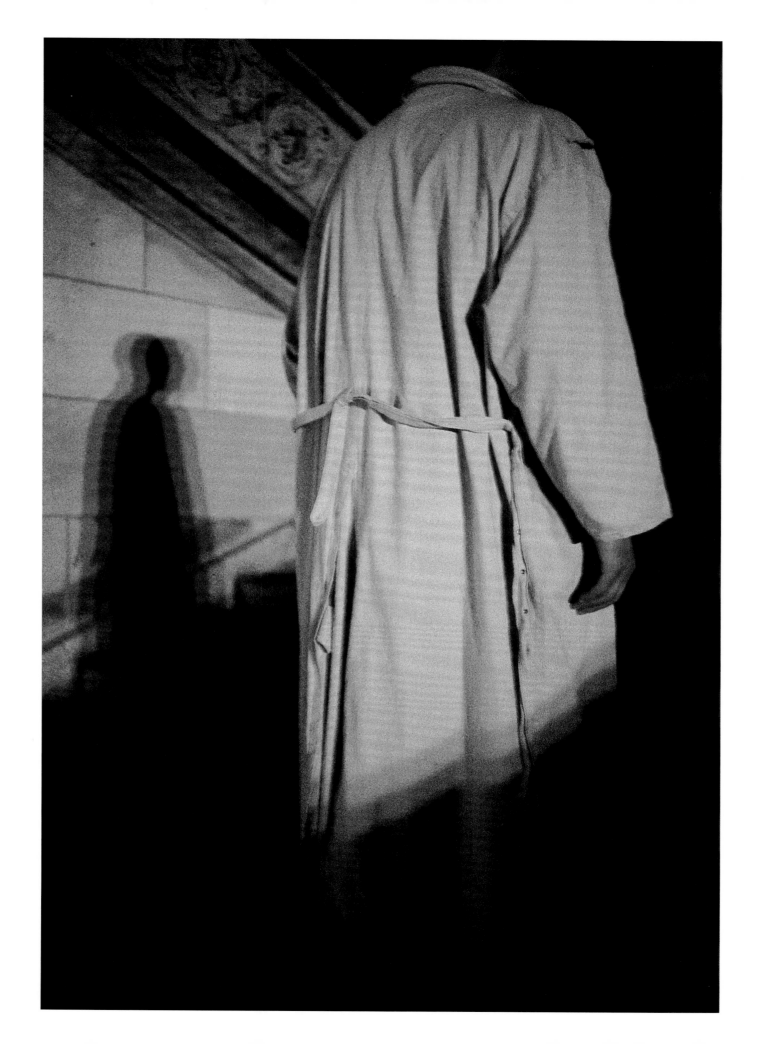

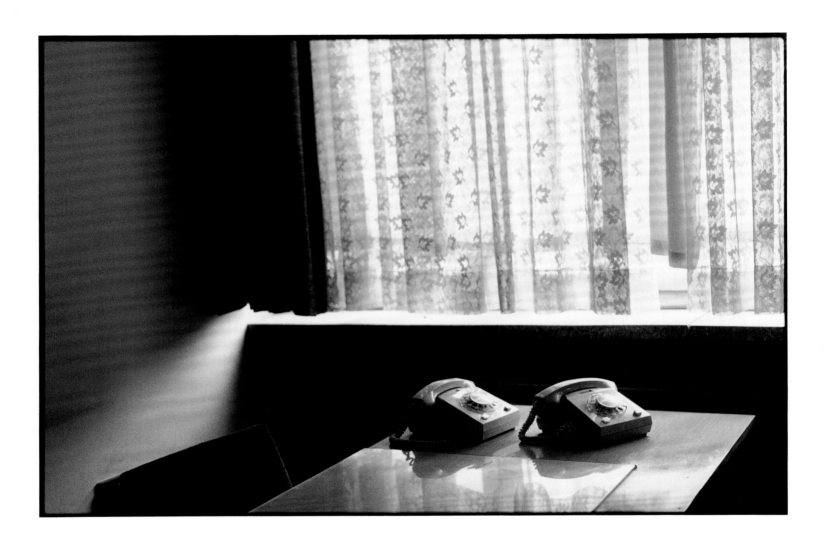

"Flower-language," (*virág-nyelv* in Hungarian),
is what speaking euphemistically was called.
In totalitarian countries our lack of power
made poets or liars of us all.

Above: *An office in the Stasi headquarters, now a museum, formerly East Berlin, 1998*

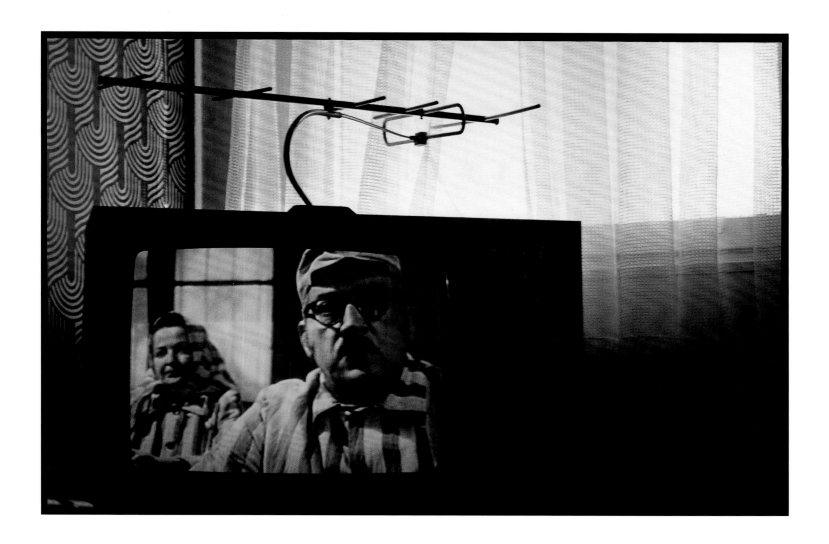

A cousin of my mother, I think Alma was her name, was sent to Siberia from her town in Czechoslovakia

as part of the re-education plan. She had a nice apartment and an official wanted it. When she and her mother left,

she promised to write and tell her friends how things truly were. She devised a code to elude censorship:

she would write in blue ink if things were fine and red if they were not. A letter finally arrived and it was in blue.

It said everything was fine, work was not too hard, the food was good, and the apartment warm;

regrettably there was just one little thing, the letter said—there was no red ink.

Above: *Political prisoners in a TV drama, Budapest, 1984.*

My early years were lean years. Saturday night was when all of Budapest stayed home and bathed, it was the only time we had hot water. Nothing was thrown away. Even years later, in New York, my father used one tea bag for a week. We wore our clothes until they wore out, lengthening sleeves as my arms grew. Food was sparse, but my parents, both great cooks, could make anything taste good. The sandwich I took to school was bread and lard with salt, paprika and thin slices of radishes or green pepper for accent. On rare occasions, there were long lines for imports of exotic fruits. I must have been around nine when my parents brought home a banana. I made it last by keeping it cool between the double windows and cutting thin wafer-like slices for everyone at meals. No other banana ever tasted as good. But, in the summer, when the scent of wild strawberries, peaches, and apricots made me swoon, my father baked his famous cakes, including my favorite, from a handwritten recipe by Irénke, my mother's mother: a strawberry soufflé on crunchy caramelized sugar and nuts, with dark chocolate poured over it.

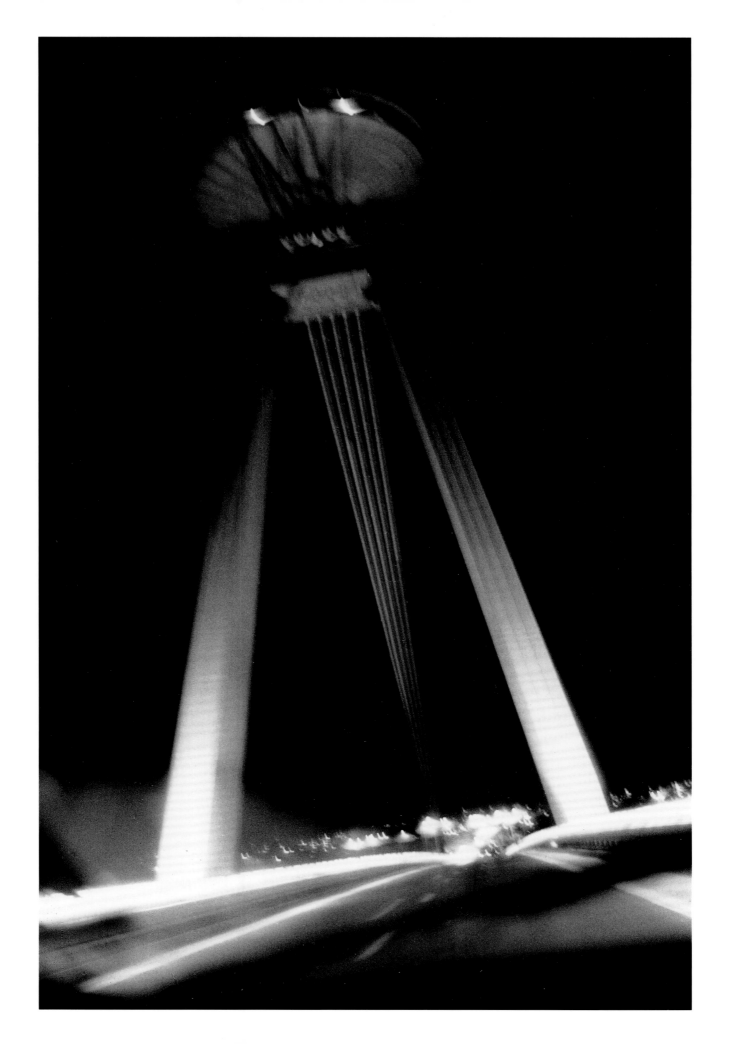

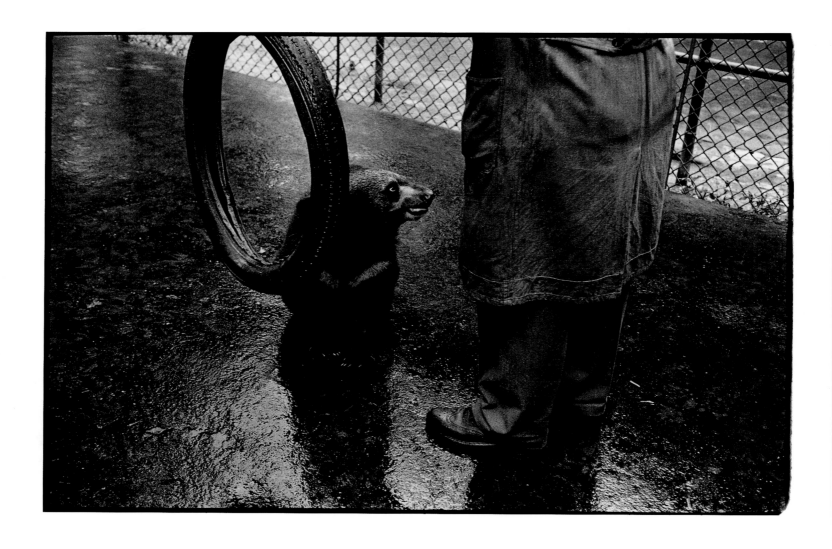

On my first visit back, in 1964, the socialist experiment was still in full swing.
This picture of a little cub looking up at an attendant is called, "Overbearing Man."
In the Budapest Zoo baby animals were taken from their mothers during the day and put with
young animals of other species. They were bottle-fed by men in green coats.
Many of the animals got sick and died. In 1972, when I visited the zoo again and asked about
the animal nursery, I was told they now had a petting zoo.

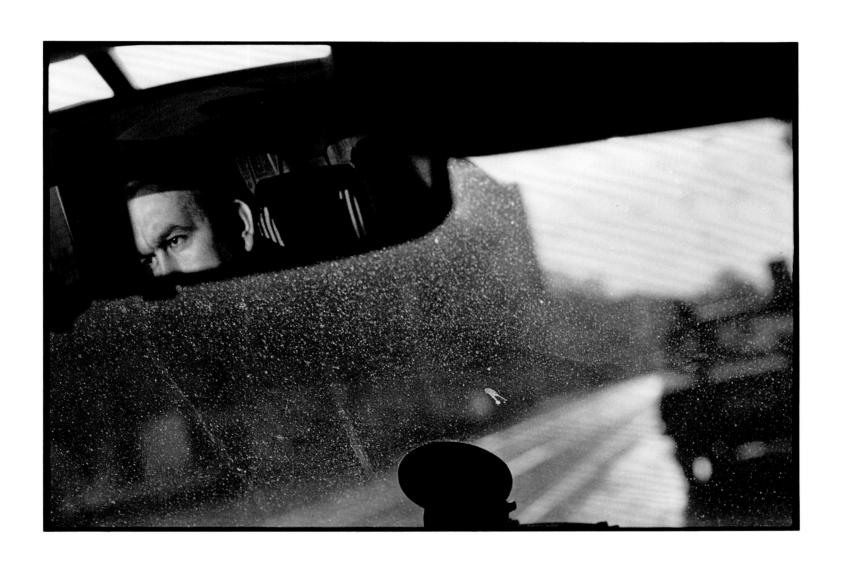

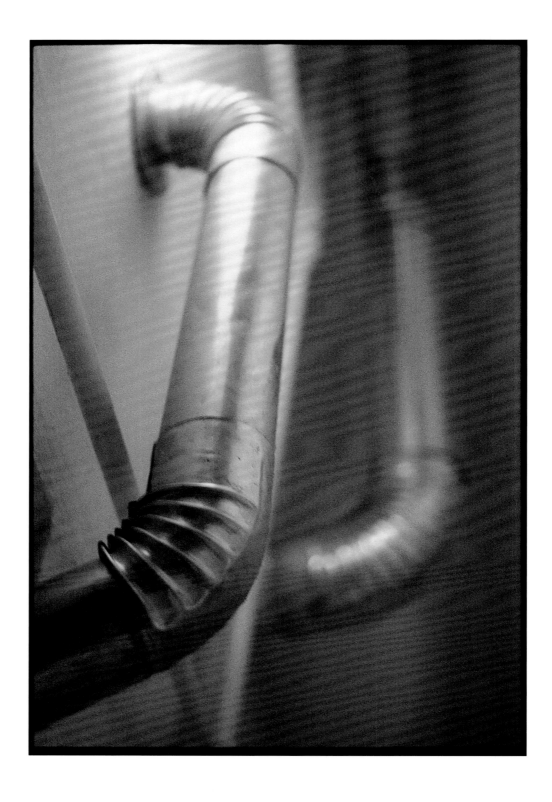

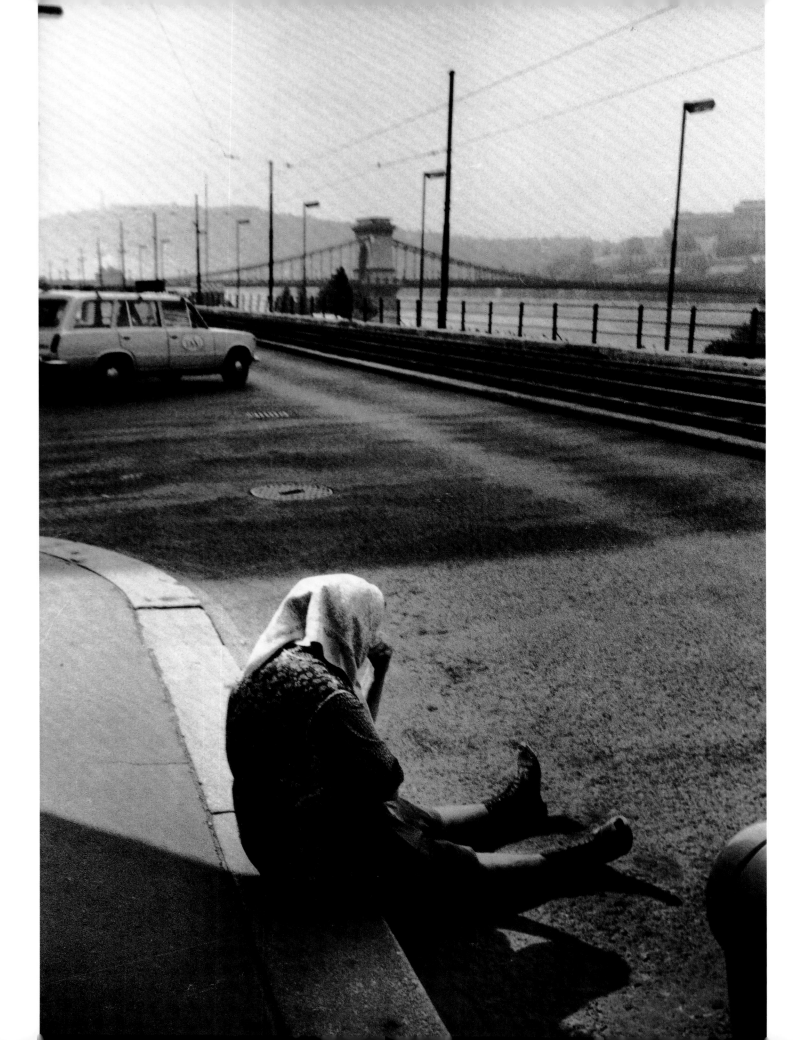

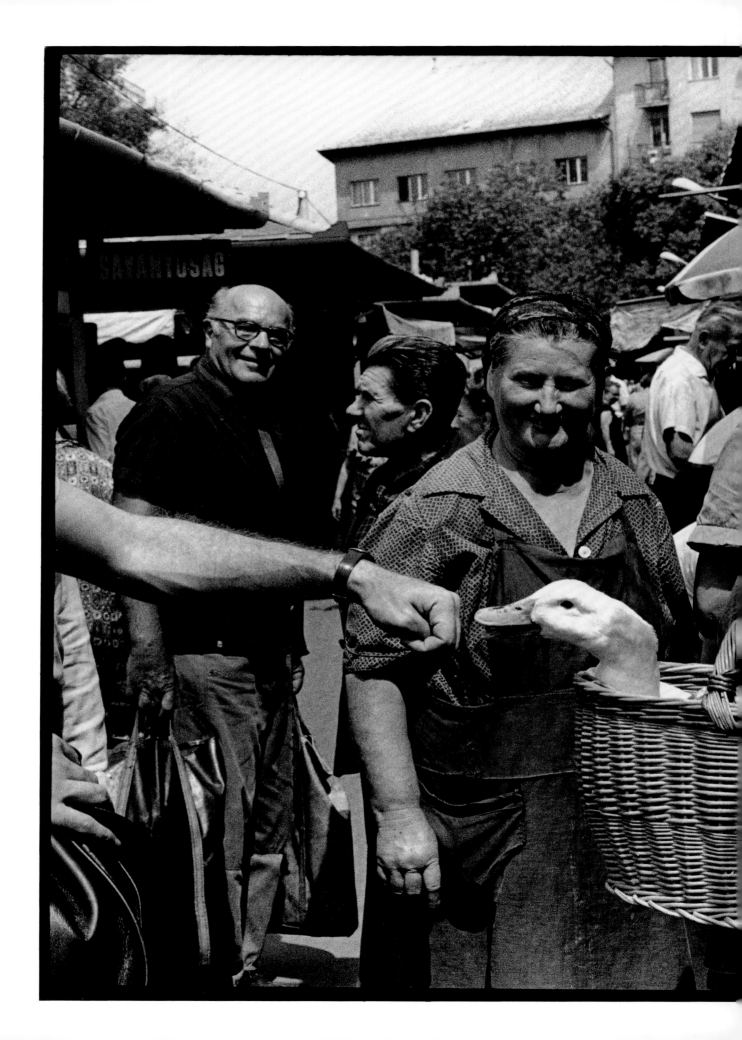

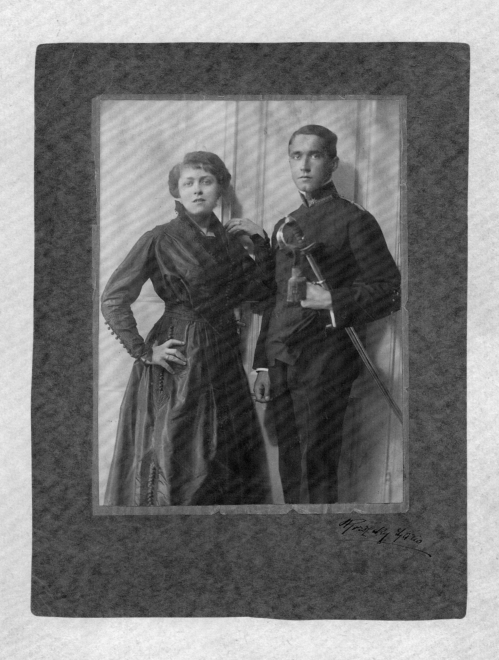

Károly bácsi, my great uncle and a gentle man was wounded in World War I.
Here he is in his uniform with his sister Anna. During the Second World War, when Christians were
drafted and Jews were sent to labor camps, he was named interim president of the bank
he worked for. Because of this and because he had a nice apartment in Budapest,
he and his wife, Klári néni, my grandmother's sister, were deported. They worked as field hands
on the collective and were squeezed into one room with two other deported couples.
Klári néni became sick with heart trouble. When she didn't die, they allowed them to return to Budapest.
Károly bácsi worked as a language tutor and even tried to teach me German.
I still remember the song he used to sing to me when I was little,
about a prince on a shining horse.

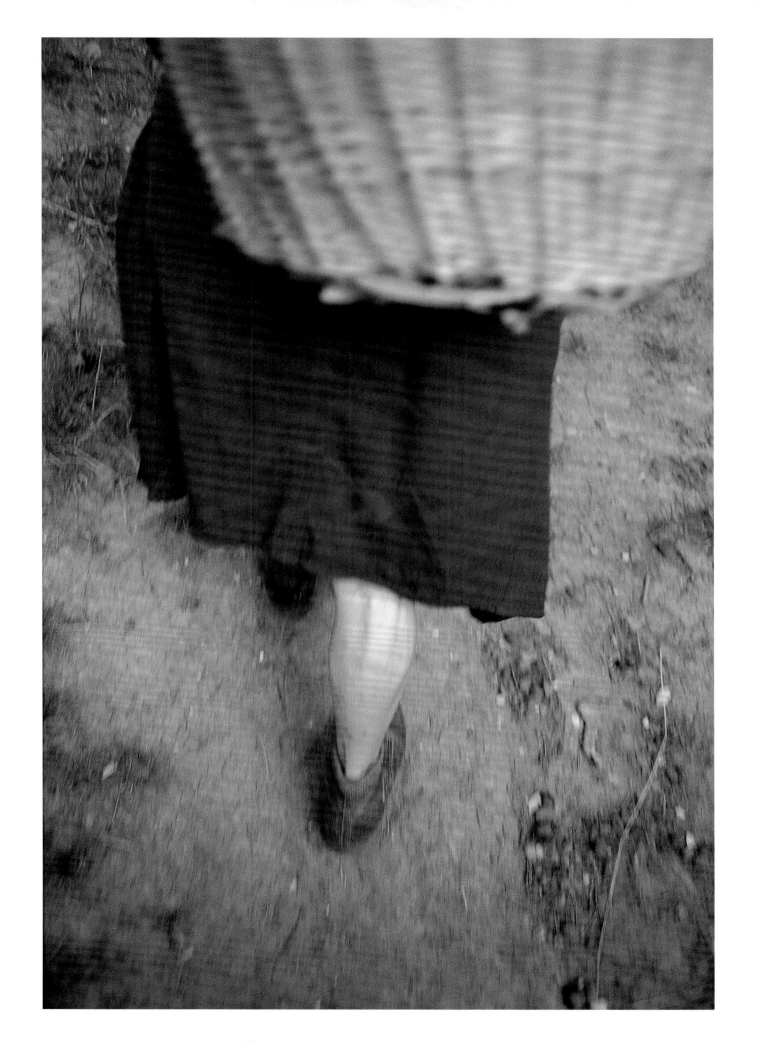

Right: *An extra on the set of the film,*
a musical about collectivization
Te Rongyos Élet *(You Raggedy Life),*
Hungary, 1983.

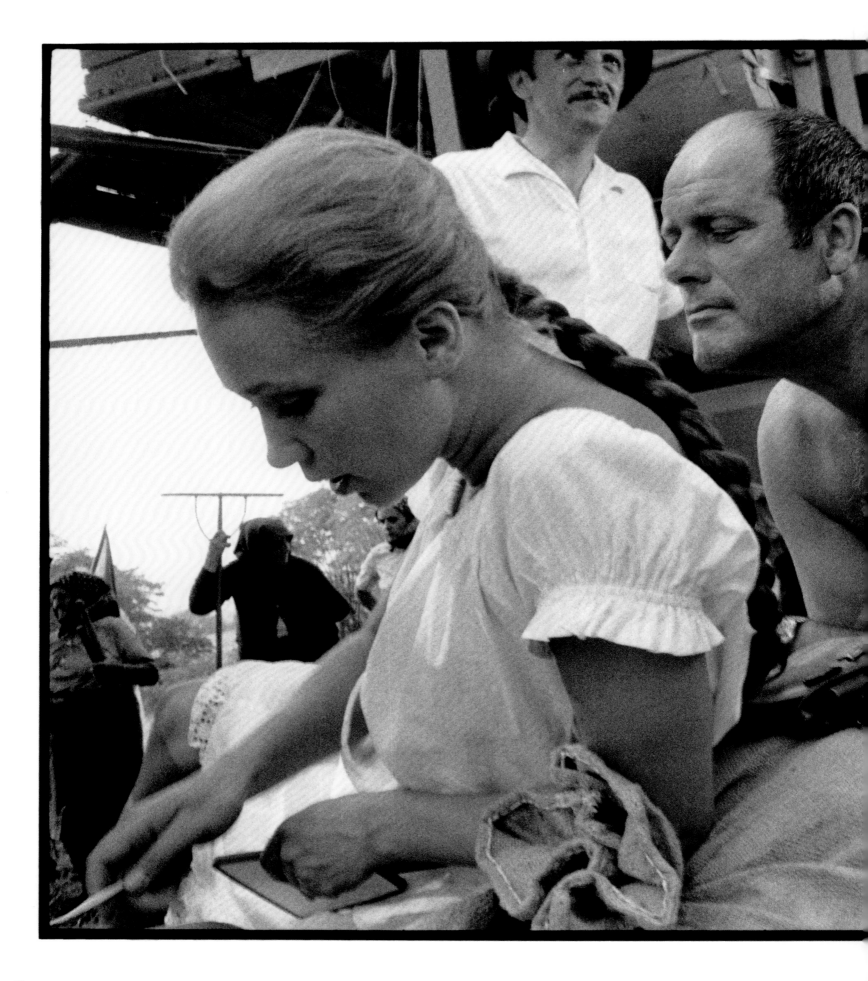

Left: *Udvaros Dorottya,*
the star of the movie Te Rongyos Élet
(You Raggedy Life), Hungary,
1983.

At sun down in small villages all over Eastern Europe
cows, their udders full, return home from the meadows.
Their hoofs clip-clop on the pavement like voluminous women in heels.
When they find the house they belong to, they moo.

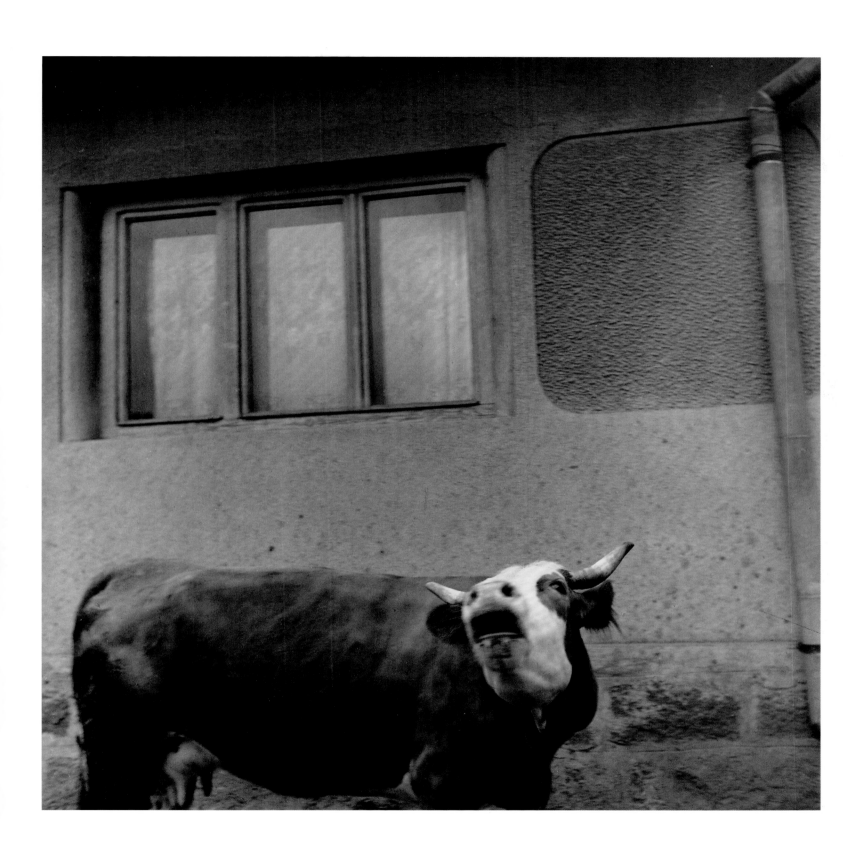

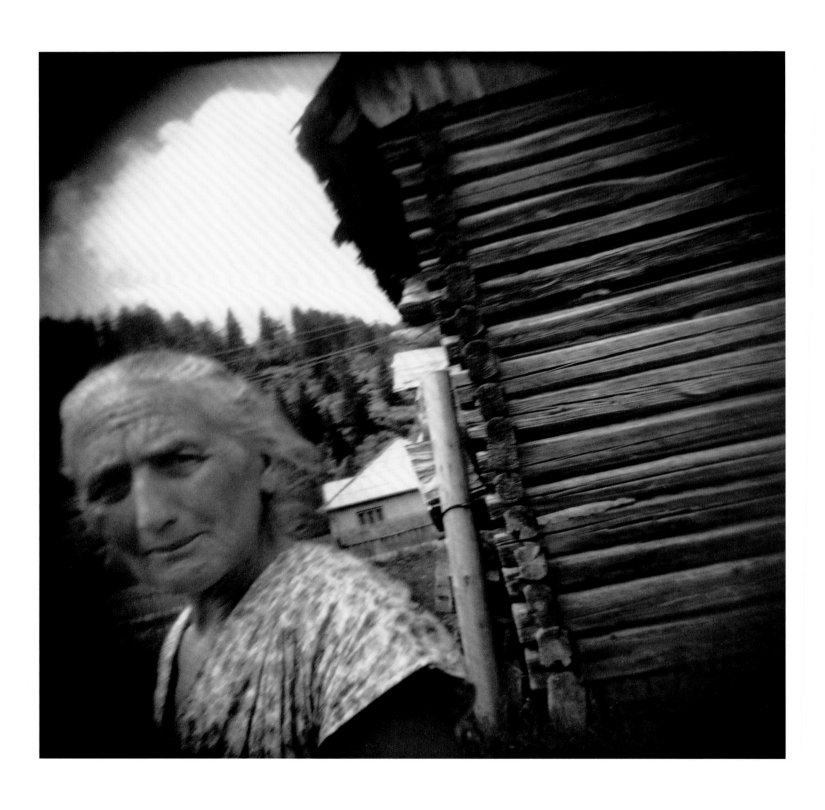

As years went by, to feed my nostalgia I went further east. In Szék, a remote, Hungarian village now in a Romanian valley secluded by mountains, the customs have changed little over the centuries. The villagers speak an old Hungarian dialect and they grow their own food and barter. All small dogs are called, *Csöpi*, (Tiny). There are only three names for women, Zsuzsa, Sári, or Rózsi and three for men, János, István, or Márton. All the men have the same haircut and are clean shaven and the one big dog in town was called Cigány (Gypsy).

Opposite: *János and Csöpi in Szék, 1999.*

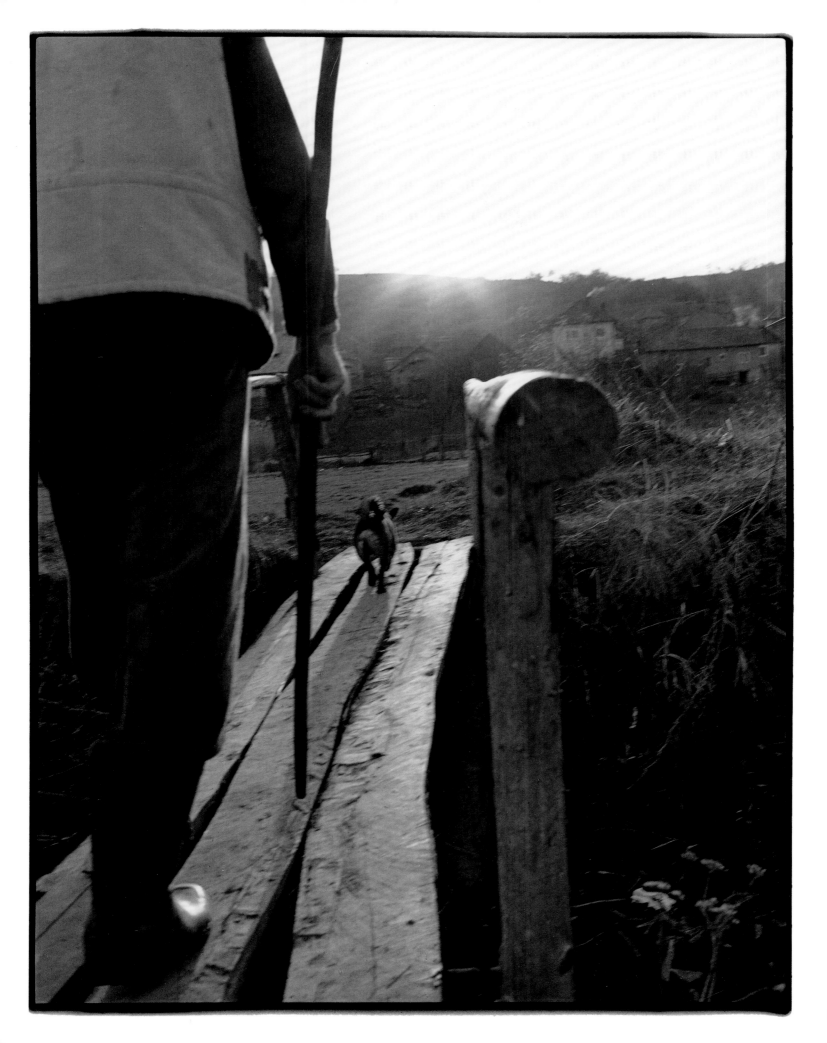

I was in Szék on Easter Sunday, 1999, when the boys in their special holiday outfit,
blue vests and green sweaters, in the company of gypsy musicians walked from house to house,
to call on the girls to dance with them. The custom at Easter is to splash the girls
with cologne in exchange for a hand painted Easter egg. This time, thinking it was a hip perfume,
they sprayed the girls with room deodorant.

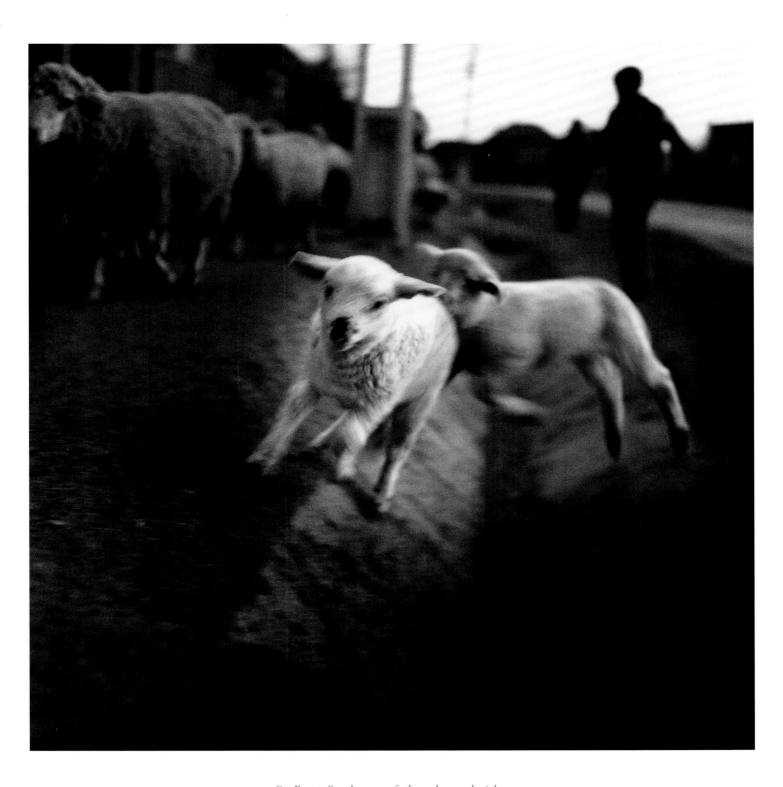

On Easter Sundays, my father, always the joker,
would burst into my room to wake me by spraying a siphon of soda water
in my face, with my mother at his heels, shouting:
"Ne, ne." Our family's other Easter tradition I liked a lot better: a basket-full of
marzipan farm animals and chocolate eggs.

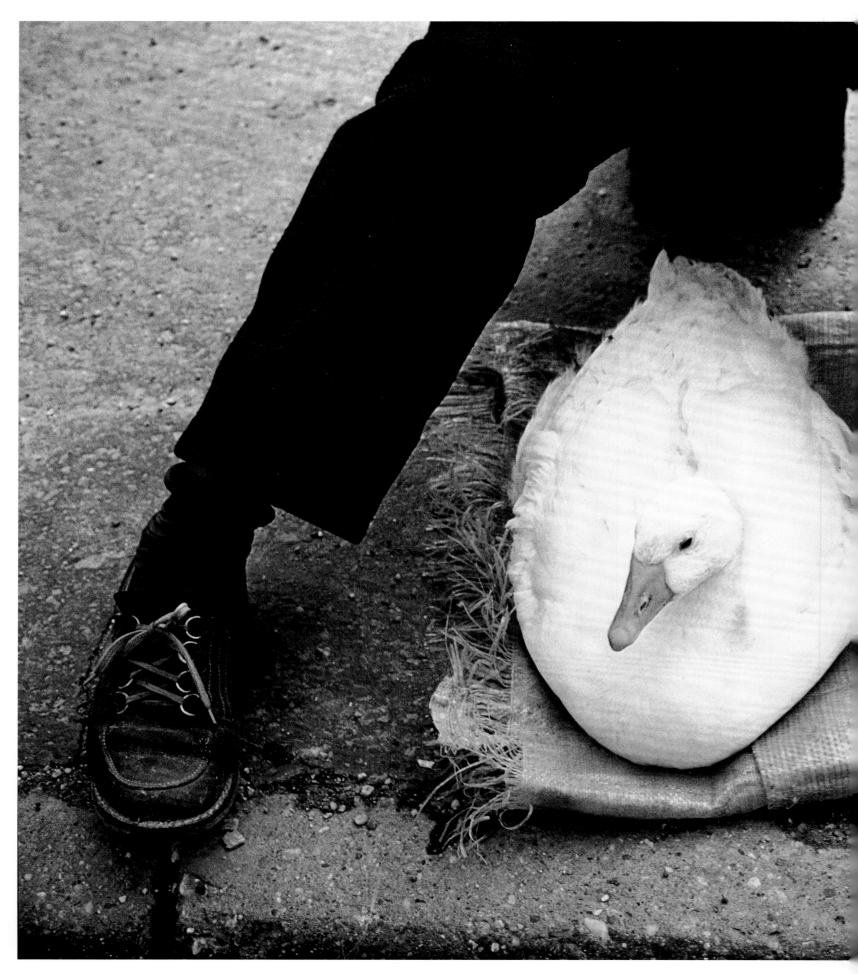

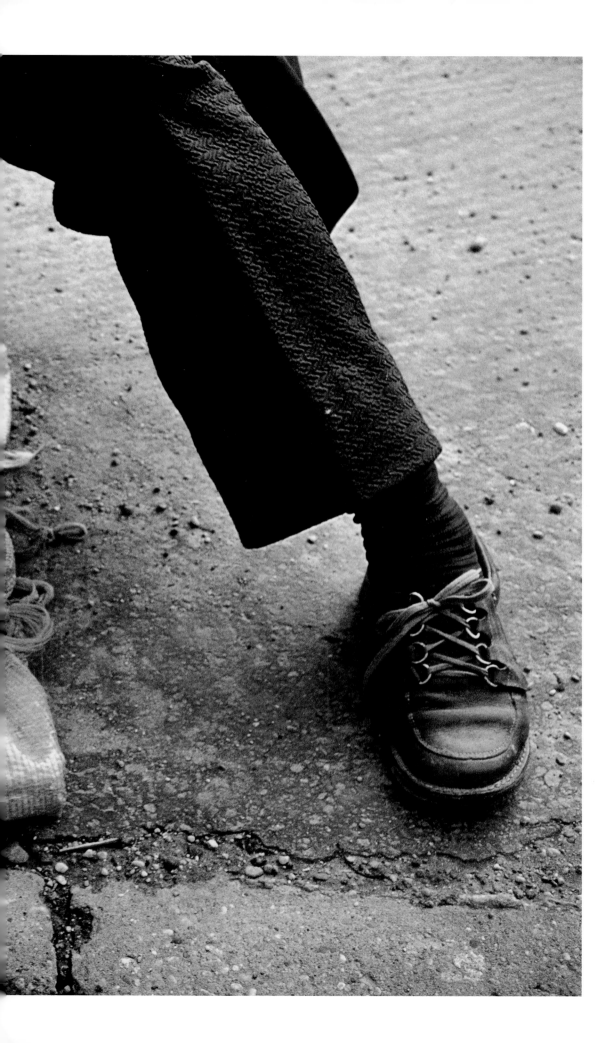

"Hello dear Szilvi, this is your childhood speaking,"
was a message Lulu once left for me.

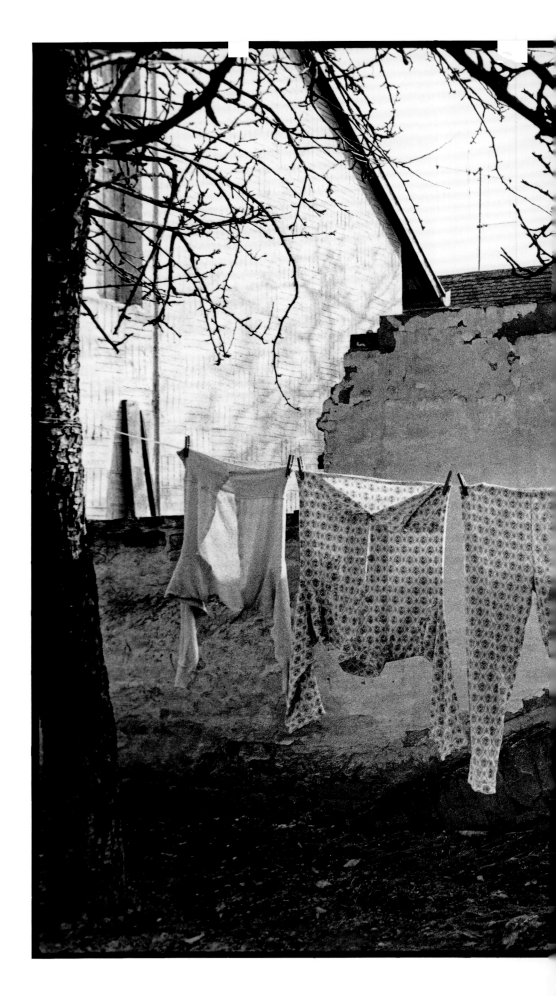

It may rain "cats and dogs" in
other places, but in Hungary I used to think
it rained frogs. Every summer we vacationed
in the country and stayed in houses
without plumbing. When my mother washed my
hair in rainwater there were tadpoles
in the basin and I, for a long time thought
that the frog eggs must have evaporated and
later fell back as tadpoles from the sky.

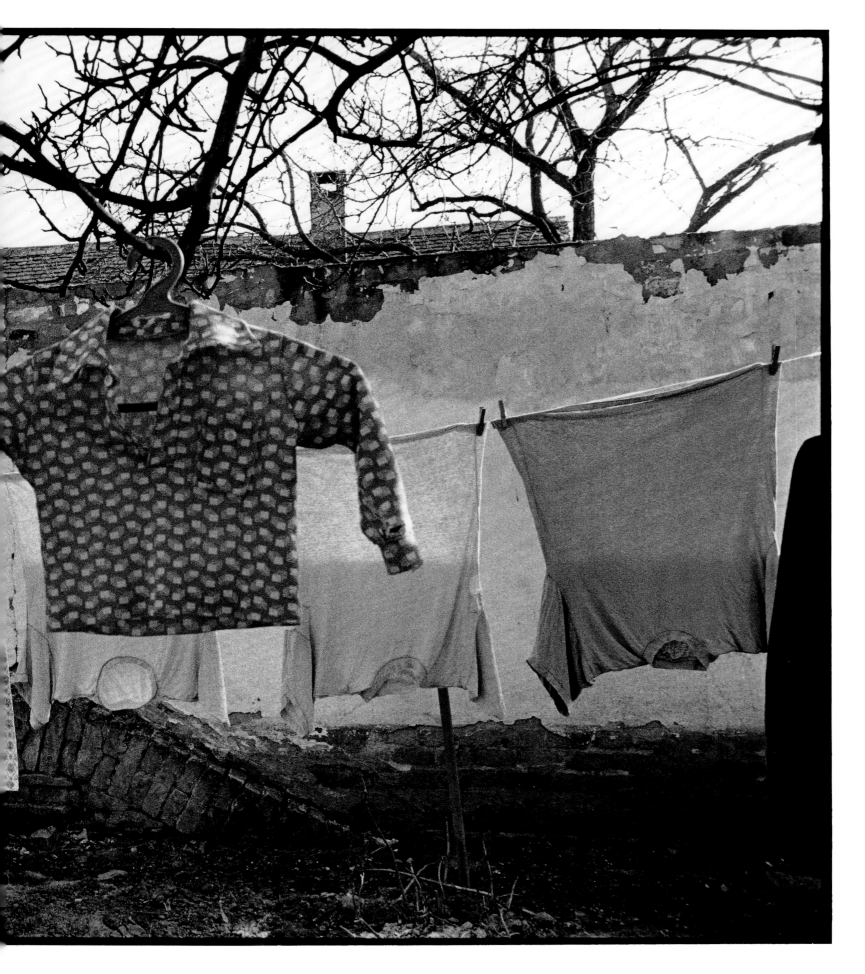

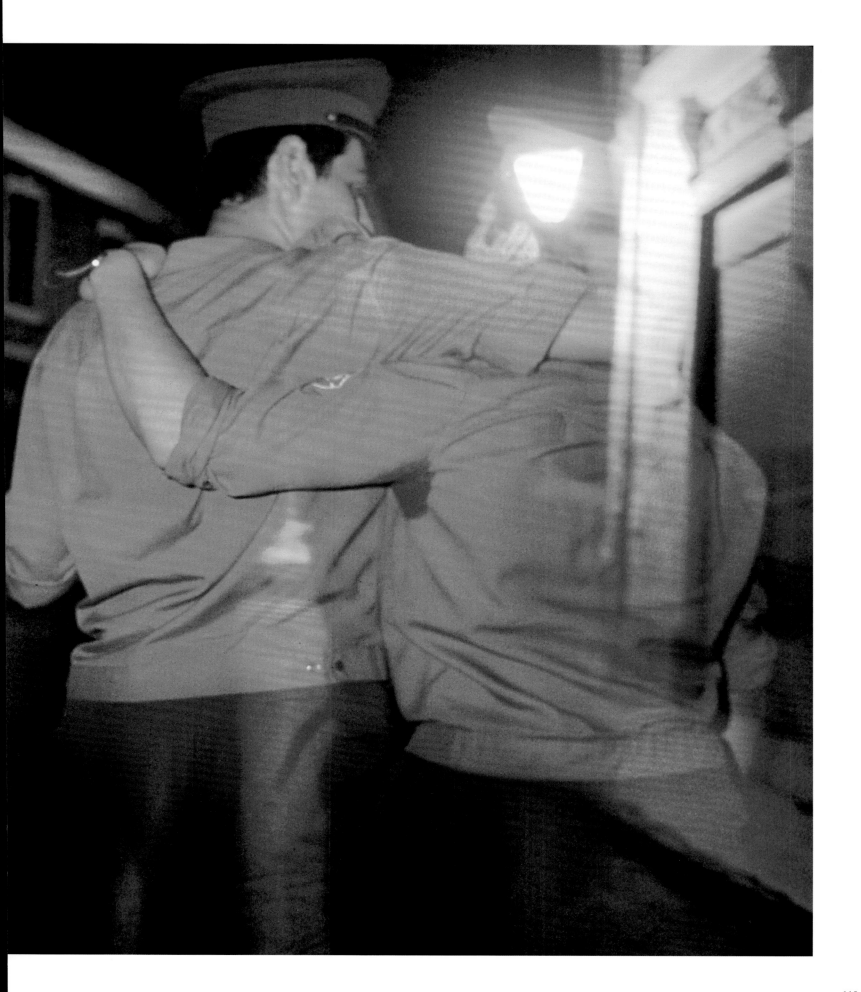

"You cannot step in the Danube twice," but for years time stood still for me as the world I left behind remained essentially the same. The buildings on my block were still pockmarked by bullet holes, though the balconies had to be propped up on beams, like old veterans on crutches. My friends and my parents' friends were still there. Later, after 1989, as Communism ended and things started to change, I traveled on assignment to photograph and sometimes translate what was going on in Hungary and the neighboring countries. When I go by the old apartment building, I look up, but since my grandmother died, only in my dream do I enter the apartment and it's dark and the lights won't go on.

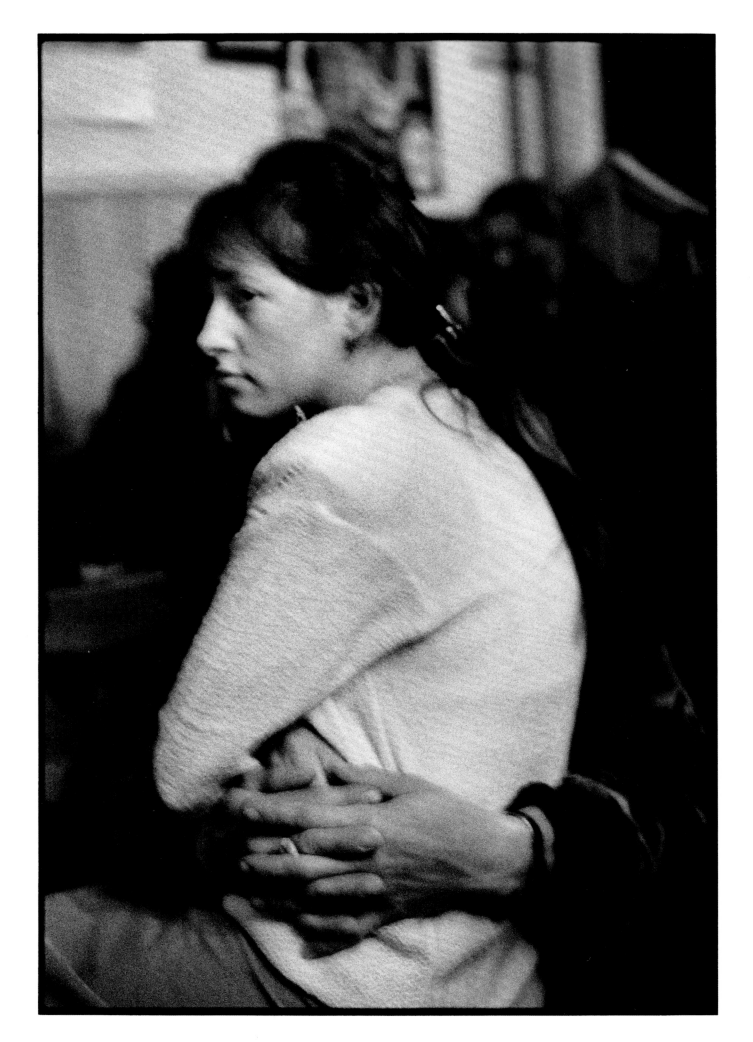

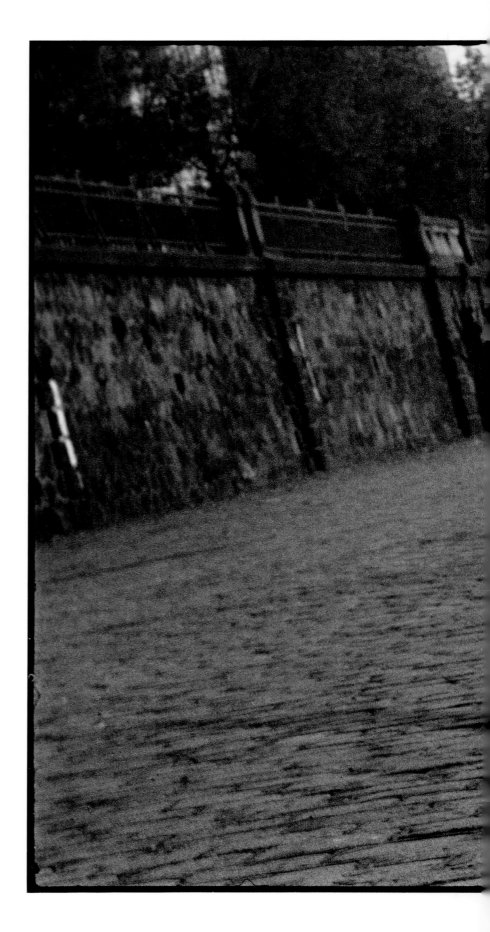

"How could I have expected that after a long life,
I would understand no more than to wake up at night and repeat:
strange, strange; o how strange, how strange.
O how funny and strange."
—Czeslav Milos

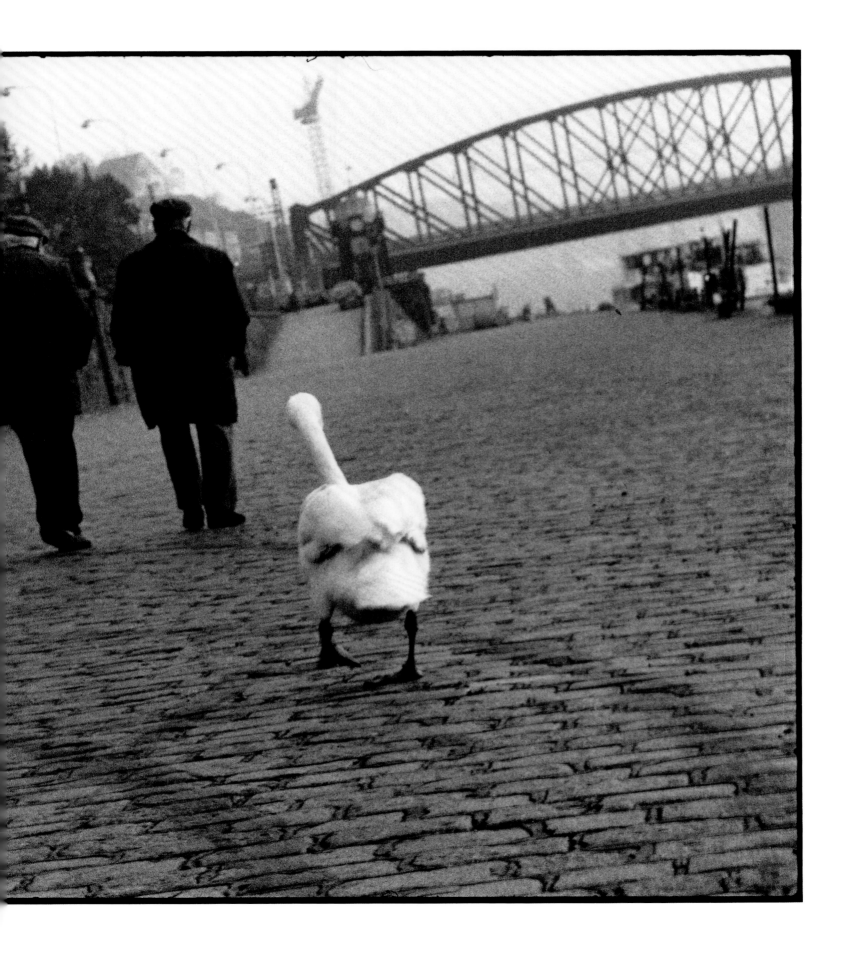

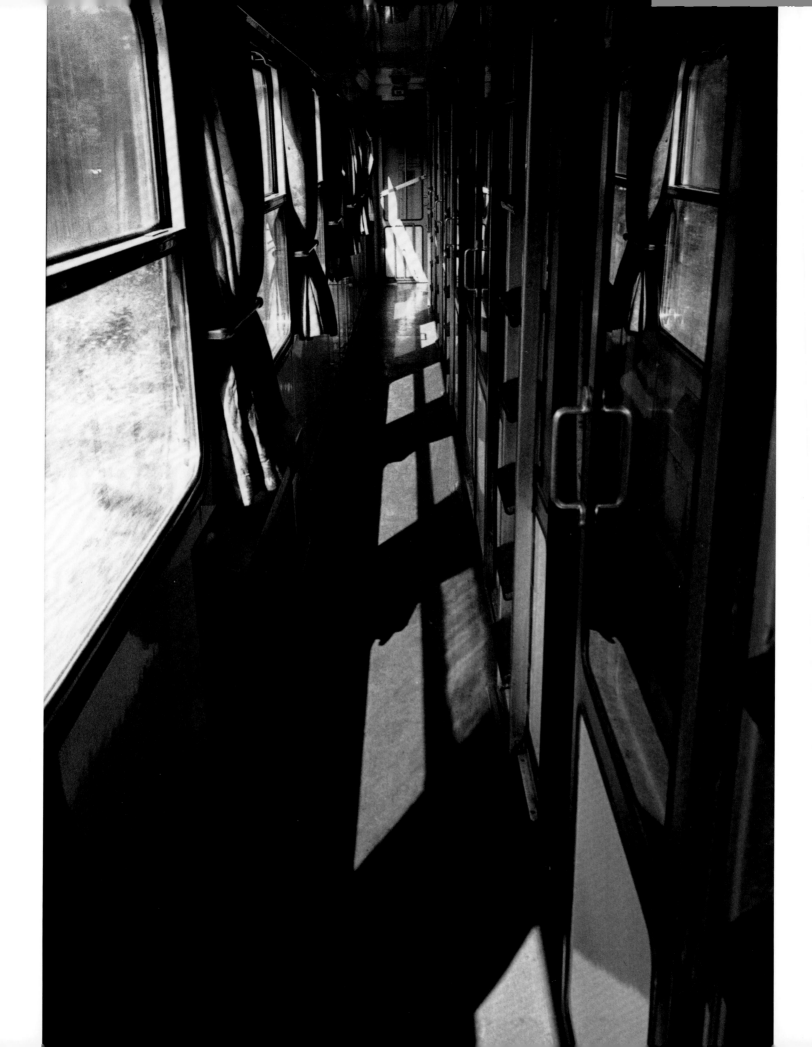

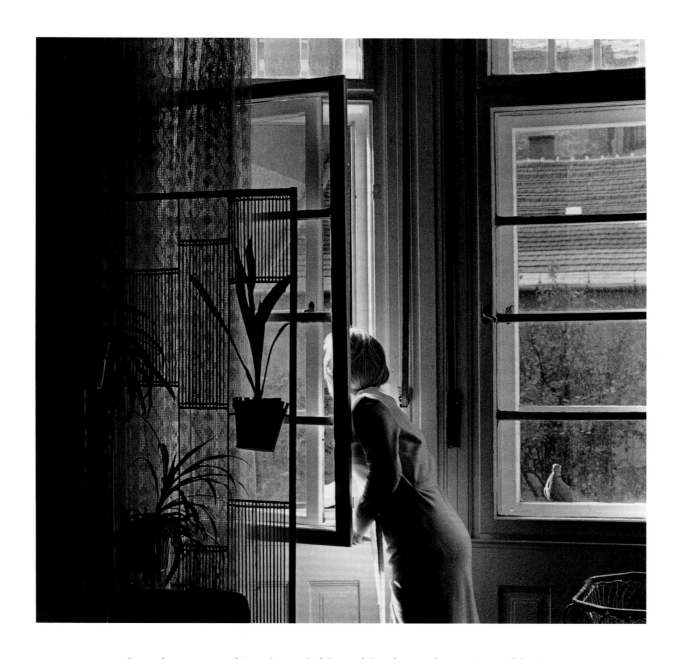

In a dream, speeding through blurred landscape by train, suddenly, my compartment door slides open and in walks Carl Gustav Jung. He sits down, we talk and before he leaves, he hands me his fedora. This was at a time when I was reading his books and knew with certainty that his gesture was my initiation into the collective unconscious.

Above: *Lulu in the room where we often played as kids and where she still lives today with her daughter Salima.*

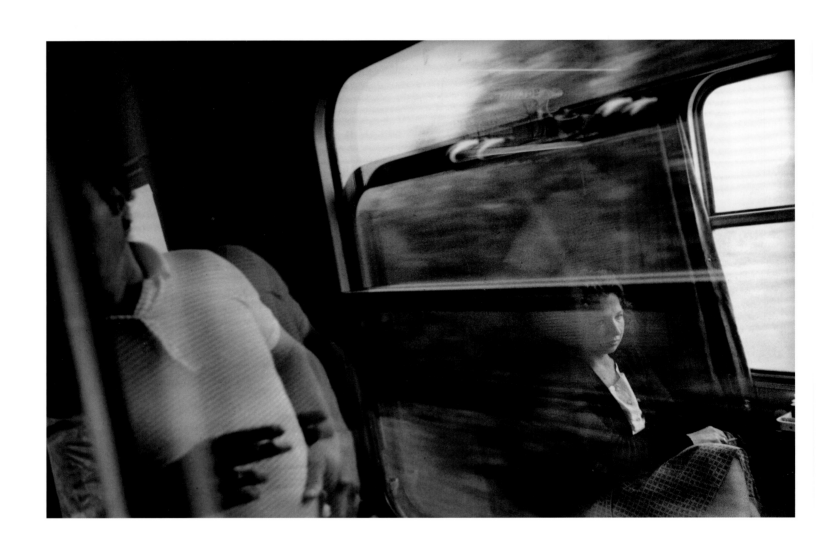

I often traveled by train and what a pleasure
it was to lean out the window and feel the breath of the countryside on my face.

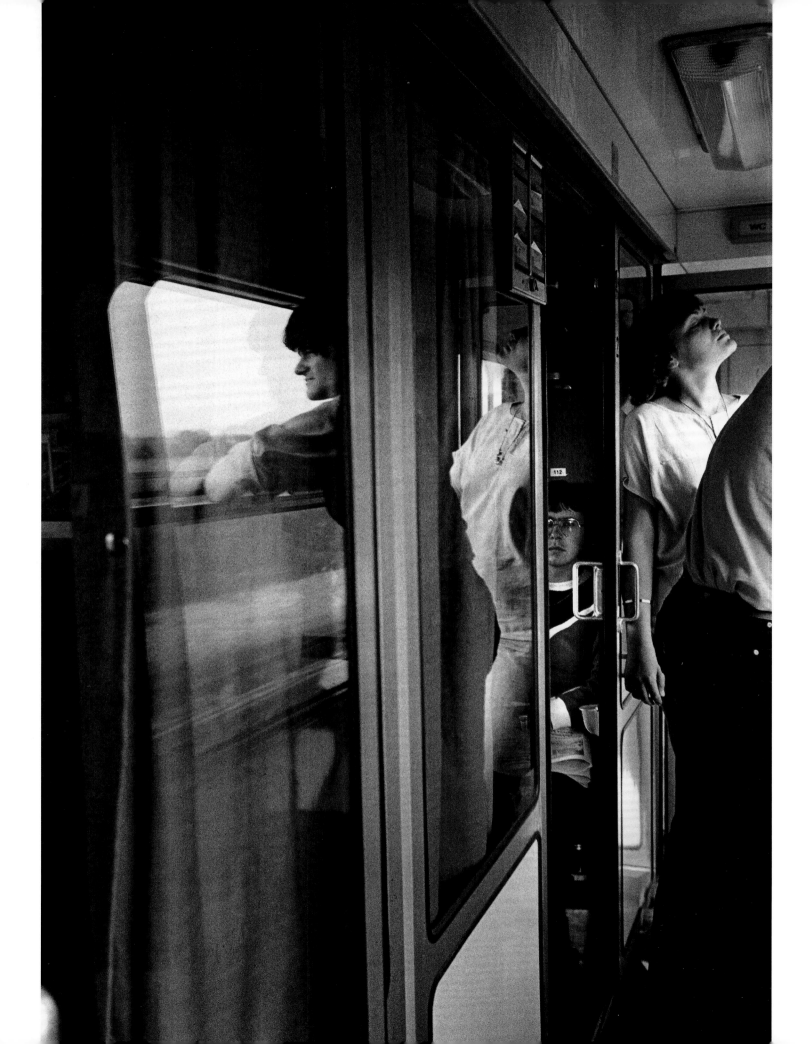

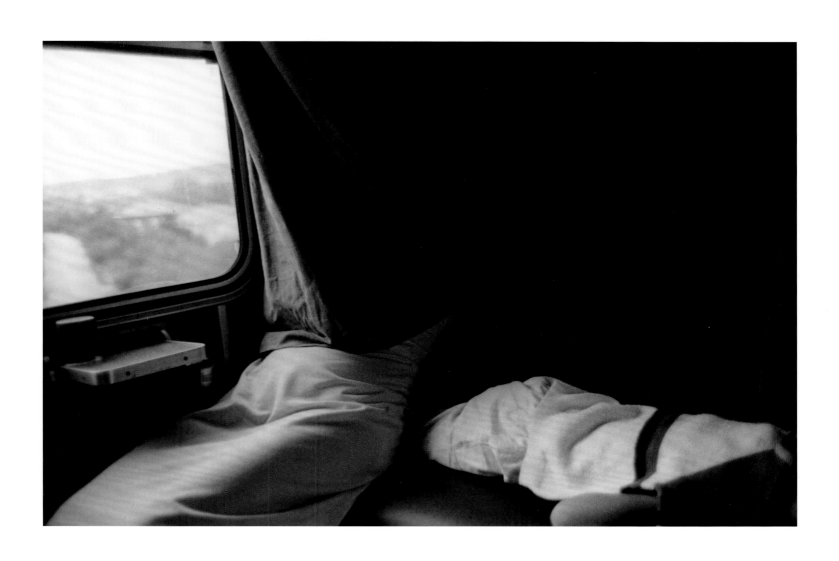

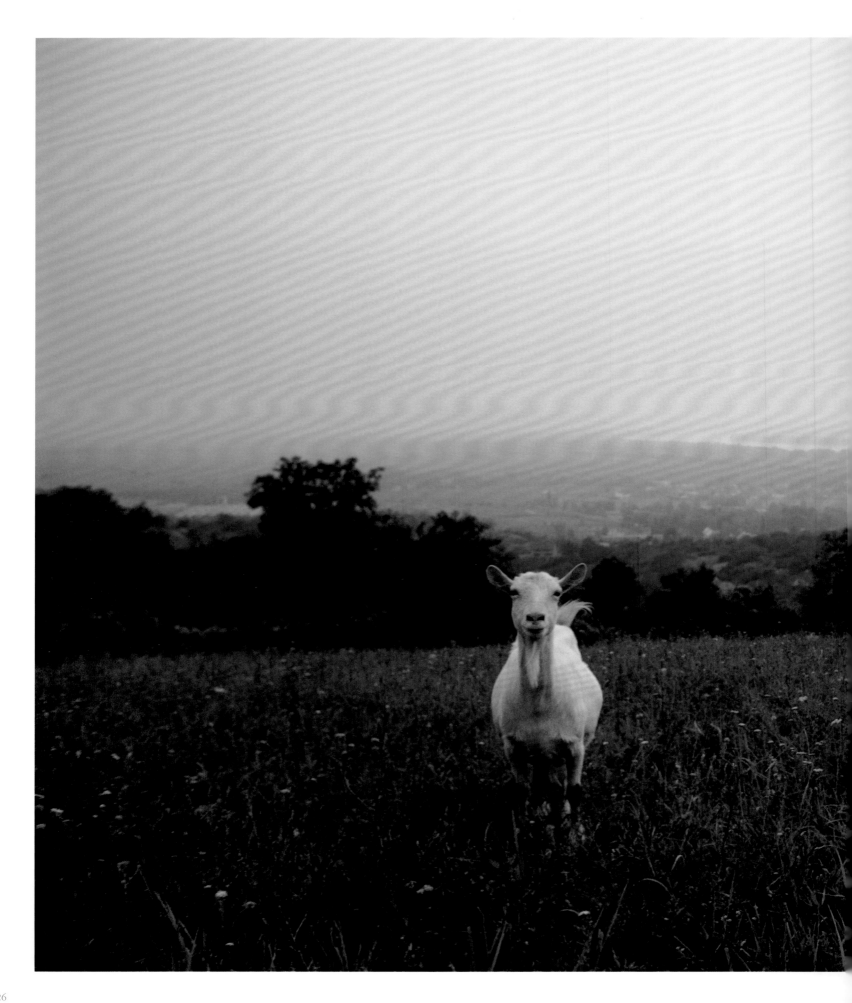

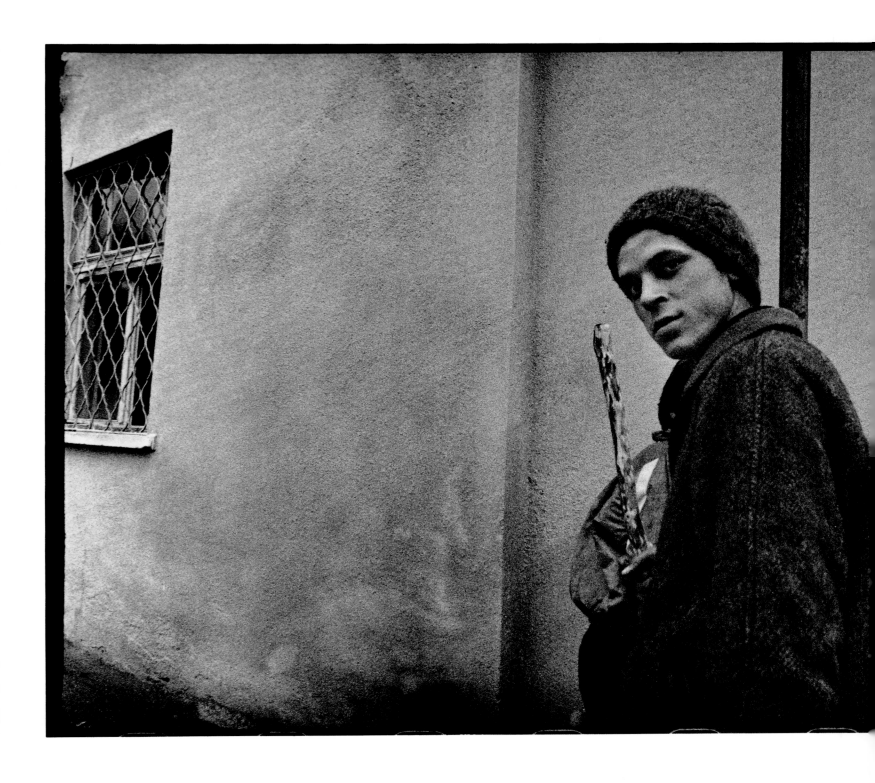

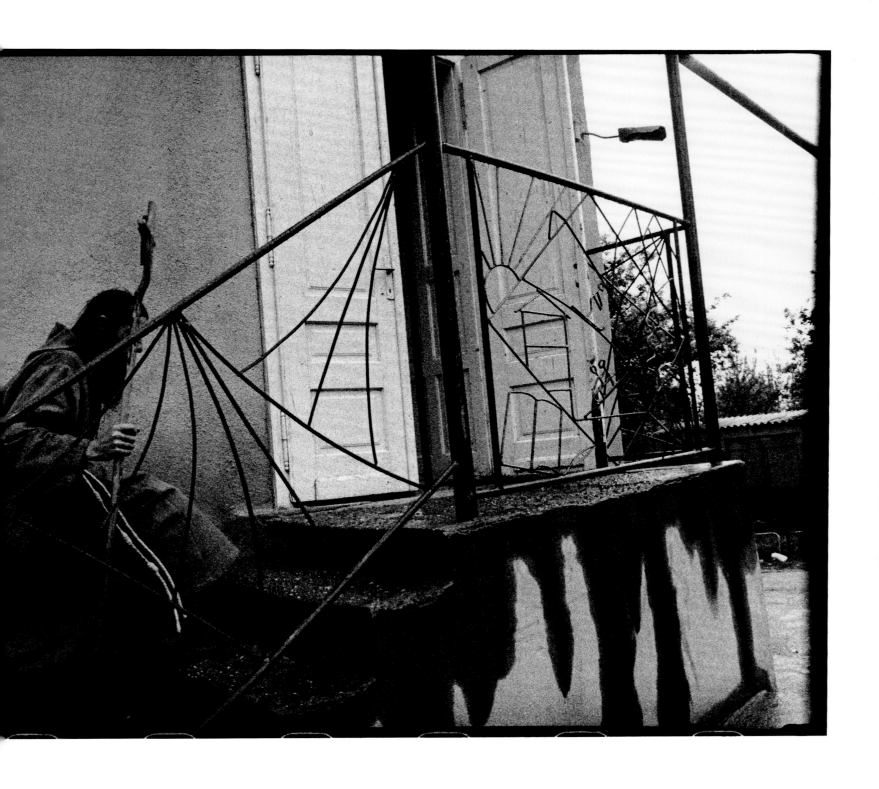

*Brother Béla, lives in
Csikszereda in Transylvania. Once,
before he became a religious hermit,
he was praying in the mountains. A bolt
of lightning struck him. He lost consciousness,
but didn't die. His large rosary beads
burned into his chest. He took it to be the sign
he was waiting for and went on to study
with the monks. He moved into the hut on the
mountaintop that stood empty for decades—
since the previous hermit had died.
Pages 128–129: Brother Béla visiting the
orphanage with his apprentice, István.*

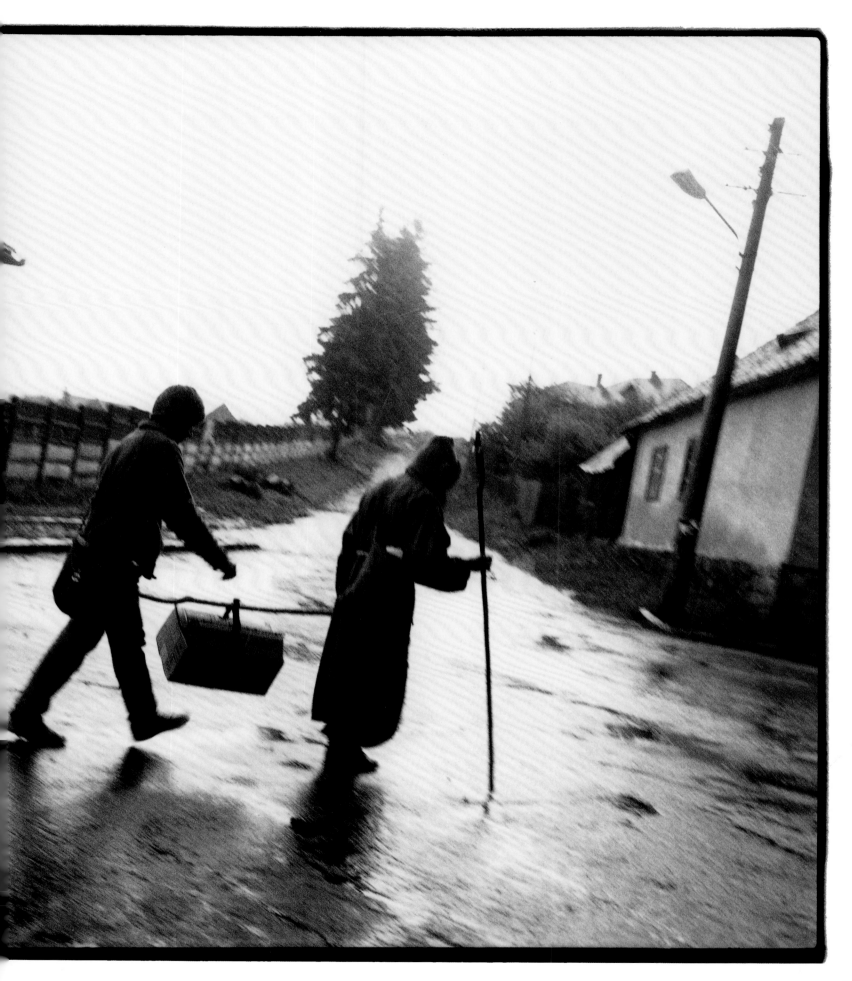

Brother Béla's dog is waiting for him outside the church while he is praying.
He used to raise goats and had a donkey. He loved his animals, but said he had too many
of them and not enough time to pray. What he really wanted, he told me, was to take his walking stick with a cross
carved on top and "become a pilgrim and travel the world like you." I have visited him three times,
usually in June during Pentecost. By my last visit he had sold the goats and bought himself a motorcycle.

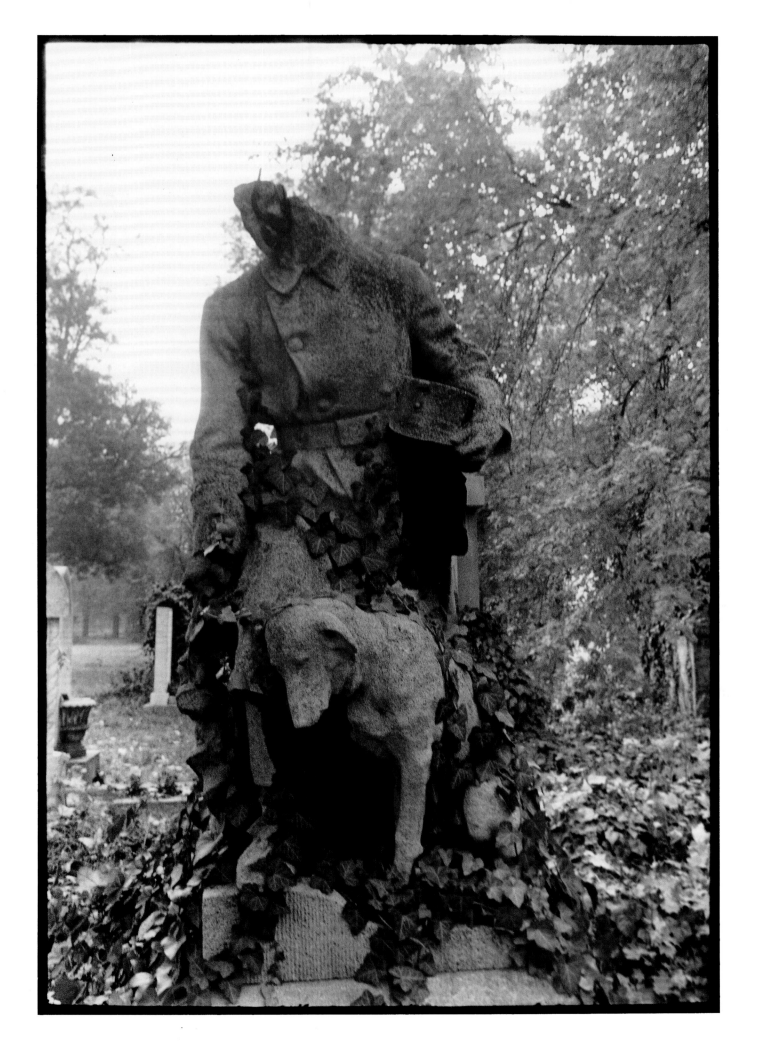

The young girl in a joke is walking alone in a cemetery.
She sees a thin old woman walking ahead and she runs to catch up with her,
"Please, may I walk with you? I'm afraid."
"Sure, honey," the woman answers,
"I, too, used to be afraid when I was alive."

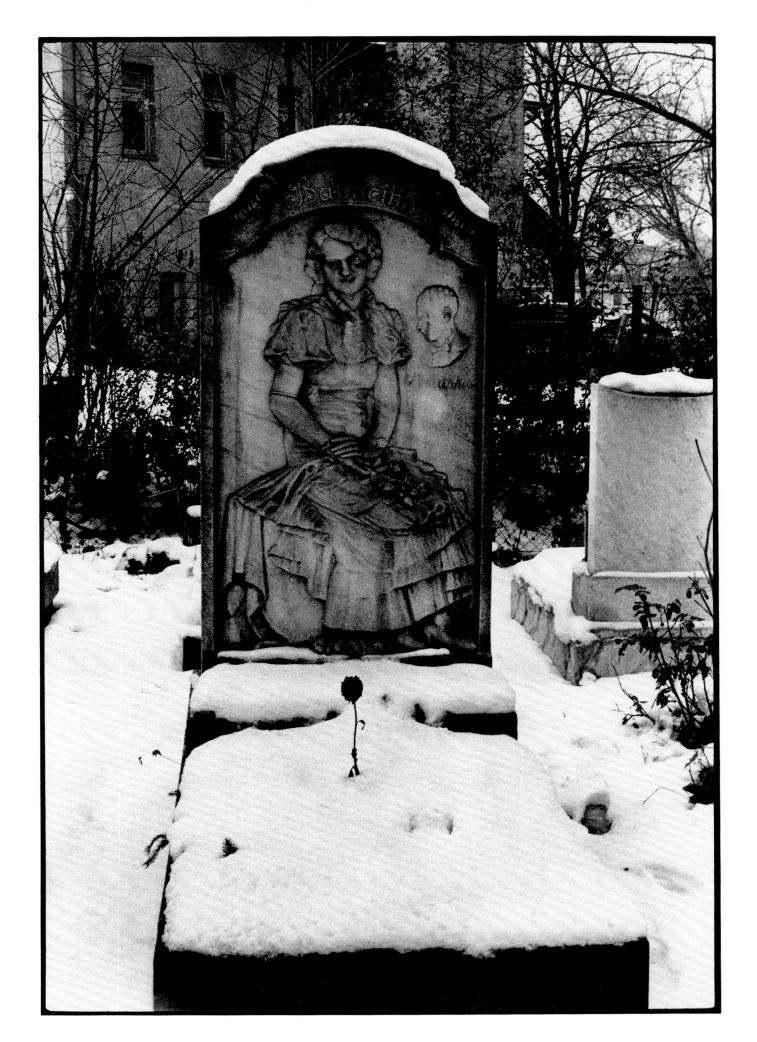

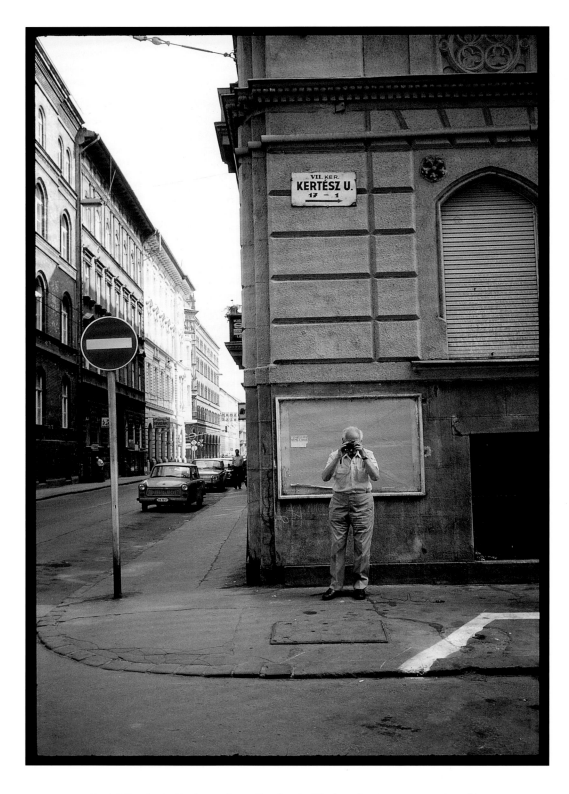

André Kertész in Budapest, in 1984, for the filming of a documentary about him.
He claimed France was his spiritual home and of his birthplace, Hungary,
he said: "All that is treasured in my life had its source here." For a while I traveled with him
on the road to Esztergom and we stopped near some women digging ditches.
"Look at Grandpa," one of them said, "How old is he? He is in good shape.
Look, he is still taking pictures."

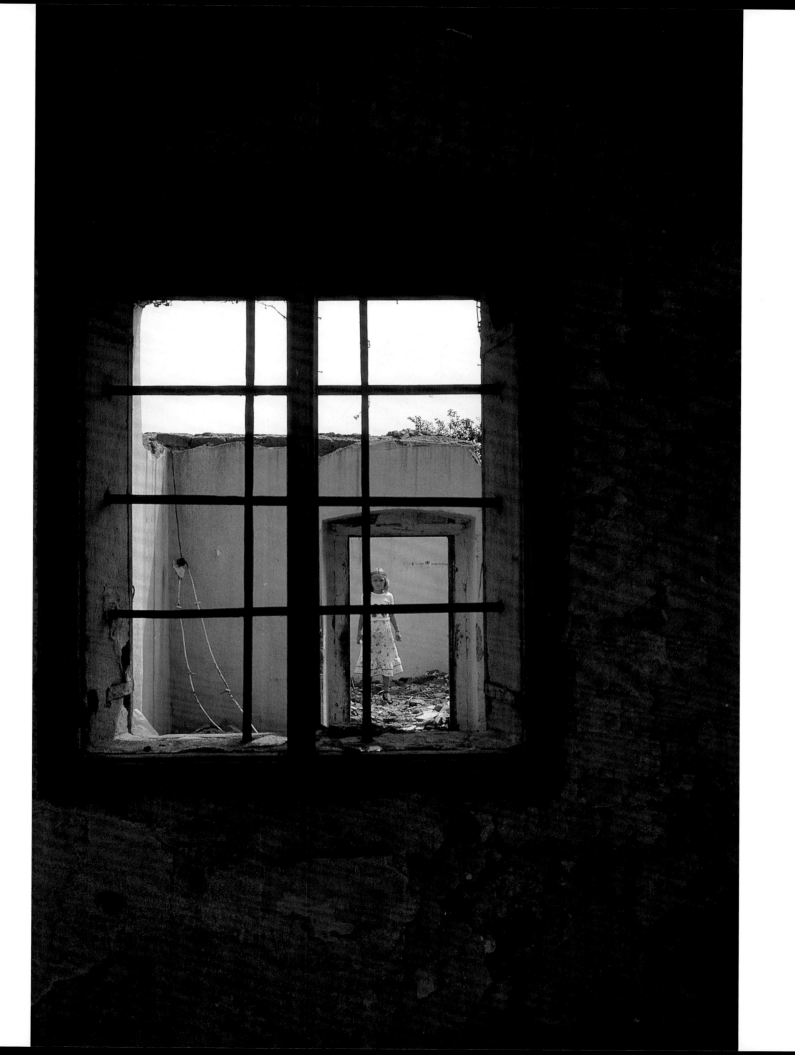

Page 141: *Every time I call Anikó,*
she says, "What should I cook for you?
When are you coming?" Antlers,
and stuffed pheasants line the hallway
of Anikó and Karcsi. The trophies
are the legacy of her father
who was a hunter and a judge.
Here you see the hide of a wild boar
that stretches over my bed,
when I sleep there.

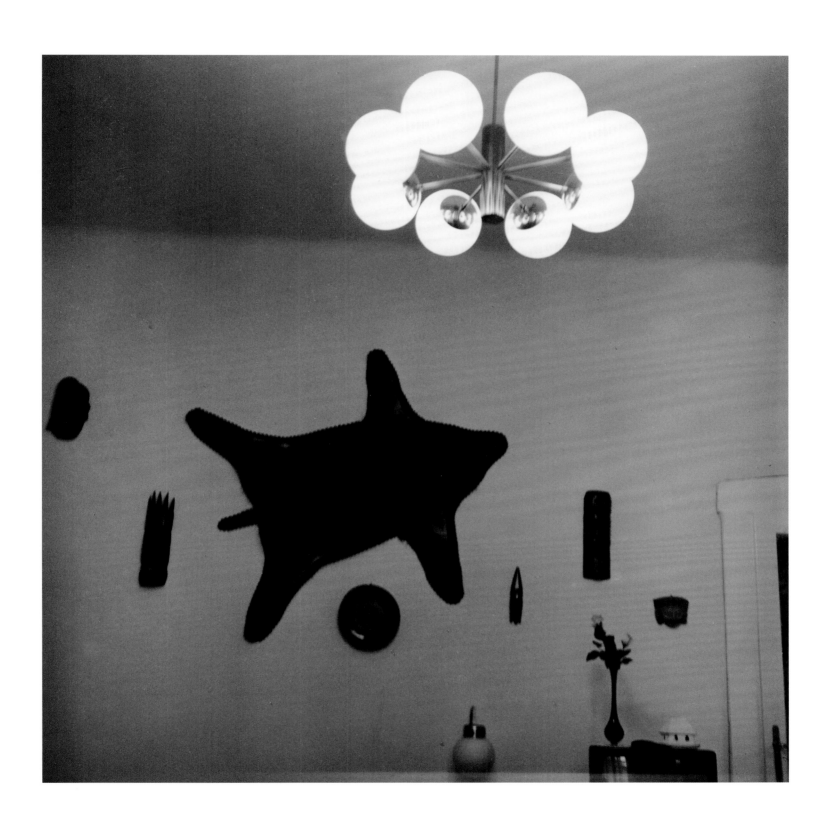

I alternate my stays at the homes
of several friends. Marika always
insists that I take the better bed
and that I eat more than I can.
Here in Marika's apartment, occasionally
I find magic. Just as in this picture
sunlight through the curtain mimics
the snowflakes on television, one night,
as I looked out her window at
the hundreds of twinkling random
lights in the Buda Hills,
I saw the Big Dipper.

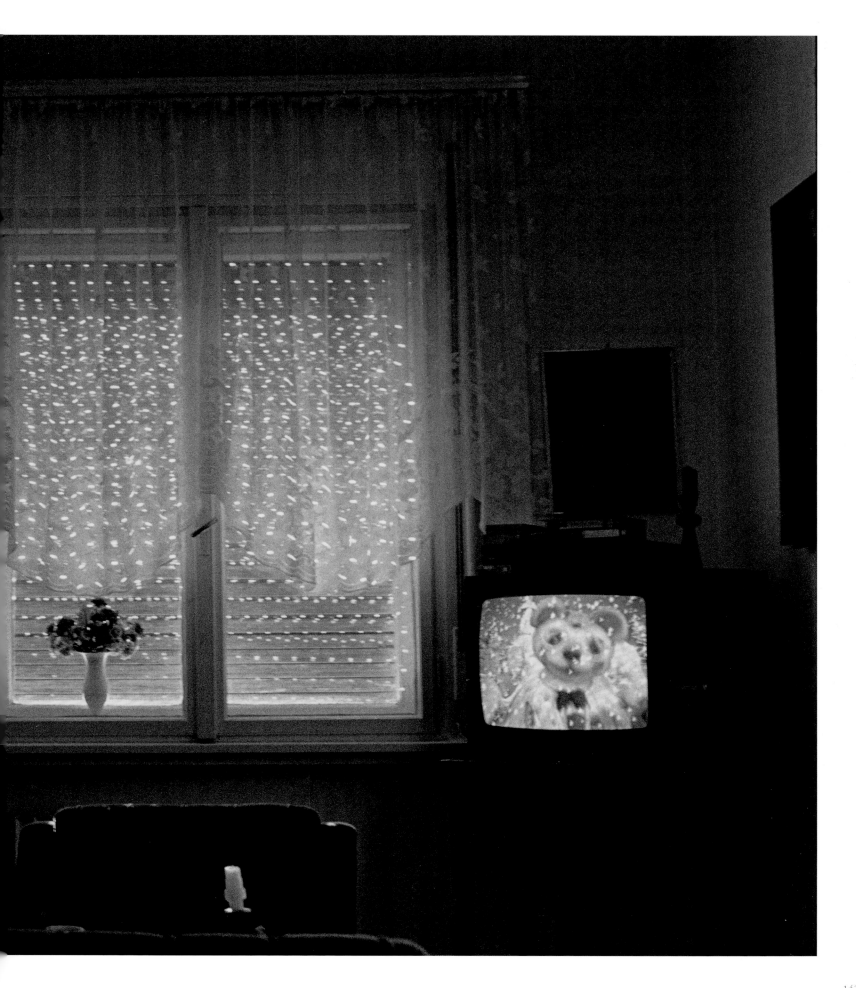

In 1976 I took my son with me to Hungary.
At three, he was not cut out for world travel.
He didn't understand the language, he didn't like
the food and inside Lulu's apartment he
looked around in disbelief, "Is this Hungary?"
He went around, "BANG, BANG" shooting
everyone with his toy gun saying,
"I'm an American Cowboy." Here, he has just
shot a friend of my father, Laci bácsi.

After a few weeks, he was happily back
in Queens. "This is my Daddy," he said
hugging Elliot and rushed to get into his car bed.
"Come on Mommy, I'll drive you somewhere."
"Where are we going, Hungary?" I teased.
"No," he said quickly, "I don't want to go to
Hungary, let's go to the amusement park."

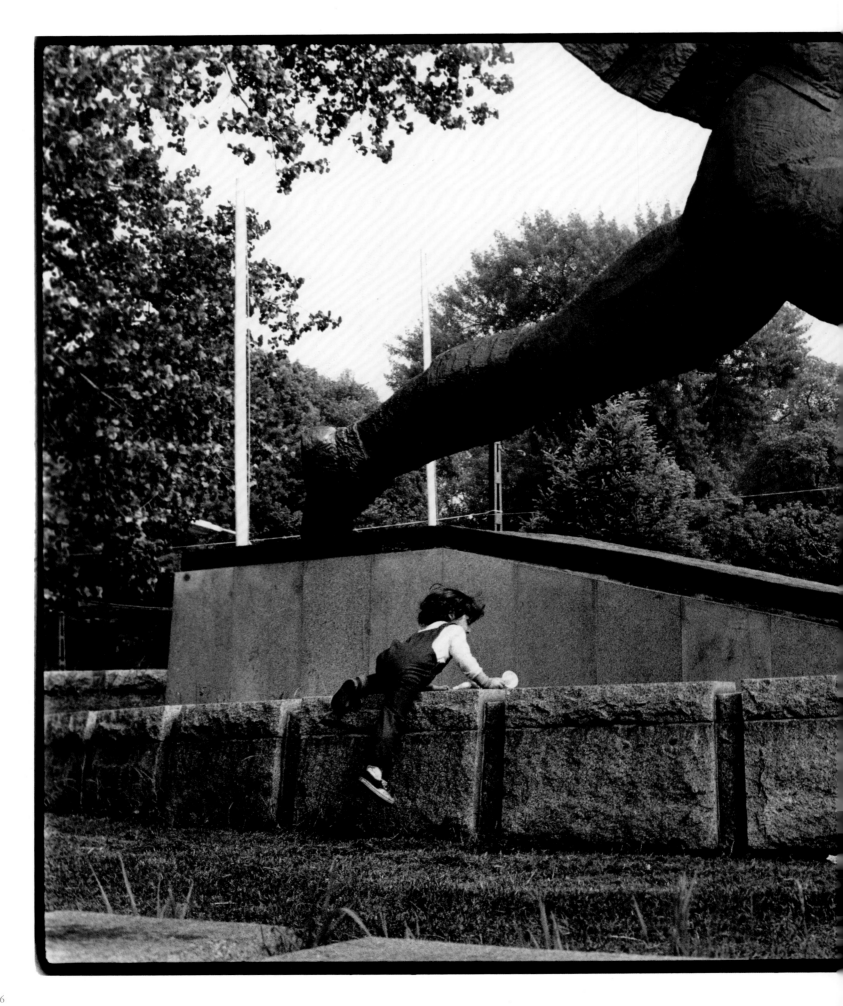

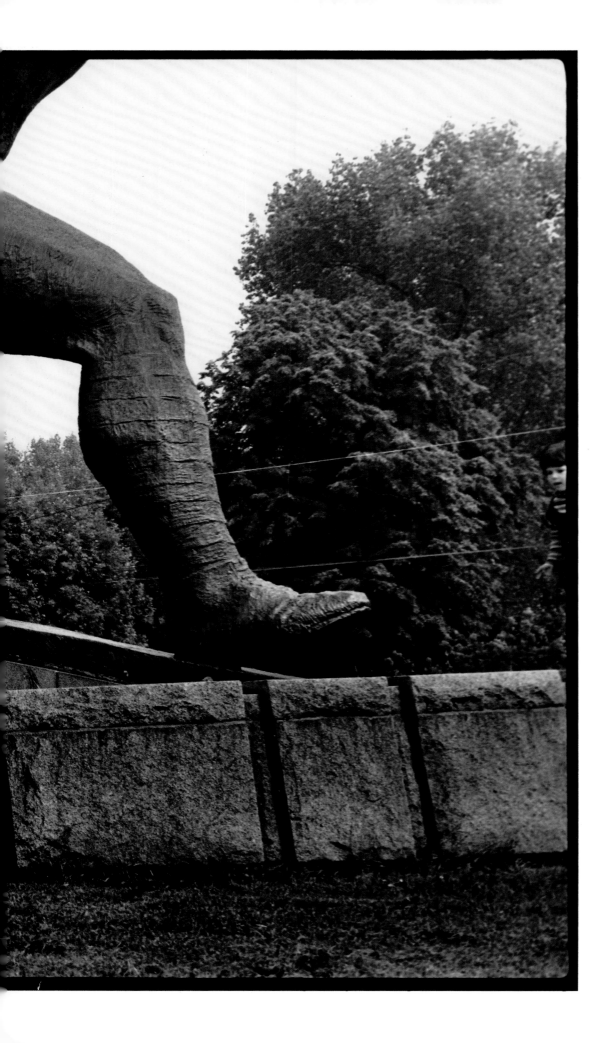

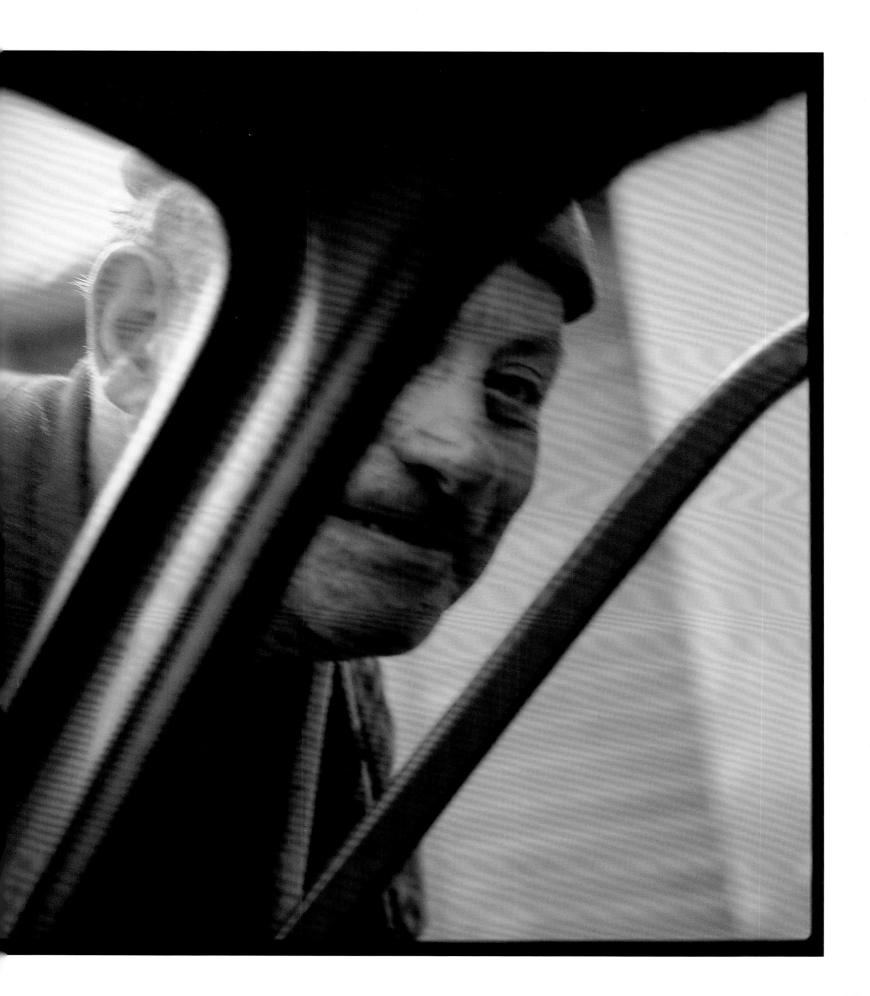

I remember a fairy tale about a storm.
One night, raging winds in a city dislodged signs and blew them about.
The next morning people were confused: the hat store sign hung over the Deli,
the toy store was marked as a shoe store and so forth.
Something like this happened after 1990: streets, stores, movie theaters,
anything that was named after a Communist leader or event was renamed or
reverted back to its pre-war name. Moskva tér (Moscow Square) was deemed neutral and stayed.
My friends, who lived their whole lives in Budapest, were lost.

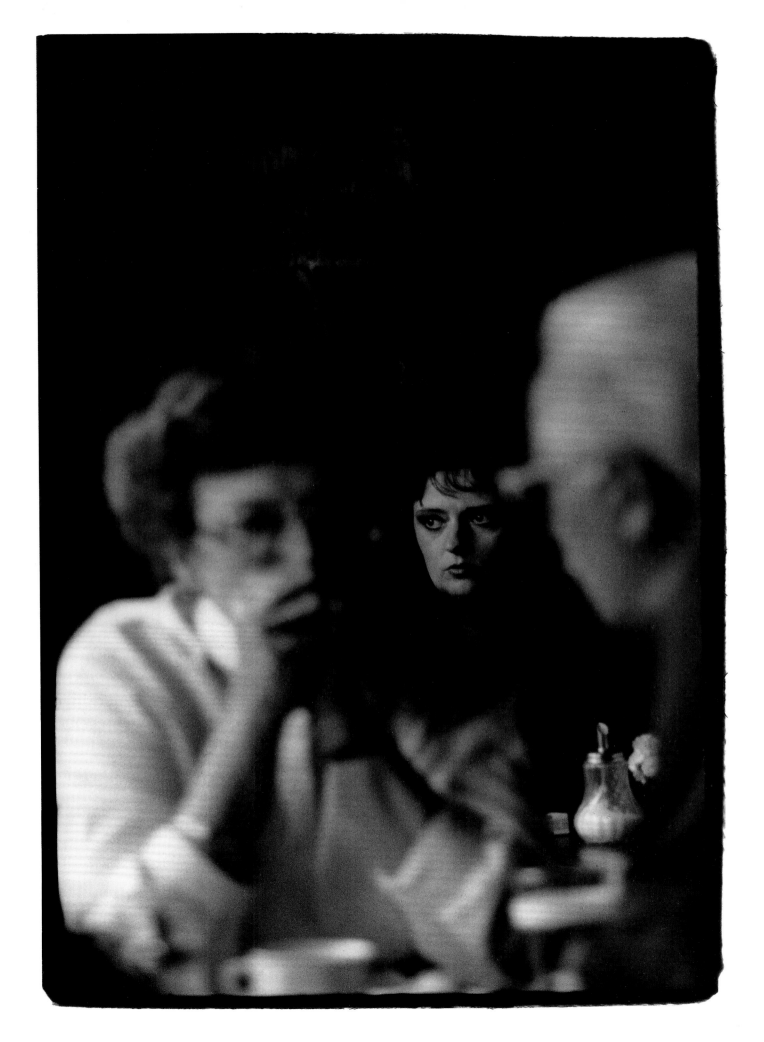

In Plovdiv, Bulgaria, there is a custom to put up death notices.
Photographs of the departed are tacked on trees and taped to walls. Black and white
or color, they all have sad faces, expressing not only the finality of the present situation,
but also their state of mind while they were alive.

Above: *A frame from a 1989 television documentary about the 1956 Revolution, Budapest.*

Opposite: *I was traveling with James Ridgeway, a journalist, on assignment in October 1989
to document the changes in the Eastern Block, and wanted to show him the historic spot, where in
1956 I had watched as men, armed with torches, separated Stalin's statue from his boots.
As we turned the corner (how could it be?), there stood Stalin on his pedestal once again surrounded by a
crowd waiting to pull him down. This tyrant turned out to be papier-mâché, and the people
around him, movie extras. They were filming* Diary, *a movie by Márta Mészáros. As the statue fell and broke,
someone rushed off with an arm—just like in 1956, when parts of the statue were dragged to side streets
and feverishly filed down for souvenirs. "Please don't, it's not real," begged the voice on the megaphone,
but the man kept running with the arm. What is real? I wondered as I continued to take pictures,
grabbing my chance to photograph my life as a movie.*

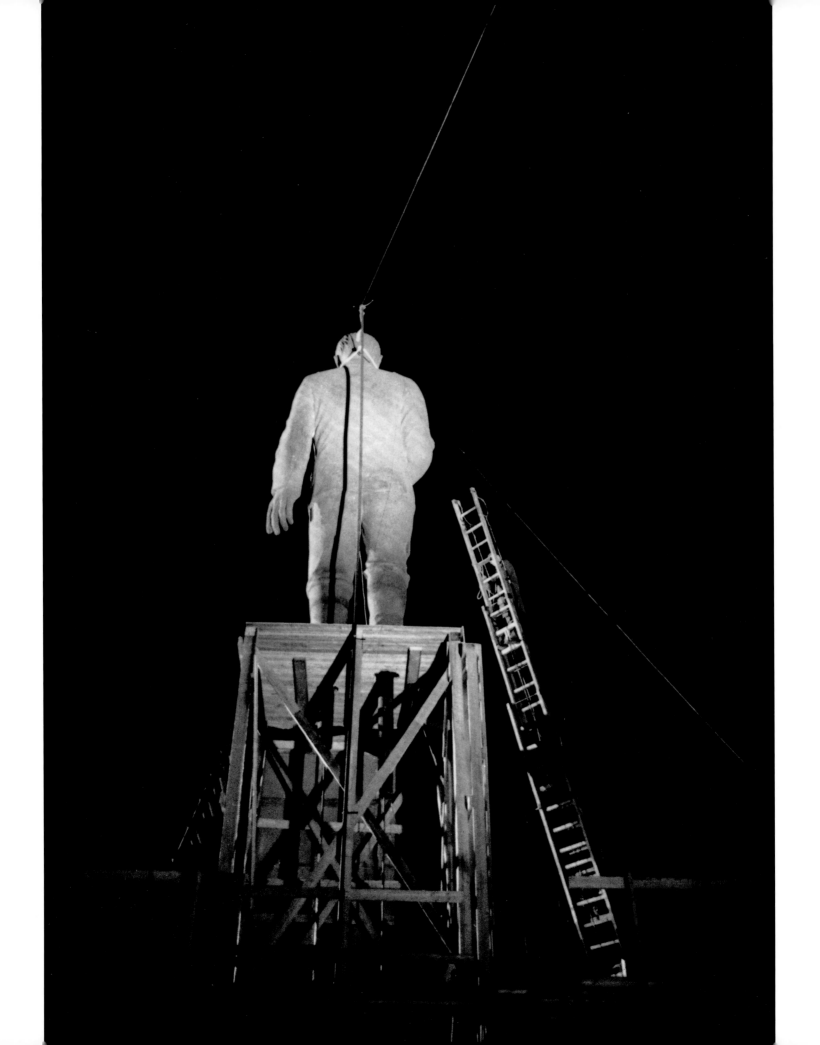

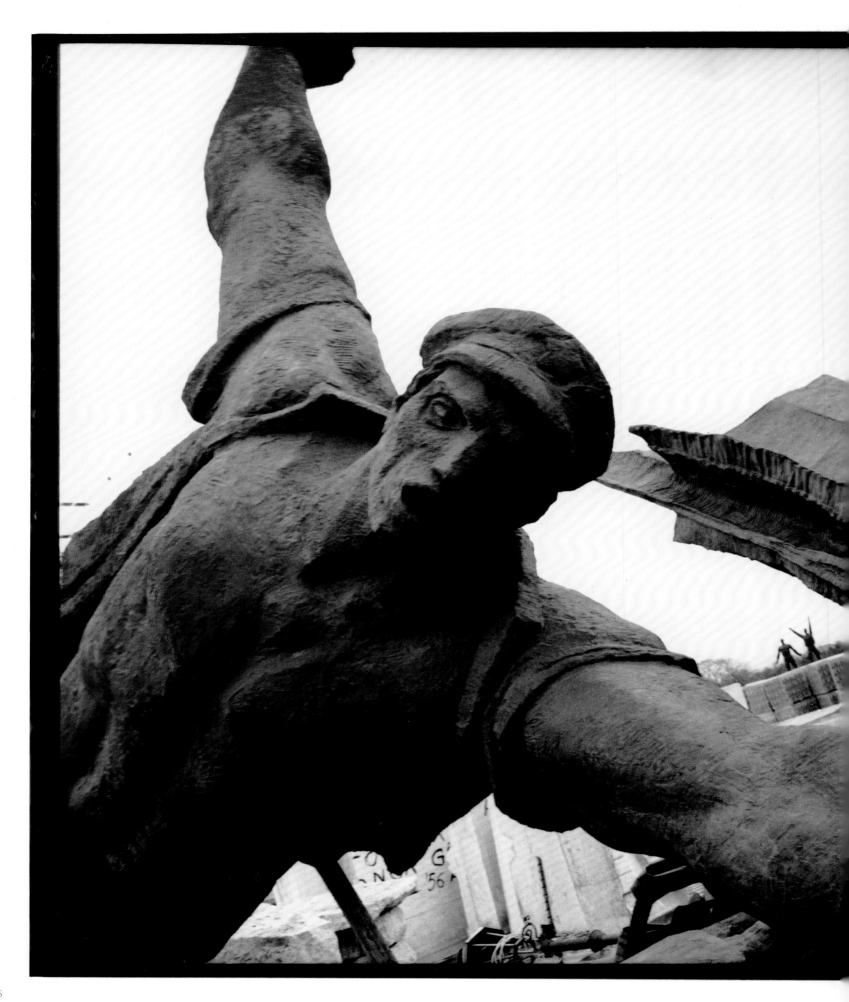

In the spring of 1993, "the Worker,"
an icon of my childhood and not as menacing as the
other statues of the Socialist Revolution,
was removed from Heroes' Square. I found it in Érd,
on the outskirts of Budapest, tossed onto the ground
with other statues in a fenced-in area. Later,
an art installation was built and fifty-eight statues
were arranged on the ground and not on their
pedestals. At the entrance, an old radio from the
fifties was blaring speeches, and the sound of marches,
including "The International," filled the air.

Marika's second husband, Lengyel Gyula,
had the words "ADVENTURE IS MY LIFE"
tattooed on his arm. Another tattoo,
the name of a former girlfriend,
he erased with a burning cigarette.

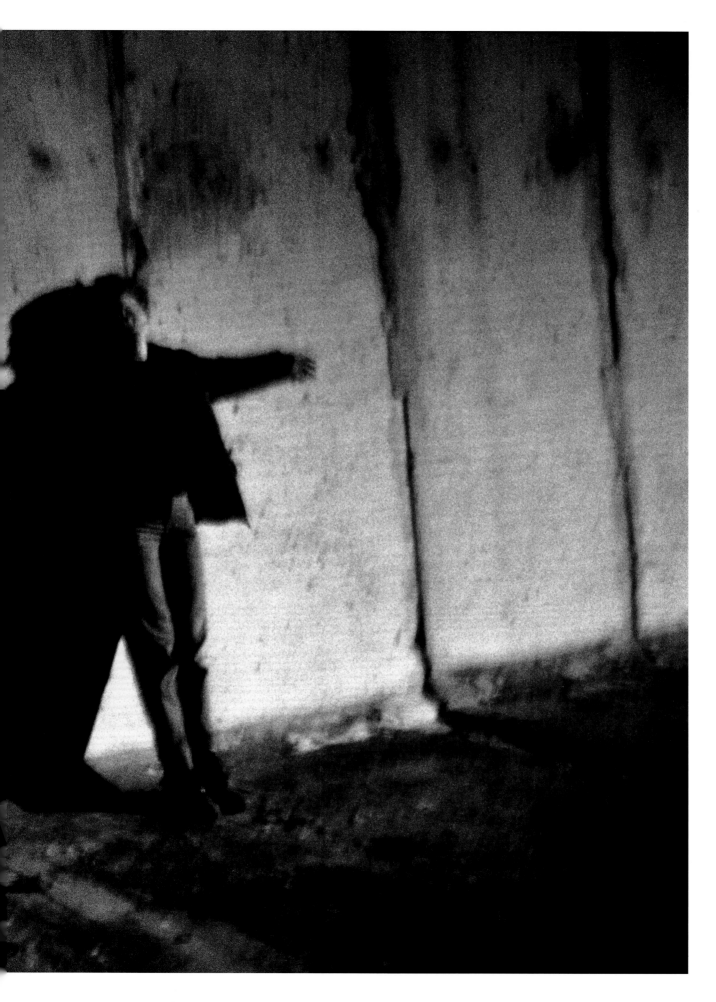

East German teenagers,
Phillipp and Steffi, tested
their newfound freedom
in March of 1990.
They pretended they were
being executed up against
the Berlin Wall.
Two border guards saw
them and questioned
them, but in the end,
did nothing; the wall
was coming down.

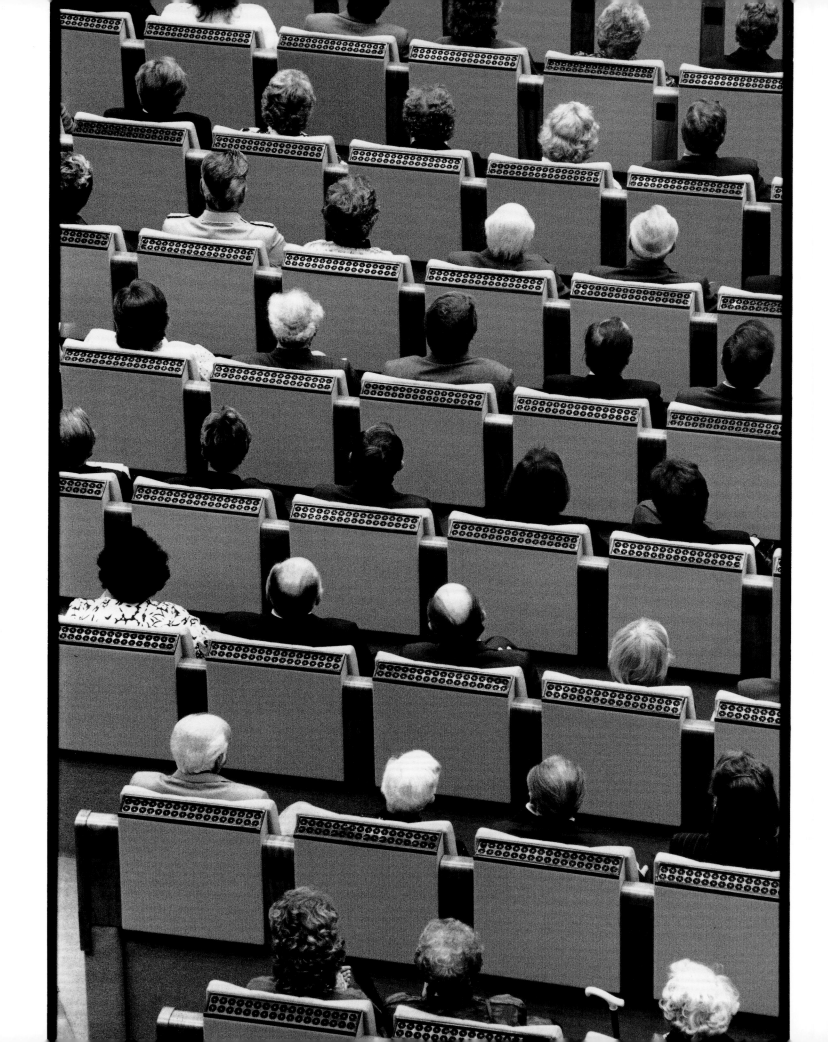

Opposite: *From the balcony during the 40th, and last Communist Party Congress*
held in East Berlin in 1989, I saw Hönicker, Castro, and Gorbachev, and the back of the members' heads.

Above: *This woman was warning her daughter, in the spring of 1990 in Romania,*
about what may come after the collapse of Communism. She said, "Beware, things will get worse."

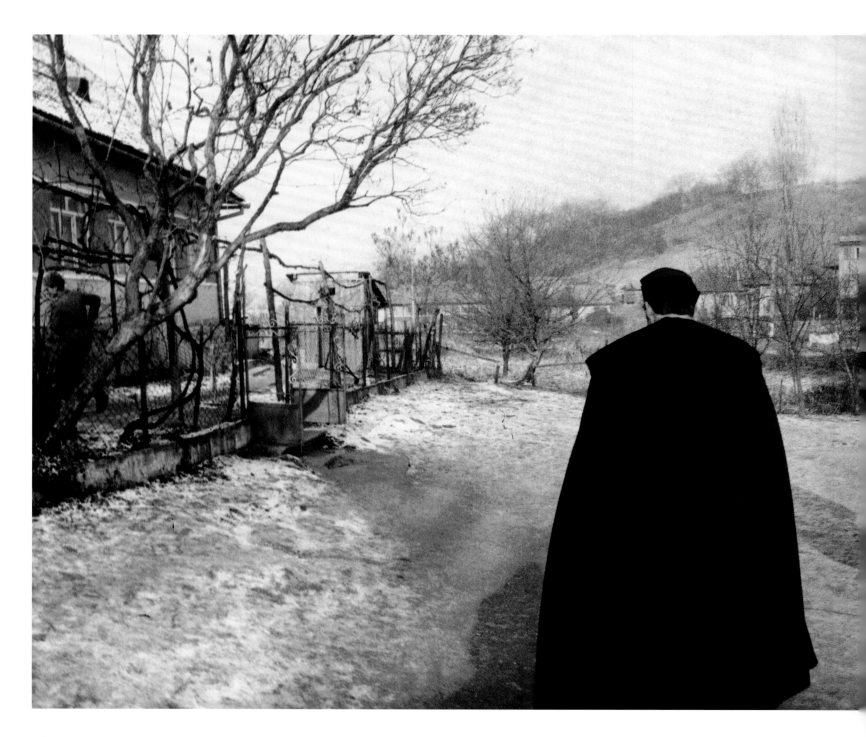

The Rev. Tökes László is seen here in his black velvet robe on his way to give his Sunday sermon in the village of Mineu, where he was hiding in January 1990. On assignment, the journalist, Guy Trebay and I drove north in snow and ice, through barricades and checkpoints, in search of him. Three weeks earlier, he had been arrested and the demonstration that followed in Temesvár (Timesoara) ignited the Romanian Revolution. When the tides turned, after Christmas Day, 1989, when Nicolae Ceausescu and his wife had been executed, the soldiers, who were initially sent to arrest the Reverend, stayed on to guard him, from the Securitat (secret agents), still roaming the country.

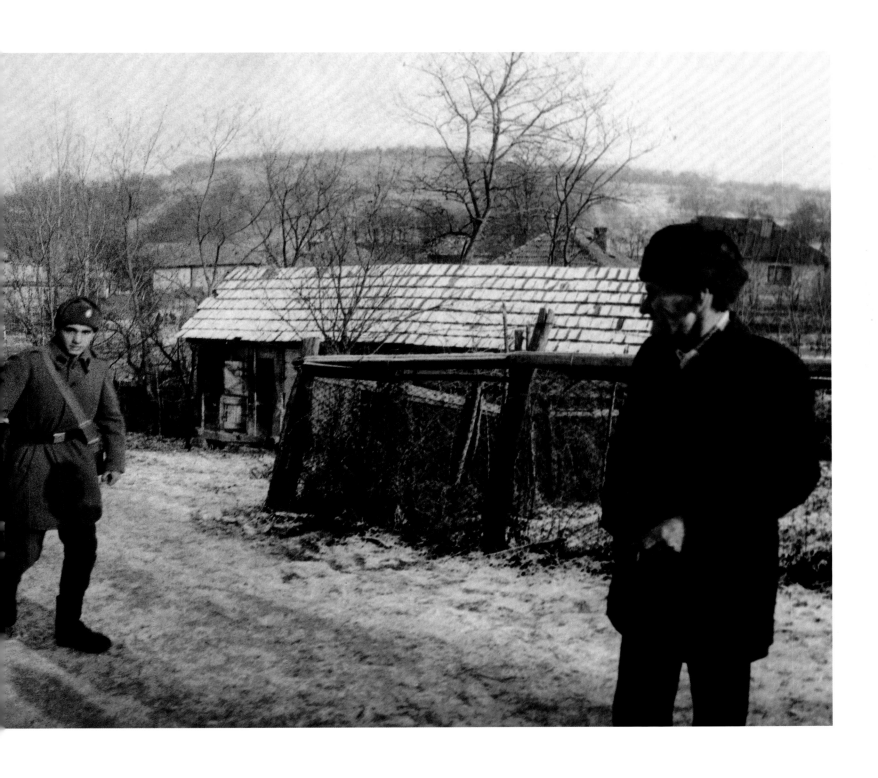

Opposite: *In this bureaucrat's office in Belgrade, 1992,
the photograph of Marshall Tito has been removed,
leaving an empty frame.*

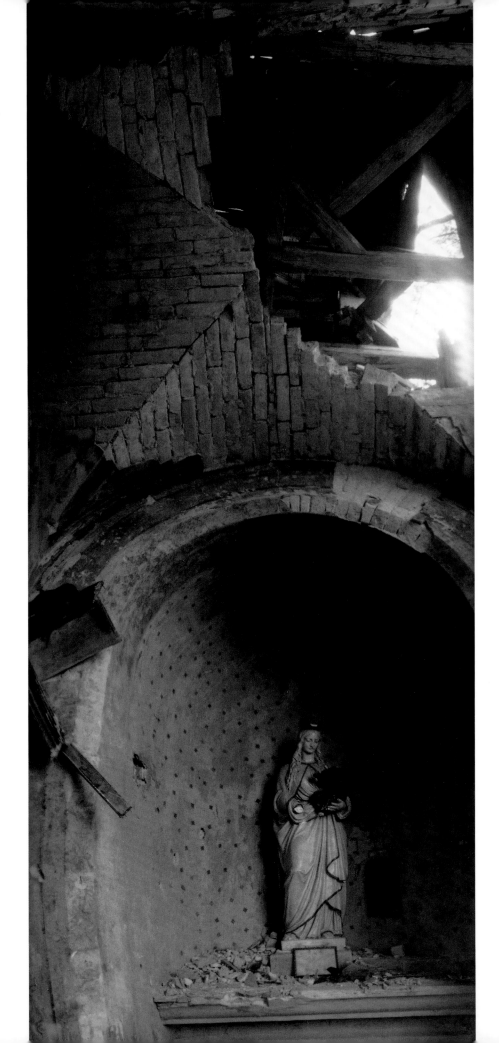

Here, as I saw Vukovar
after its destruction in 1992.
Some years later, in 1999,
I watched a re-enactment
of the battle of Vukovar,
filmed outside of Prague
as I photographed my son
(opposite) in the role of a war
photographer in the movie,
Harrison's Flowers.

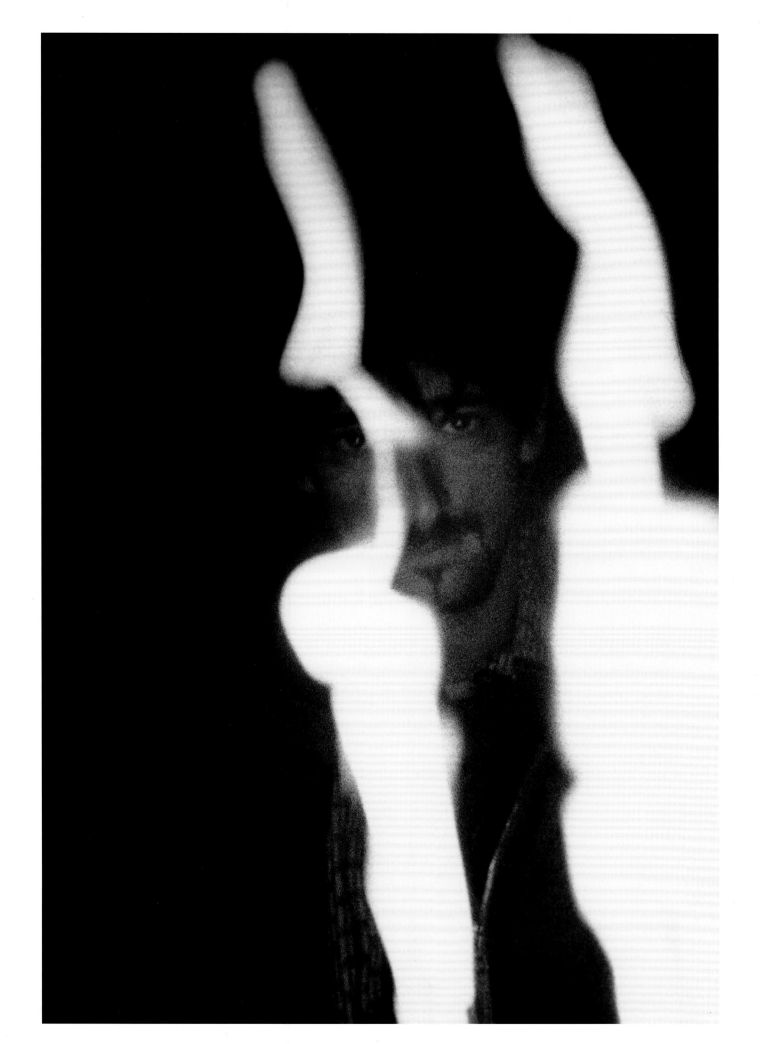

By 1990, when most of Eastern Europe had shed Communism, the bones of martyrs from the 1956 uprising were dug up from mass graves and laid to rest with ceremony in Hungary. There and elsewhere, stories buried for more than forty years in people's minds began to surface.

Old grievances never die and scores will be settled. On a trip in September 1992 through Serbia and Croatia, I witnessed disemboweled villages and people who had nothing left as a result of an insane fury. Soldiers with mortal wounds languished in hospitals, while others were learning to walk without legs. Blinding hatred, akin to that experienced by my parents' generation was back and I saw hellish visions of horror and fanaticism. And that was before Bosnia and Kosovo.

We visited wounded Serb soldiers in Yugoslavia (opposite) and a rehabilitation center for Croatian wounded soldiers in Zagreb (pages 174–175).

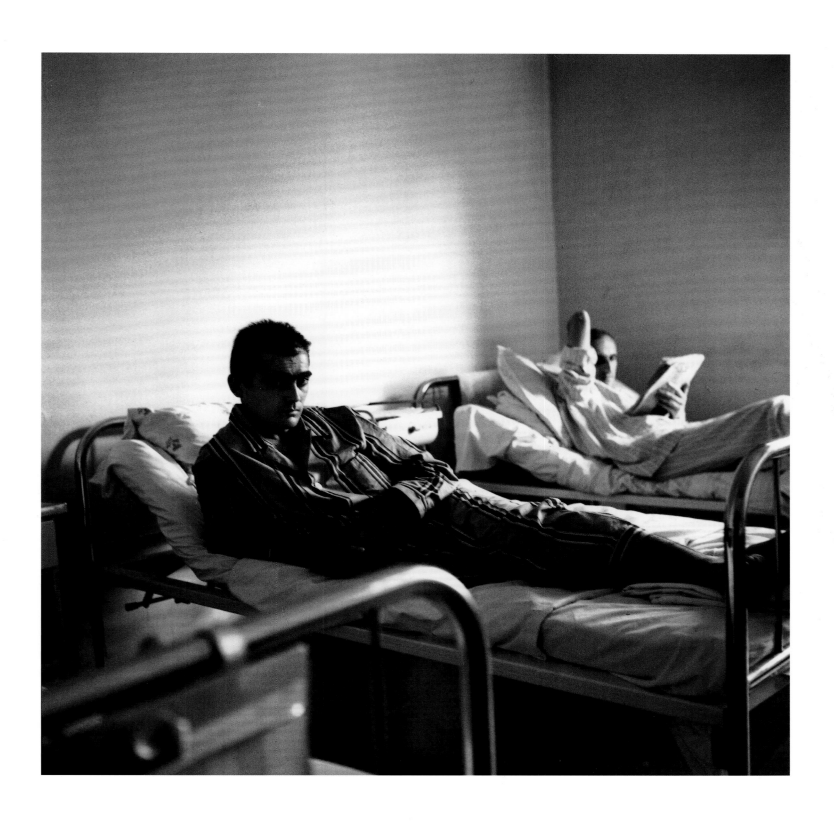

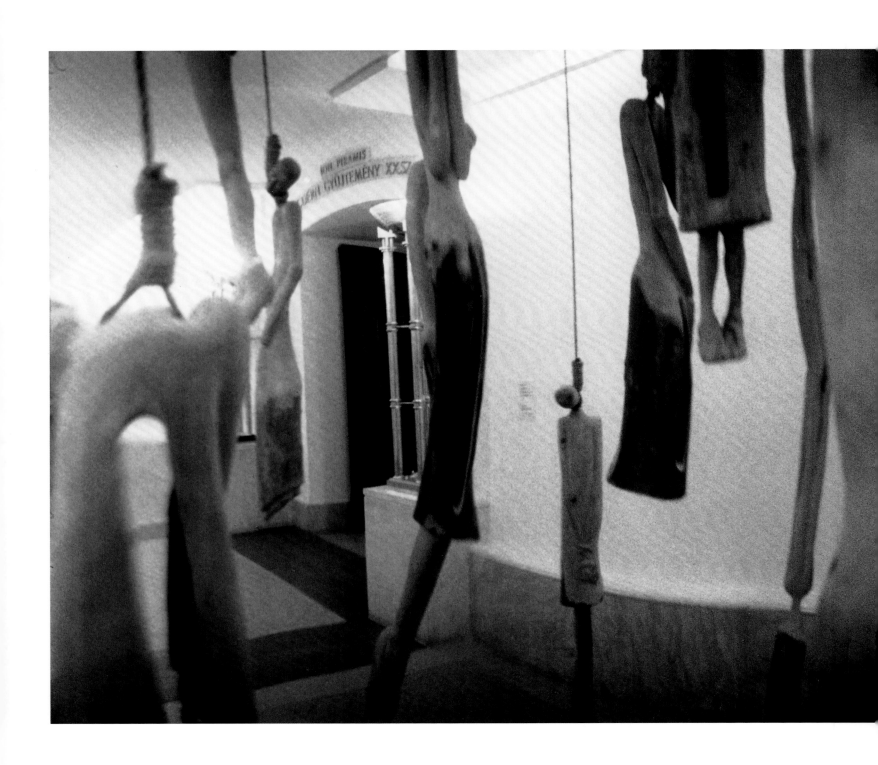

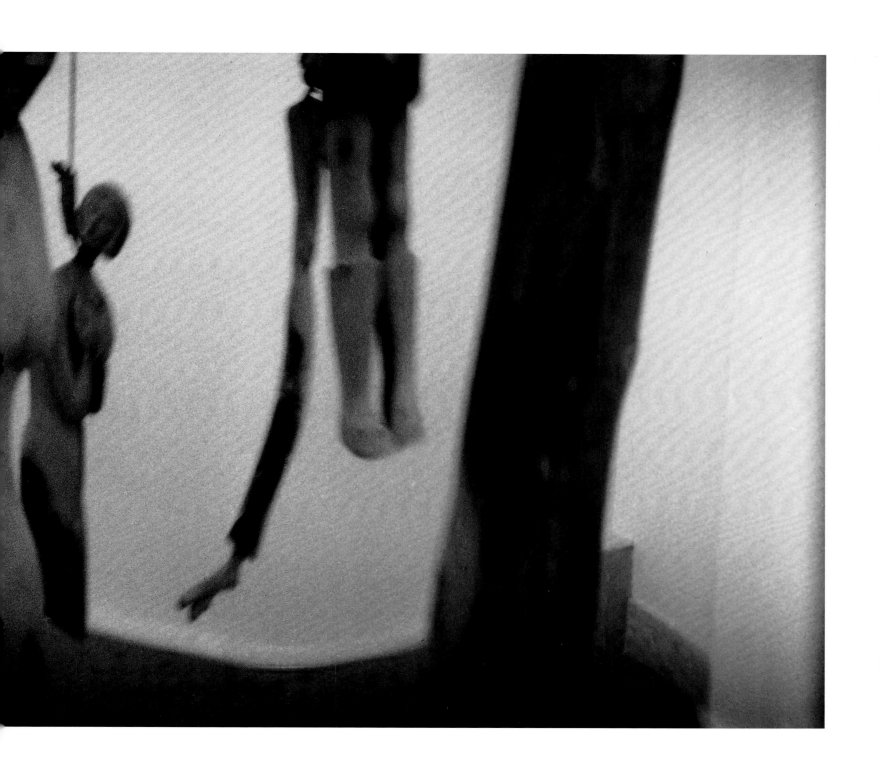

I heard Misia, the singer,
tell an interviewer on the radio,
that to sing Fado well,
the sadness has to come
from healed experience:
"from the scab and not from
the wound." If I had a voice,
I would have liked to have
been a Piaf, a Billie Holiday, or
the Hungarian singer Karády.

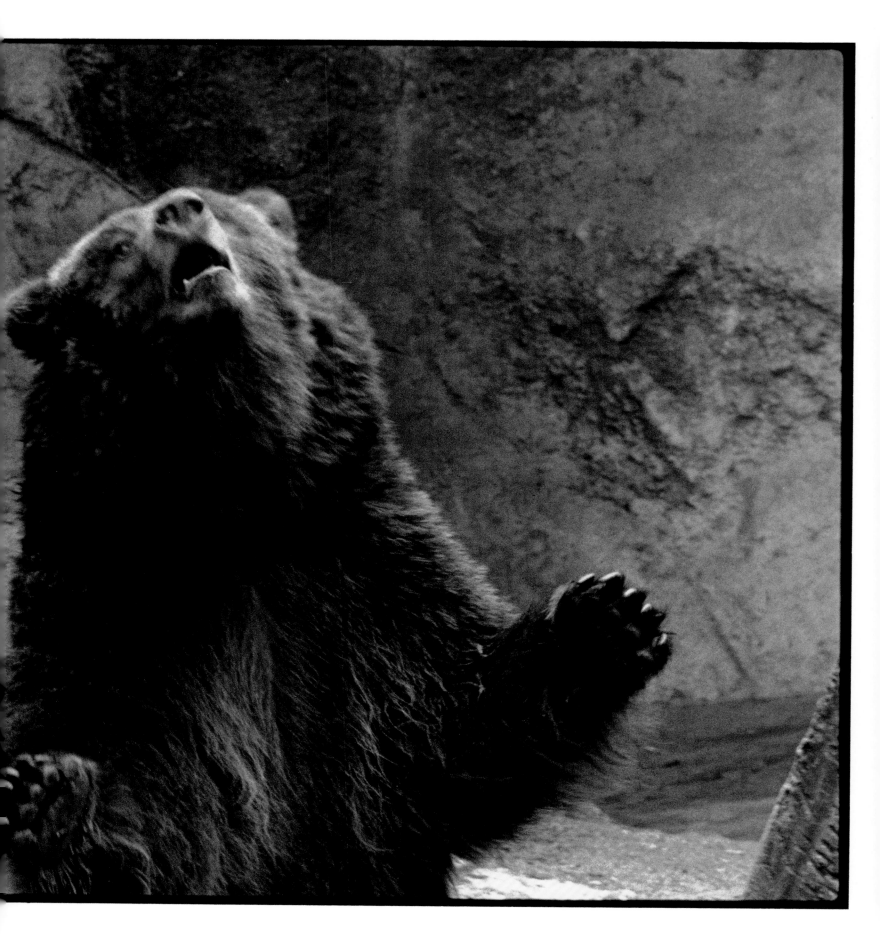

After she was widowed and alone, my mother surrounded herself with photographs of those she loved, including relatives, long dead, and us, the living. Pictures were propped up on chairs and sofas, leaving hardly any room to sit, and the desk had no available surface left. Similarly, my Great-Aunt Klári, bedridden in Budapest, spent her life in the company of pictures of her relatives painted by her father. One morning, I spied her going around the room, putting her fingers to her lips and touching each portrait tenderly. I, too, feather my nest with relics and bones of ancestors. My great-grandfather's tooth rests on cotton inside a tin film canister. When I miss my father, I put on his slippers and my mother comes to mind each time a butterfly flitters by. Phantoms in my photographs haunt me and unprinted negatives scream for my attention from the dark of cabinets. Our house is like a shrine or like an art installation of Middle Europe. Almost everything is damaged or cracked. My mementos, torn from life are: the roof tile from a vicious battle in Vukovar, a charred antler, a worn broom made of twigs, but my most cherished fragment is a remnant from a gravestone. I found it in a garbage heap in a Budapest cemetery. It's just one startling word, "FELEJT." It means forget, and on its own it is the inverse of the original inscription, "I WILL NEVER FORGET YOU."

Opposite: *Candles are lit for the dead on the 40th anniversary*
of the Hungarian Revolution outside the Parliament in Budapest, October 23, 1996.

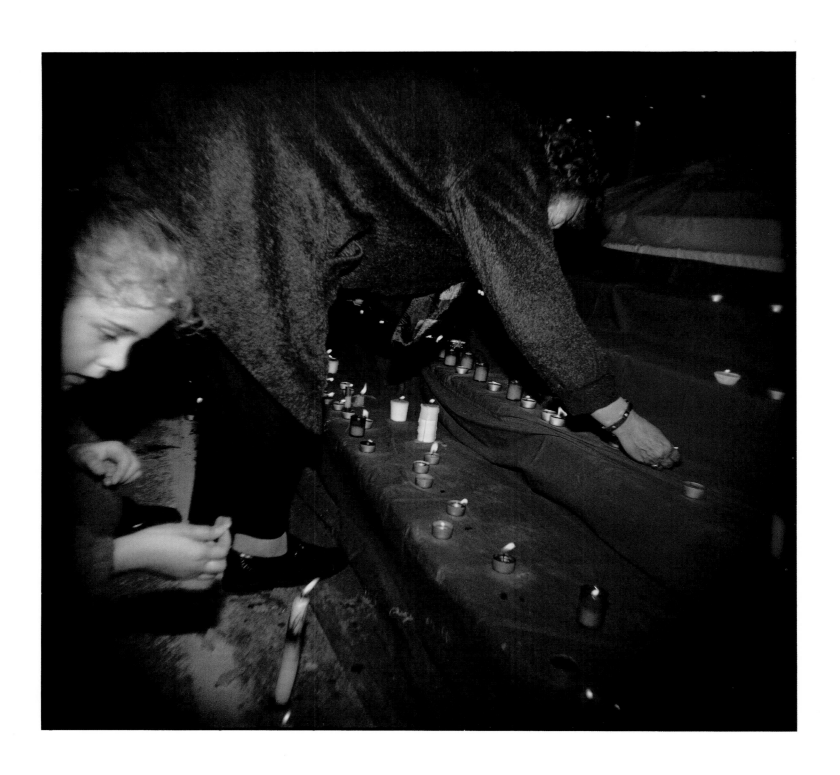

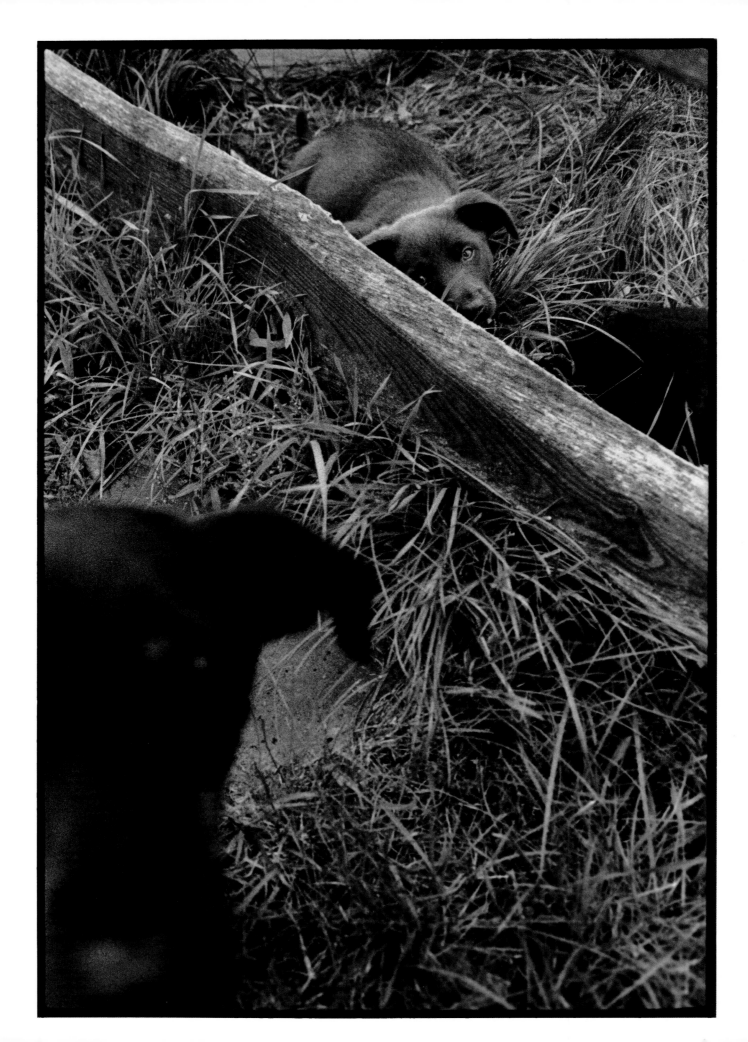

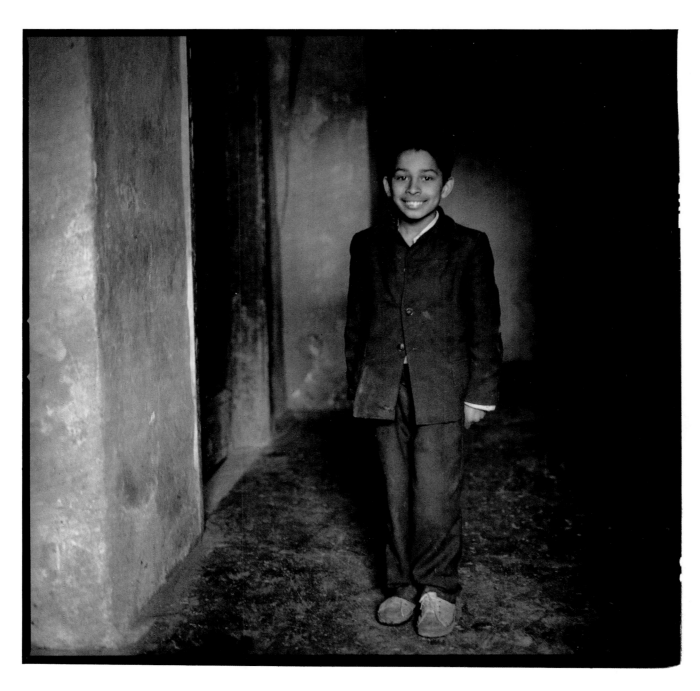

I met this boy, when he was about eleven, in an orphanage in Gelou, Romania.
He wanted me to take him home—he wanted anyone to take him. Like in a true Transylvanian folk tale,
the orphanage was a mixture of enchantment and curse. It was for boys, between the ages of eight and
fourteen. Their parents, who couldn't afford them, gave them to the State. Although they lived in a 16th century stone
castle, they had barely enough food and only cold water to wash themselves and their clothing.
Still chilled from the winter, they wore knitted caps indoor, as late as March. They slept in simple iron beds
in the Grand Ballroom, like the wounded in a hospital ward in some old war. A portrait of a
woman in national costume, a stand in for "Mother," hung askew and untouchable above the doorway.
It was March, 1990. We brought candy and it wasn't enough.

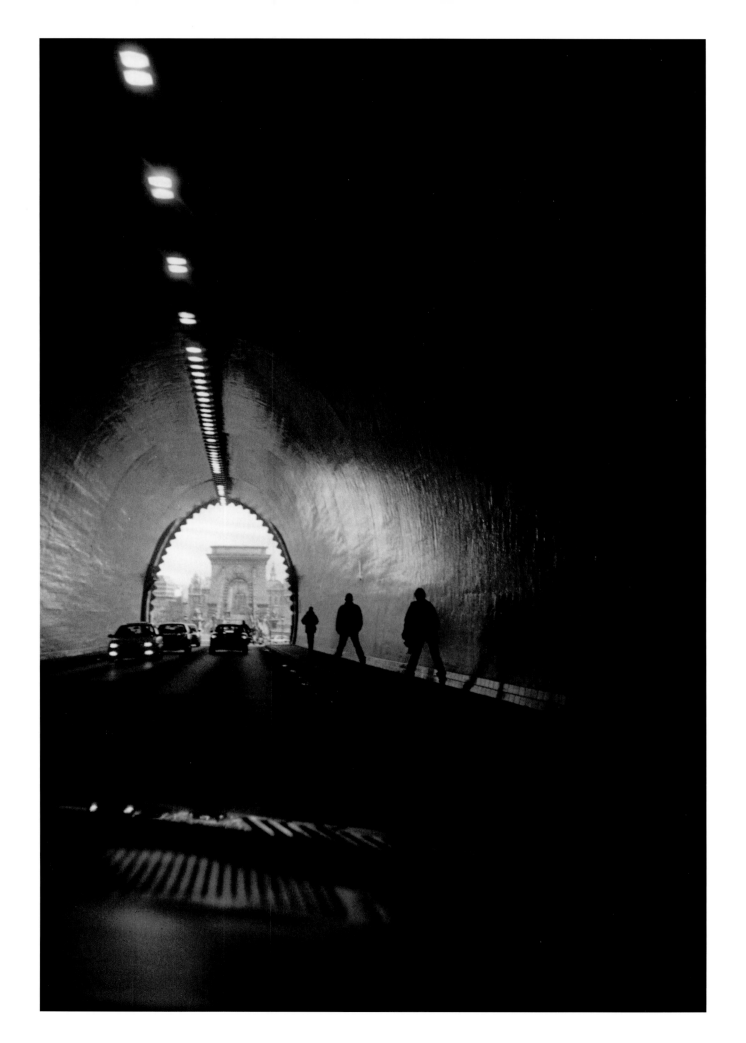

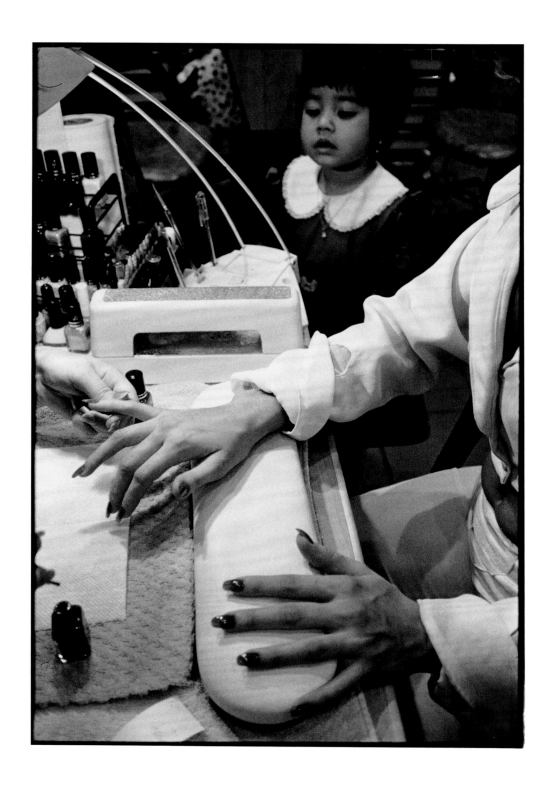

*In 2001, in a mall in Budapest, Marina, a Porno actress from
Transylvania is getting a manicure and a Chinese-Hungarian little girl,
called Szilvi, is entranced by her beauty.*

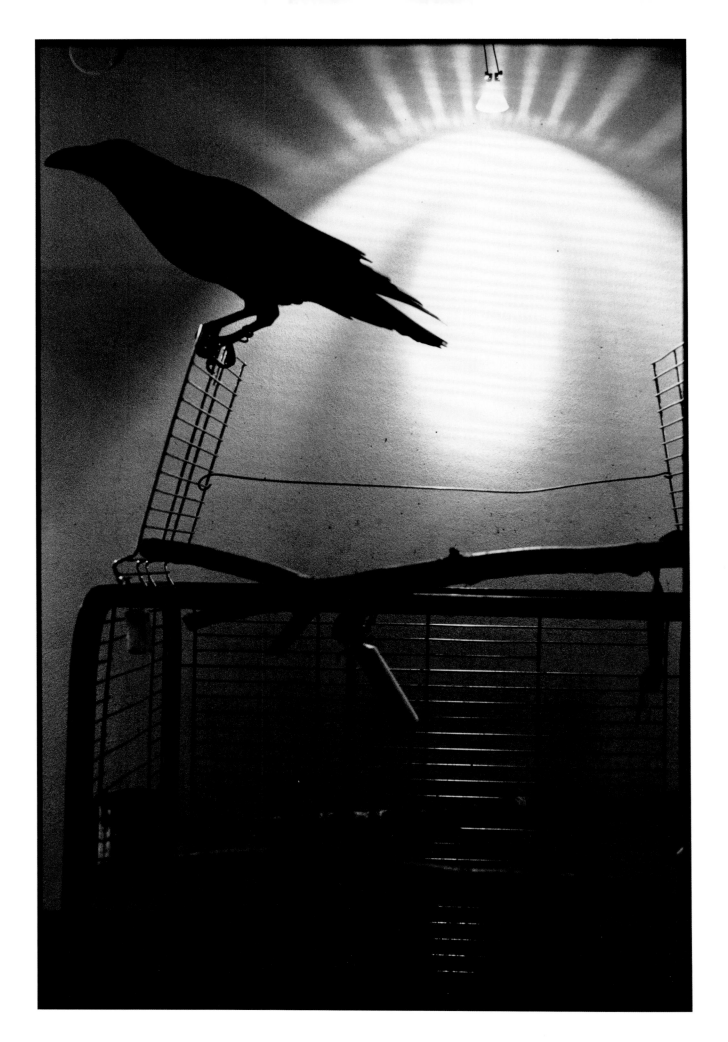

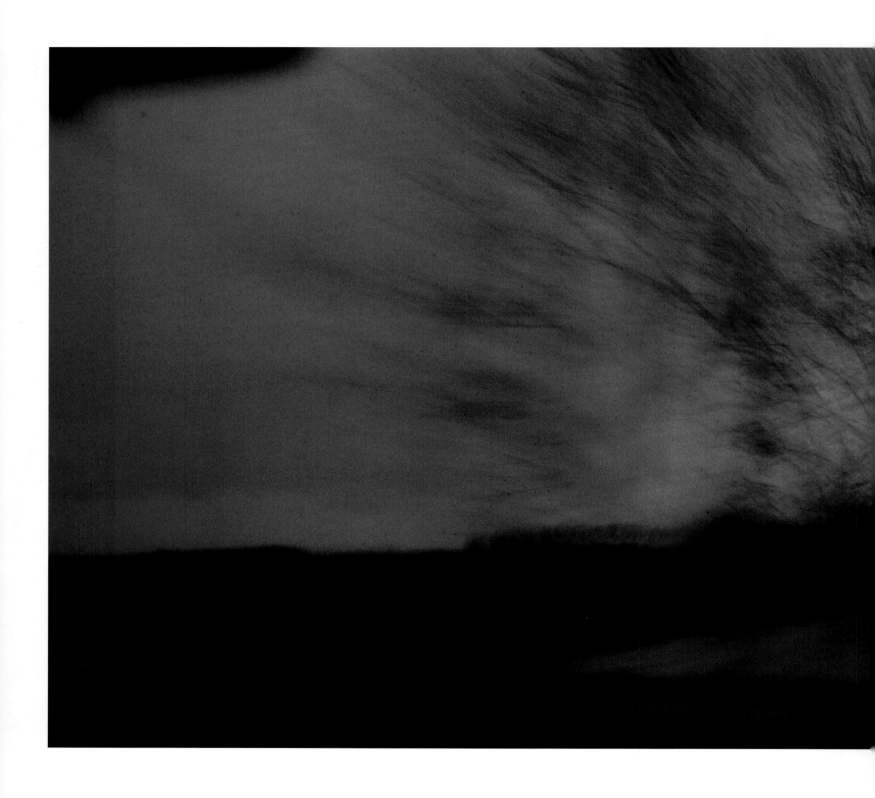

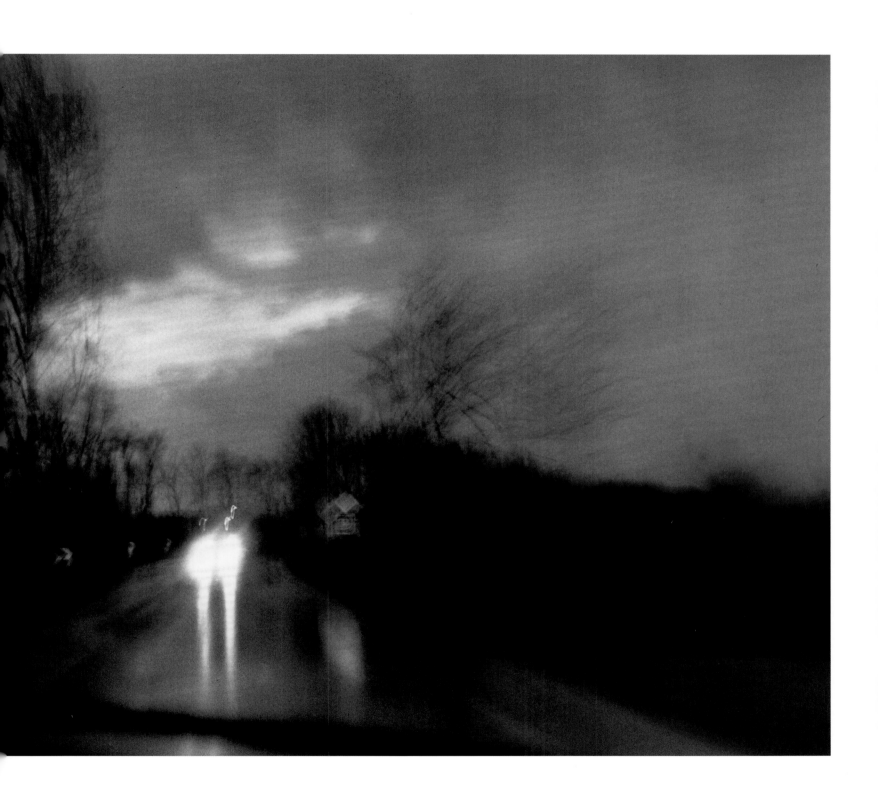

The Red Army has gone home.
Atop a diner in former East Germany,
Uncle Sam is blowing in the wind and in Budapest,
if you have the money, you can buy anything.
The buildings in their fresh pastels are privately owned,
yet the homeless huddle in the underpass to keep warm and locksmiths do well.
The gray has been pushed to the edges of town.

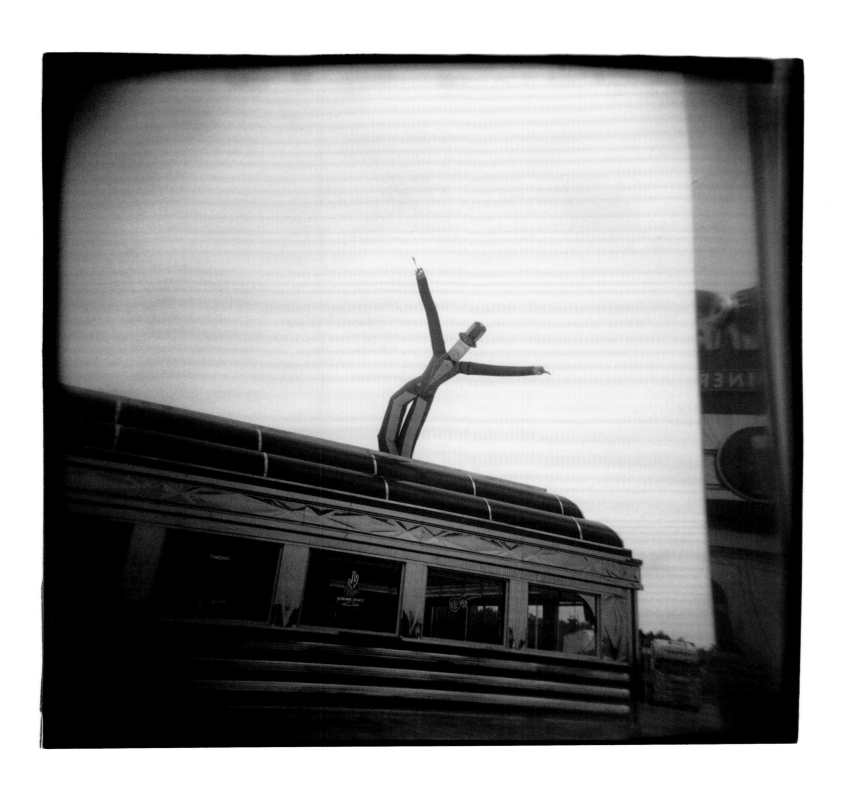

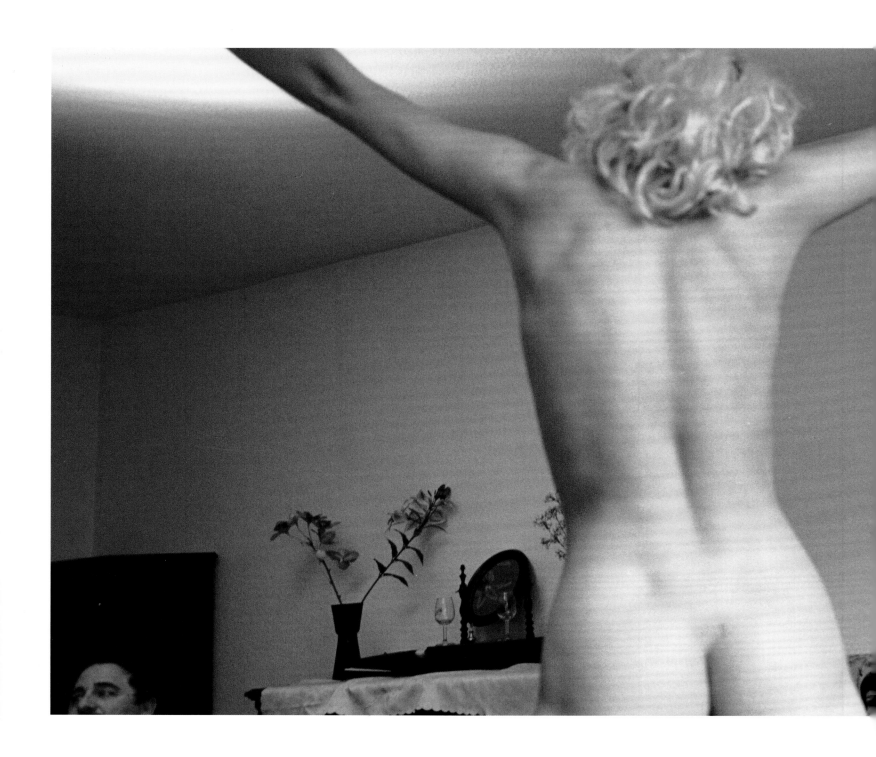

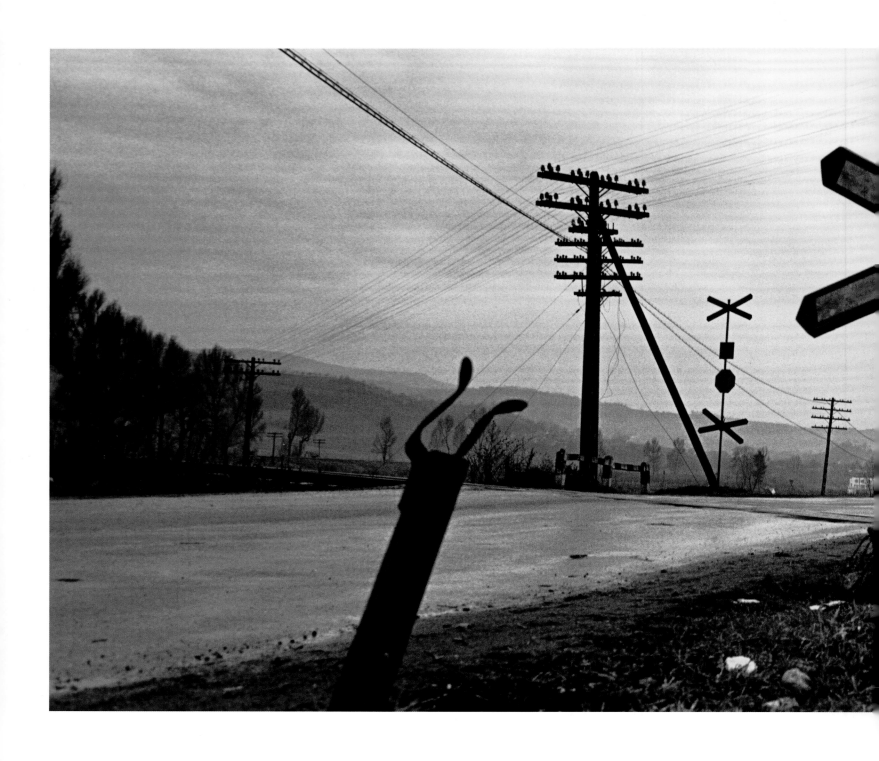

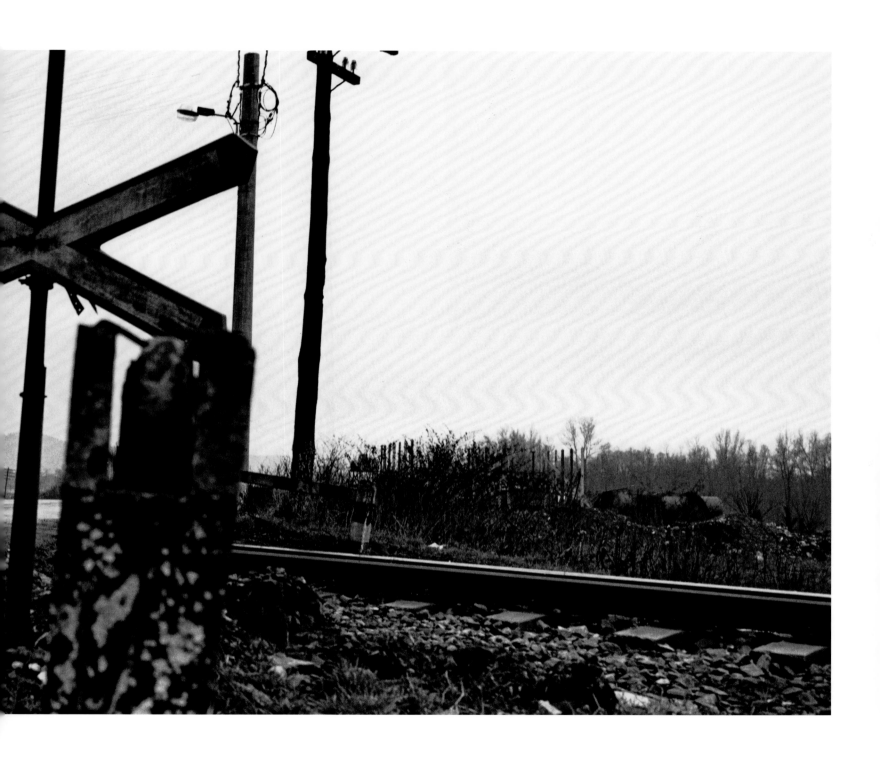

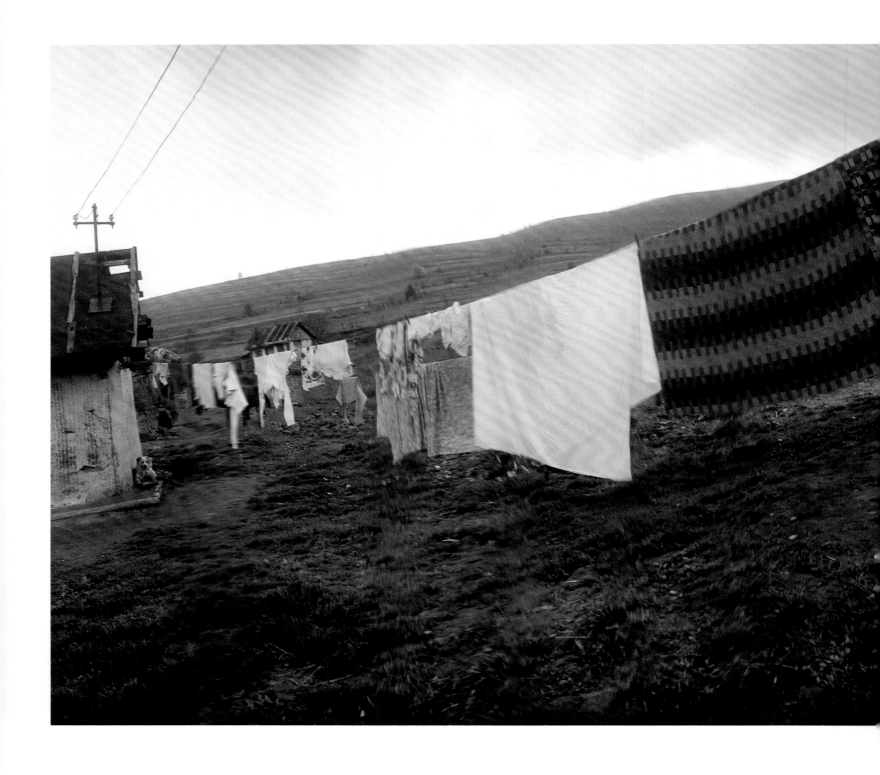

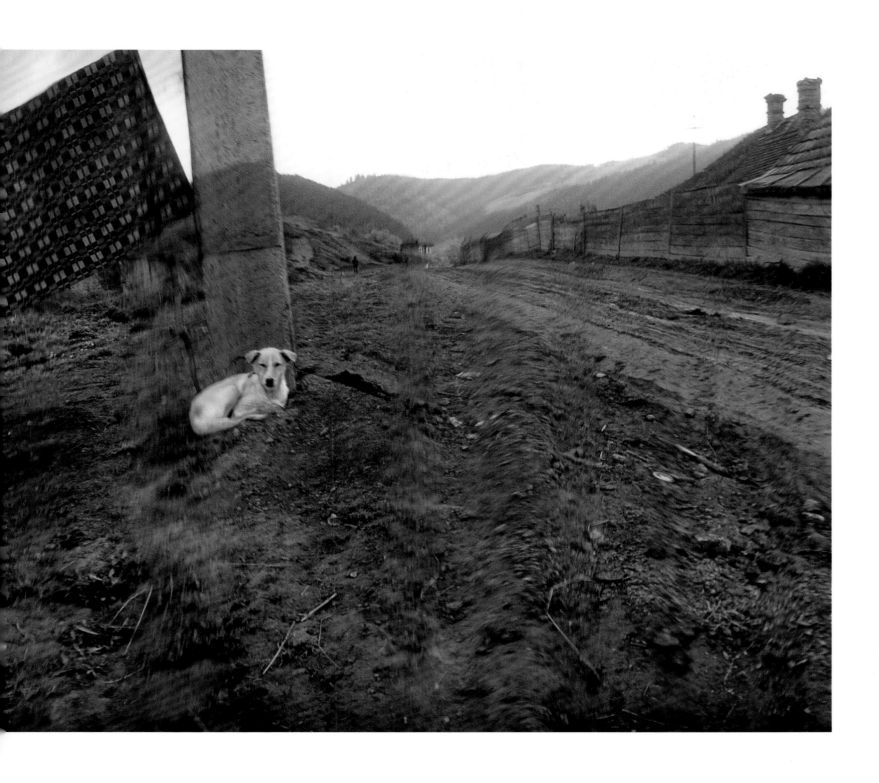

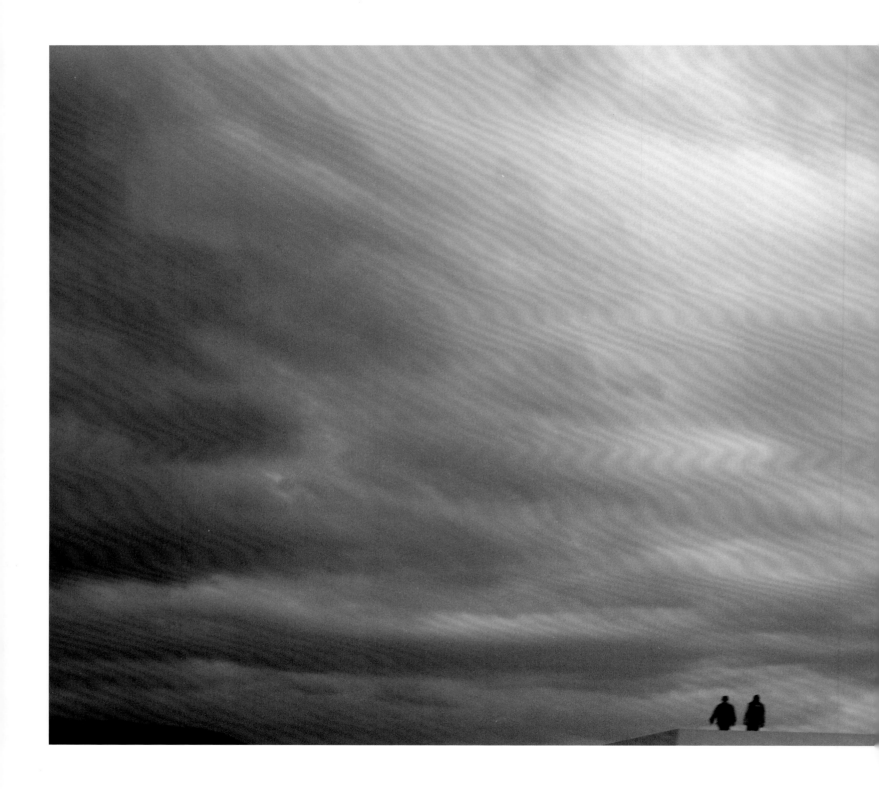

Marika doesn't cry at her parents' grave anymore.

They died many years ago and as she says, "They have gone to another strata."

In postwar Budapest big red stars perched like predators on rooftops
and little enameled ones sparkled menacingly from the lapels of gray-suited people.
Now huge billboards, garish and desperate like clowns, adorn those buildings.
The big stars have disappeared—perhaps sold to China or more likely to Western Art collectors—
and the small ones were scooped up as tourist trinkets. The Hungarian Socialist party
in post-Communist times has switched its symbol to a stylized red carnation, and presently,
to display red stars is against the law. But in 1992 at the Folk Art Museum
of Budapest I saw a ghost of a star. Through a crack in the heavy drapes
that kept out the winter chill the sunlight came through
and there was a star of light.

For Elliot and Adrien,
where would I be without them and without their love?

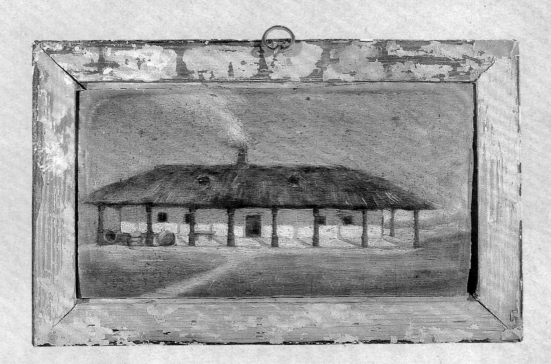

This book is a personal history of Eastern Europe and a summation of my early years in Hungary. It is a farewell to my long attachment to my birthplace. When we left abruptly, in 1956, I thought I would never be allowed back, but like a ghost, I've been returning over and over again. Each trip, especially in the beginning, seemed miraculous: I embraced my friends and floated in and out of the past with my camera. From forty years of travel back and forth, I have brought back these images and stories, and offer them as a bouquet at the shrine of my childhood memory. Exile is inevitable, whether we stay or go. They call me Hungarian-American in the U.S. and Amerikás–Magyar in Hungary and I have an accent in every language. In the end, I'm grateful to my parents for dragging me away at an early age—their humanity, wit and courage still guide me. I wish they could be here now.

Above: The family country home, by my great-grandfather, the painter, Ábrányi Lajos.
Hungary ca. 1880.

I'm thankful to my friends who regularly take me in, give me food and shelter and the pleasure of their company: Marika, Anikó and Karcsi, Lulu and Salima, Carmen, Attila and Erzsi, Bandi and Zsuzsa, Péter and Kinga. I'm grateful to Gyuri, who drove me all over Eastern Europe, to Joan for her insights, to Melissa for her patience, to Sid, Jen and Esteban for their craftsmanship and to Yo and Kristi for their friendship and design savvy. I owe thanks to the spirits who helped convert the negative into positive and to everyone listed below, who gave me their friendship, time, and their know-how or let me in and allowed me to photograph them; including the passers-by, the children, the animals and the trees. Here is the alphabetical list of names I recall: Aaron, Abby, Ági, Alan, Alain, Alex, Aly, Alison, András, André, Anna, Anne, Arthur, Audrey, Becky, Ben, Beethoven, Bettina, Bözsi néni, Brother Béla, Carl, Catherine, Carole, Charlie, Chris, Cica, Clay, David, Deborah, Dilys, Don, Dóra, Doris, Dorothy, Drinka, Egizio, Elie, Elisabeth, Elizabeth, Ella néni, Emese, Erika, Ernie, Erzsi néni, Esteban, Esther, Éva, Feri, Fred, Gabi, Gábor, George, Giselle, Grazia, Grace, Guy, Hanna, Hansgert, Henner, Howard, Igor, Ilu néni, Jackie, Jane, Janet, Jasminka, Jeff, Jim, Joan, Joe, John, Jonathan, Jonas, Judit, Julie, June, Jutka, Karcsi, Karen, Karin, Károly, Károly bácsi, Kati, Kate, Keith, Kevin, Klári néni, Laci bácsi, Larry, Laura, Leslie, Lisa, Little Gray, Lucy, Maca néni, Magda, Mannus, Marci, Margó, Marian, Mária, Marion, Marisa, Mark, Marko, Marnie, Martin, Marty, Mary, Mary Jane, Maryanne, Masha, Mel, Melanie, Mike, Nagyi, Naomi, Natasha, Nicole, Nina, Nora, Nubar, Öcsi, Pali, Panni, Patrick, Pedro, Pegi, Petra, Philip, Pityu bácsi, Poco, Puci, Rae, Richard, Robert, Rodica, Roger, Risca, Roman, Rui, Sandra, Sassy, Shelley, Sister Margaret, Sunshine, Sura, Susan, Tamás, Ted, Teri, Terry, Titi néni, Tom, Vivian, Wendy, Wil, Willie, Zizi, Zezsa, and Zuszsa néni and my apologies to those I've forgotten.

Aperture gratefully acknowledges the generous support
of Lynne and Harold Honickman

Copyright © 2004 by Aperture Foundation, Inc.;
unless otherwise noted, all photographs and text copyright © 2004 Sylvia Plachy.
Page 36: Photograph by André Kertész of Sylvia Plachy,
courtesy and copyright © the Estate of André Kertész
Page 118: quote copyright © Czeslav Milos.

Library of Congress Control Number: 2004104396
Hardcover ISBN: 1-931788-43-X

Editor: Melissa Harris
Associate Art Director: Kristi Norgaard
Production: Lisa Farmer

The staff for this book at Aperture Foundation includes:
Ellen S. Harris, Executive Director; Roy Eddey, Director of Finance and Administration; Lesley Martin, Executive Editor, Books;
Lisa A. Farmer, Production Director; Andrea Smith, Director of Publicity; Linda Stormes, Director of Sales & Marketing;
Diana Edkins, Director of Special Projects; Work scholar: Julie Schumacher
Aperture Foundation books are available in North America through:
D.A.P./Distributed Art Publishers
155 Sixth Avenue, 2nd Floor, New York, N.Y. 10013
Phone: (212) 627-1999 Fax: (212) 627-9484

Aperture Foundation books are distributed outside North America by:
Thames & Hudson
181A High Holborn, London WC1V 7QX, United Kingdom
Phone: + 44 20 7845 5000 Fax: + 44 20 7845 5055
Email: sales@thameshudson.co.uk

aperturefoundation

547 West 27th Street, New York, N.Y. 10001
www.aperture.org

The purpose of Aperture Foundation, a non-profit organization, is to advance photography in all its forms
and to foster the exchange of ideas among audiences worldwide.
Printed in Hong Kong by Sing Cheong Printing Co. Ltd.

First Edition
10 9 8 7 6 5 4 3 2

BOOK DESIGN BY SYLVIA PLACHY AND YOLANDA CUOMO

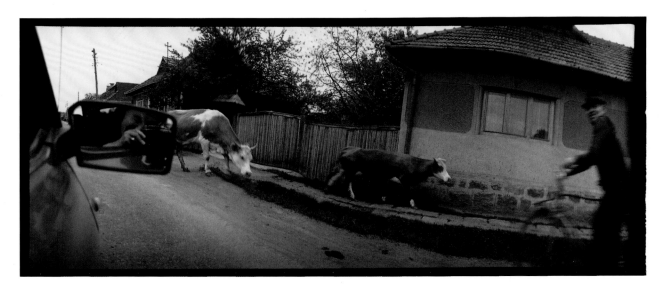

Limited-Edition Print

A limited-edition of Transylvanian Woods, 2001 (pages 4–5), digital C-print on archival paper signed and numbered by Sylvia Plachy,
is available through Aperture Foundation. The edition is limited to 40 prints and 4 artist's proofs.
The image size is: 7¼ x 18 inches; paper size: 11½ x 22 inches. For more information, visit Aperture's website.

Sáři Fánk.

adde reszelve 1 kanál liker va...
és kis rumba. Mindezeket a j 25dkg liszt 14dkg dió vagy
dió kavarjuk míg tova le... 14dkg cukor egy kis rumba
T. 16 tojás sárgája 14 dkg vajra és béhenyre kinyújtani
2 14 dkg mandula réteggel harral kitraggatni la...
két rúd csokoládé jol kezd összeravja...ltam
...jás habja. Tharura 110 d... jeggel keverni.
...cukrozva csomuk keveradé idg. 4 rud csko...
... két rúd csokoládét puhra vízzel, megpuh...
vajjal elkeverőljük össze darabonkt hozzá adni 20
...da van a masszára um ... ért felyözni. itt kja...
(...Anyuka féle) 5 tojás ... vagy bele mártani és ...
...or 3 rúd csokoládét őralt dios vagy man...
...rdula 1 marék bréz
...öntrabja. (Ez a legfinom.)

Krémes

...nag...
...kan... tmás vagy ... 25 dkg vaj 30 dkg liszt
... rás ecet és egy tojás sár...
...kg liszt 25dkg cu... lisztrol el vajjal jo...
...nár bor vagy tej? több lisztet a tört kai...
...topor és cukor letmér... tart gyúrjuk (4annyov...
...nyujtani meg tettem tyeds a vajat és kihejel...
...it tenni. kap ha a pihentetjük (háro tész...
...H... i nyujtjuk és a le rási...
Mignon.
... érral megronha...
...sárgája 12 dkg cukor... tesnt.)
...jet kemény habbá... krémje. 5 tojás jorahan...
...ja itt cukornak nyuj... tj kerül dio...
...jeg verjuk. itt cukor tuk bor...
...jgájával kavar...
...a habot és 12 dkg

Krémes Karames és Pitoly
...vat.
...hozzá... 40 dkg cukor tojás fehérjét kemény hab...
... addig forszuk nyomjuk 9 evőkanál ham 20...
... ... túros kezdelövel 9 evőkana...
...kg tett ezt ej... ...adtt idatolyu...
...re és ha ... evőkanál tejen...